For Helen and Bill Biren —
our dear friends —
with love,
Fan and Stephen

March, 1981.

RUSSIA ON CANVAS

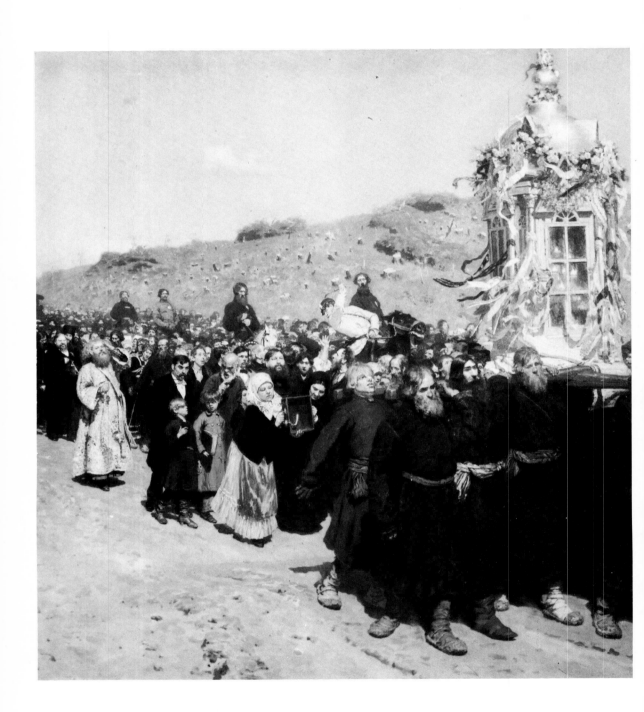

Russia on Canvas

Ilya Repin

Fan Parker
and
Stephen Jan Parker

The Pennsylvania State University Press

University Park and London

Frontispiece: Detail from *Religious Procession in the Province of Kursk*

Library of Congress Cataloging in Publication Data

Parker, Fan
 Russia on canvas.

 Includes bibliography and index.
 1. Repin, Il'ia Efimovich, 1844–1930. 2. Painters
—Russian Republic—Biography. 3. Russia in art.
I. Parker, Stephen Jan, joint author. II. Title.
ND699.R4P33 759.7 [B] 79–20577
ISBN 0–271–00252–2

Contents

Acknowledgments

We are especially grateful to I. S. Zilbershtein, the distinguished art historian of the Soviet Union, for his guidance, counsel, assistance, and, most of all, for his friendship. We would like to thank I. A. Brodsky, art historian and Repin specialist of the USSR Academy of Art, for his aid and encouragement, and the late Korney Chukovsky for his commentary on the Repin-Nordman relationship and his support of our research efforts. Special acknowledgment is due N. A. Baklanova of the Academy of Art Archives for the transcription of all Repin letters to E. N. Zvantseva; to the staffs of the Tretyakov Gallery in Moscow and the Russian Museum in Leningrad for their help and generosity in assisting us to obtain photographic reproductions of Repin's works; and to Simon Lissim, Russian-American painter and professor of art history, for his critical reading of the manuscript when still in its infancy.

Last, but surely in no sense least, we thank the head of the family, Irving Parker, for his infinite tolerance and unflagging support during the years this book was in preparation.

A Note on Transliteration

The authors have followed the recommended system of transliteration from Russian to English as given by J. Thomas Shaw in *The Transliteration of Modern Russian for English-Language Publications* (Madison: University of Wisconsin Press, 1967). System I is used for transliterating personal and place names in the text, though not in bibliographic citations. The only exceptions are the use of well-known and accepted spellings, such as Tchaikovsky (rather than Chaikovsky). System II, the Library of Congress system, is employed in all other instances.

All translations from the Russian are the authors' unless otherwise indicated. Italicized words in the original Russian are preserved in the translations.

List of Illustrations

Unless otherwise noted, the works are by Repin and the medium is oil on canvas.

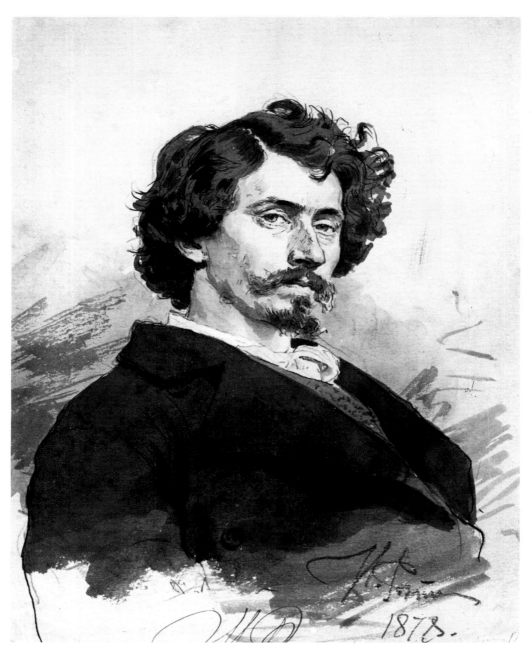

Self-Portrait of the Artist.

Introduction

Americans have been particularly well disposed to Russian culture of the nineteenth and early twentieth centuries. There is an element in the Russian psyche, formed by its oppressive history, which keeps alive in the consciousness of the Russian people a striving for justice and for freedom. In the galaxy of Russian writers, musicians, philosophers, scientists, the same element prevails: the struggle against oppression and the hunger for freedom.

It is curious, then, that the name Ilya Efimovich Repin (1844–1930) is barely known to Americans outside of the limited circle of specialists in Russian art and culture. Many Americans have seen some of Repin's work—*The Volga Boatmen, Musorgsky, The Church Procession*—since they often appear on book jackets and advertisements for the purpose of expressing that which is quintessentially Russian. But their creator's name remains unknown. Some Western art historians and critics have minimized Repin's achievements and contributions either because his very "national" identity has not been grasped, or because—and this is most likely—Repin was neither a technical innovator nor the creator of a school of painting.[1] Moreover, he was a realist and not a modernist. Yet in the esteem of both prerevolutionary and Soviet Russia, Repin occupies a position alongside Dostoevsky and Tolstoy, Musorgsky and Rimsky-Korsakov. He was and is Russia's foremost national artist, whose *œuvre* adheres to the requisites for national art as proposed by the noted painter and art historian Igor Grabar: it must reflect the spirit of the people, expressing their thoughts and aspirations; it must excite; and it must be understandable to the people.

In the course of eight decades Repin produced a momentous artistic heritage for Russia past and present. His creative work was varied, as he worked in all genres and touched upon many aspects of contemporary life. He illustrated the writings of most of his literary contemporaries—Nekrasov, Tolstoy, Leskov, Garshin, Chekhov, Gorky, Andreev—in more than 150 drawings. He executed portraits of Musorgsky, Rimsky-Korsakov, Turgenev, Tolstoy, Fet, Mendeleev, Pavlov, and many others. His voluminous correspondence with the intellectuals and artists of his time, covering many decades, offers a fascinating record of

both the man and his era. Nowhere is the particularly characteristic aspect of the arts of nineteenth century Russia—the close, organic ties that existed between them—more evident than in his life and paintings. Self-educated in the humanities, Repin stood as a recording center of Russian cultural life from the 1870s into the early years of the twentieth century.

While many volumes in the Russian language have dealt with Repin's art and life, varying from specialists' work to popular literature, this book is the first in the English language devoted to him. Neither a definitive biography nor an exhaustive treatment of his voluminous *œuvre*, it is a selective account of Repin's life and art, an introduction to his multifaceted activities and contributions. In order to demonstrate the unique national cast of Repin's achievements, the authors have chosen to write of Repin as he himself perceived his life in the social and political violence of his time.

1
Beginnings

Against a background of the wide, almost endless Volga with its quietly sleeping waters, the boatmen are towing a barge with the strength of their harnessed bodies. They are the outcasts, tramps, and wanderers, the vagabonds of their native soil, a magnificent collection of types gathered from every corner of Russia, each a unique portrait. Wearily dragging their load along the sandy flats of the Volga, young and old, strong and weak are united in a common travail.

Eleven barge-haulers are depicted by the artist. A young boy in their midst, whose torn shirt reveals a cross, protects his chest from the pressure and soreness by placing his hand under the strap which is cutting into his tired body, while his eyes gaze sullenly into the distance. The leader in the foreground is flanked by two herculean figures with bushy hair and bronze chests, arms hanging loosely against half-bent bodies. Behind them a tall, gawky lad smoking a pipe stands almost erect with a questioning look on his face. Further down the line an exhausted, emaciated figure covers his face with his arm to hide it from the scorching sun, while another old man leans heavily on the young lad. These figures supply the impetus to the rest for "a strong pull, a long pull, and a pull all together."

The large canvas carried the name *Burlaki* and was signed Ilya Repin. The venerated art historian, critic, and scientist Vladimir Vasilievich Stasov rendered his homage in the public press:

One look at Repin's *Burlaki* and one is at once compelled to admit that no one before has dared to undertake such a theme. Such a deeply moving picture of Russian folk-life has never before been seen, despite the fact that this task has been before us and our artists for a long time. Is it not the basic quality of a great artist to observe and incorporate in his creations that which is truthful and obvious, and yet which is passed unnoticed by hundreds of thousands of people. . . . From the plan and from the idea of his painting, Mr. Repin is a significant and mighty artist and thinker, and at the same time he also possesses the mastery of his art, with a power,

beauty, and perfection equalled by no other Russian artist. Each detail of his painting is thought out and so drawn as to call forth deep contemplation and sympathy from all who are capable of appreciating genuine art. One cannot but foretell for this young painter a most promising artistic future.[1]

Burlaki, literally "The Barge-Haulers" but known more popularly as "The Volga Boatmen," brought instant fame to the twenty-nine-year-old Ilya Repin, fame as sudden and as widespread as it had been for Fyodor Dostoevsky upon the publication of *Poor Folk* and Leo Tolstoy with the publication of *Childhood*. In these ragged social outcasts, the young artist had captured the age-long suffering and the strength of Russia's common man. The year was 1873. Russia had read the complete works of Pushkin and Gogol and major writings of Turgenev, Dostoevsky, and Tolstoy. Naturalism in literature had long since passed on to realism, and the golden age of Russian prose was drawing to its close. At this moment the young Ilya Repin exhibited the first of the canvases which would later secure for him the reputation of master practitioner of realism in art. Painting, long after literature and following its traditional *arrière-garde* position in Russian arts, was still seeking to develop an independent Russian voice.

The history of Russia has no period that can be considered a Renaissance parallel to that of the Western world, no religious development comparable in magnitude to the Reformation; after Christianization, however, Russian religious art changed, and religious fervor was expressed in monumental art forms. Prince Vladimir's adoption of Greek Orthodoxy as the official Russian religion at the end of the tenth century created conditions for the embellishment of the interiors of the new Pravoslavnaya churches and cathedrals with a shining opulence. Besides the rich ceremony of the Orthodox liturgy, there was the splendor of new churches and cathedrals whose interiors were covered with mosaics, frescoes, and icons. Russian art was clearly spellbound by the antique magnificence of the Byzantine. By the next century, during the reign of Vladimir's son, Prince Yaroslav (1019–1054), and the construction of the Cathedral of St. Sophia in Kiev, with its thirteen cupolas representing the Christ and his twelve Apostles, art was already characterized by Russian thought.

Ecclesiastical art was under the direct supervision of Russian rulers through the twelfth century and until the Mongol conquest (1238), when the control of icon painting passed from the jurisdiction of the monarch to that of the churches and monasteries. In the course of the domination of Russia by the "Golden Horde" ecclesiastical art not only served as a unifying force for the people but it also was in this period that the art of icon painting reached the height of its glory in the famous Novgorodian icons produced by such masters as Theophanes of the late fourteenth century and particularly Andrei Rublev of the

early fifteenth century. His icon *The Holy Trinity* (1411?) was a first intrinsic Russian expression in art. The geometric composition, a structure of circles and triangles, is harmonious and the beautiful interweaving of lines gives the icon elasticity and a symphonic richness while the gentle color combination of lapis-lazuli, yellow, and white caresses the eye. Unlike the Byzantine icon with its intense, severe, passionate images and muted colors, Rublev endows the three angels symbolizing the Trinity with expressions of tranquillity, compassion, and humaneness in praise of life. This indigenous Russian iconographic art, thriving through the fifteenth century, deteriorated in the following century when the Moscow State, through its Church, restricted free artistic expression of icon painters by demanding conformity in representation of divine images.

At the end of the seventeenth century, with the accession of Peter the Great, Russia forcibly embarked on a massive cultural importation from the West. Although Peter's efforts may have been sincere, his attempt to Westernize "Little Byzantium" amounted to no more than a coating of European tastes and habits. In art the results reflected an expediency which had characterized the general Europeanization. Emphasis was first placed on the practical disciplines of engraving and anatomical diagramming. Then, in 1757, the Empress Elizabeth established the St. Petersburg Imperial Academy of Art. Under the tutelage of foreign instructors, the pupils—often serf children conscripted to guarantee full enrollment—produced, for the most part, a mildewed art drenched in the mists of European pseudo-classicism. With the sole exception of portrait painting (Rokotov, Levitsky, Borovikovsky), the painting and sculpture of Russia remained accessories to architecture and the decoration of interiors. The art of the eighteenth century was a formalized amalgam striving ineffectually to reconcile biblical themes and classical mythology with a Russianized Byzantine heritage.

The onset of the nineteenth century brought little change. The teachers and students of the Academy continued to paint nymphs, pretty maidens, and minor aristocracy, quite as if Moscow had not burned in 1812 and there had been no momentous Russian heroes such as Kutuzov. There were, however, some individual and notable exceptions, such as Orest Kiprensky (1773–1836), an excellent portraitist, and Vasily Tropinin (1776–1857), a painter of genre scenes and sentimentalized portraits of young ladies. The titan of the first half of the century, Carl Briulov (1799–1852) established the norm of the panoramic mode (which endured until 1863) with *The Last Days of Pompeii* (1834), a huge canvas in grandiose quasi-historical style.

The work of Alexander Venetsianov (1779–1874) exhibited the first manifestations of an authentically Russian school of art within the context of a society vibrating with the initial tremors of social reforms under Tsar Alexander I. Displaying an analytic quality and appreciation of technique unknown among his predecessors, Venetsianov employed in his renderings of peasant scenes a realistic style suggestive of the Dutch school. Yet, compared to the genre paintings of the late nineteenth century, Venetsianov's peasants now strike the viewer

as puppetlike, registering emotion devoid of living expression. But his recognition of the peasant's life as a worthy object of the artist's study was a revolutionary innovation in Russia.

Though the pen had marched well ahead of the brush with the works of Pushkin, Lermontov, Gogol, Aksakov, Turgenev, Dostoevsky, and Tolstoy, the Russian defeat in the Crimean War of 1854–1855 altered the situation. The shock of military defeat acted as a stimulus, rousing the population out of its torpor and revitalizing its interest in public affairs. Indeed, many patriots took the view that the defeat could be a blessing if it produced a rejuvenation in the economic and political spheres. The sordid conditions within Russia's obsolete social structure were put on view and the reappraisals which followed involved government, nobility, journalists, and practitioners of the fine arts.

The forerunner of the new realism in Russian art was Pavel Fedotov (1815–1853), whose reputation derives primarily from two satirical works, *The Major's Offer of Marriage* and *The Brand New Cavalier*. In the latter, he satirized petty state officials by posing a loutish-looking clerk in his bedroom, barefoot and in bathrobe, pompously pointing to a medal pinned to his chest. Using Fedotov's example, the young Russian artists turned to their own personal experience to find the subject matter of their art. They strove to paint in a language comprehensible to their native culture, in a medium free of classical restraint, and in a spirit like that which had already penetrated into Russian music and literature. For example, Vasily Perov (1833–1882) chose the clergy as his target in his caricatures *Village Sermon* (1861) and *Monastery Meal* (1866); in *Troika* (1866) he depicted the misery of the peasant masses with a strong and painful realism.

The *Zeitgeist* was obvious: no socially conscious artist could regress to the realm of the unreal. The Russian painter was at last taking the realities and inequalities of Russian life as his subject. The cultural atmosphere deriving from the emancipation of the serfs in 1861 and the Zemstvo reforms of 1865 (replacing the power of the nobles with a county council) supplied a context in which the artist could develop his new freedom. In Dostoevsky's words, the creative minds, the intellectuals, became "the great wanderers of the Russian land." They bore an acute sense of social responsibility, an expanded social consciousness, and a morbid conviction of guilt evoked by the gruesome panorama of Tsarist Russia. Previously the painter had been an impotent witness. Now, with the advent of artists such as Fedotov and Perov, new prophets of the Russian people appeared.

2

Youth

The Ukraine, as is common in the case of borderlands, is an area with a history so complex, so full of religious and political struggle, that aspects of it are still debated. Situated in the fertile land of Eastern Europe, it is a vast plain, extending from the Carpathian Mountains to the Sea of Azov, in the midst of which, around the city of Kiev, the first Russian state emerged in the ninth century. From the tenth century until the Mongol invasion in the thirteenth, Kievan Rus was the center of Russian culture.

Since there were no natural barriers such as mountains or large bodies of water, the Kievan state, from the earliest days of its history, had to repel attacks from Mongols, Tatars, Turks, and European powers. As the struggle for this rich and fertile area intensified, the Dnieper, on whose banks the city of Kiev was situated, became the dividing line between western lands under the rule of Polish Catholic power and eastern lands under Russian Orthodox government. Not until the eighteenth century, when the Russian government regained control of the lands to the west of the Dnieper, was there a fully unified Ukraine. This was envisioned by the Tsarist regimes as a Muscovite unity and efforts were made to Russify the Ukrainians, to bind them to the land and employ their Cossack fighters as a potent military force in defense of Russia's national borders.

The Cossacks of Chuguev, the central military settlement in the Ukraine and the town in which Ilya Repin was born and grew up, were settled there by the Moscow government in the middle of the seventeenth century. They traced their descent to peasants who in the course of the Ukraine's violent history had chosen the freedom of the steppes over feudal servitude. With time they evolved from nomadic tribes into autonomous military estates governed by an elected official called the Hetman. The Cossacks (a Turkic or Tatar word meaning "free man") cherished their freedom above all else, adhered fanatically to Russian Orthodoxy, prized the institutions of a primitive collectivism, and gloried in heroism on the battlefield. Under Moscovite rule their freedom declined considerably. Peter the Great forcibly increased the Chuguev community by several

thousand Cossack settlers. Catherine the Great abolished the office of Hetman, bound the settlers to the land, and liquidated all Ukrainian institutions. Still the Cossacks stubbornly maintained their own way of life and cultural traditions.

At the end of the eighteenth century and the beginning of the nineteenth, the Russian government became increasingly aware of its dependence upon the nobility for recruits and military supplies, which in turn tended to foster a political opposition. To alter the situation, Tsar Alexander I initiated a new military-agricultural estate, a system of military settlements which were meant to serve as a standing army. State peasants served in perpetuity, their families under military discipline and their young sons in military schools. The settlers were considered to be of the lowest social status and their lives were governed by uncouth and for the most part brutal officials of minor military rank who ruled by the whip and the gauntlet.

Having participated in the campaign against the Napoleonic armies in 1808 and the capture of Paris in 1814, the Chuguev regiment returned home to find that its town had been razed and then rebuilt as a military settlement. For the Cossacks it was an outrage. Henceforth their uniforms were symbols of bondage and their medals a mockery. In 1819 the Chuguev Lancers rebelled when they were ordered into the steppe for the hay harvest and stood against the Russian troops as a single force. Arakcheev, the commander of all military settlements, was forced to bring in overwhelming reinforcements to suppress the revolt. The defeated Cossacks were brutally flogged, exiled, or executed.

Repin's autobiography, *Far and Near,* is the sole source of information about his early life, affording us personal details of his family, childhood, and youth.[1] His father, Efim Repin (1804–1894), served as a common soldier in the Chuguev Lancer regiment of Tsar Alexander I. For thirty years he saw duty in posts from Turkey to Persia, from the Caucasus to the Crimea, earning several medals for bravery. He married Tatyana Stepanovna Bacharova, the daughter of a well-to-do family of Chuguev, while on leave from the army, and Ilya, born in 1844, was the second of their four children.

Repin's early years were spent in poverty. His father was away most of the time and his upbringing fell largely upon his mother, a devout and highly superstitious woman. She added to the family's meager livelihood by fashioning coats of rabbit fur for the peasant women of the neighborhood. As recollected by the artist, the most notable event of his childhood was the family's acquisition of a house, paid for with difficulty by funds gained by Efim Repin through horse purchasing and selling.

The young Ilya's introduction to art occurred during an illness in 1855 when his cousin Tronka came to amuse him with a demonstration of the magical effects of watercolors. The boy became passionately fond of painting and was soon filling commissions from relatives and friends who desired flora and fauna decorations on various trunks and boxes. But for the most part his early years were difficult and barren. His mother was ordered to work in the fields mixing

straw, cow manure, and clay for use as building materials. Repin recalls one day at noon, hungry and barefoot, his trousers held up by one suspender, he brought his mother something to eat and had difficulties in distinguishing her from the other shawl-covered women who paused, soiled and exhausted, from their labors. He recalls the commandeering of their home for the quartering of soldiers on several occasions, and he remembers especially vividly the abusive Corporal Sereda, a gaunt man with a large staff, the symbol of his authority, who enforced community discipline, driving the settlers to their tasks with blows.

Repin's education began when his mother engaged priests to teach him rudimentary subjects and religion. It continued with his enrollment in the Chuguev School of Topography, again arranged for by his mother. The School of Topography was a military establishment whose students were drawn from Kantonist battalions. The Kantonists, sons of the more prosperous settlers, were members of the military from birth, and from the age of twelve were listed as reserves in the battalions of a given regiment. The School was generously subsidized by the state treasury, which permitted the purchase of the finest paints and materials from England.

In 1857, when Ilya had reached his thirteenth birthday, the system of military settlements was abolished, an admission of the failure of the peasant-soldier system. The School of Topography was dissolved and the teachers were recalled to their regiments. The young Ilya expressed his sorrow at the closing in a watercolor depicting the school and part of the town in affectionate detail. But a greater bereavement occurred the following year when Ustya, his elder sister, died. She had introduced him to the novels of Sir Walter Scott and the poetry of Zhukovsky and had been the vivacious and intelligent companion of his childhood.

In 1858 the fourteen-year-old Ilya apprenticed himself to Ivan Mikhailovich Bunakov, the recognized local master of church art. Icon painting was the Bunakov family *métier*. Bunakov's father and uncle earned their livelihood from it. The father, a painter of the old school, would prime his painting surface with a sticky mixture of chalk and glue, use egg-tempera, and cover his finished works with a specially cooked drying oil which he would rapidly smooth out with the palm of his hand to avoid its turning hard and dark as amber. The uncle was more modern, having received art instruction in Moscow, and was judged a superior painter. Both were devoted readers of the Bible, and the father had a lifelong interest in the history of the Raskolniki (the Schismatics of the seventeenth century who believed that ancient Russian national rites and church forms were more pure than the "corrupted" practices of the Greek Orthodox Church). Occasionally on Sundays he would visit Repin's mother and spend the day discussing with her textual interpretations of biblical passages.[2]

Ilya's teacher, Ivan Mikhailovich Bunakov, was a tall, dark-haired man with black, magnetic eyes. Sitting upright at his easel, his hands would move along

Portrait of the Artist's Sister, Ustya.

the maulstick with great precision and assurance even when painting the finest, most delicate parts of the icon. He painted with passion and his students could hear his expressions of consternation when at rare times the wrong brush stroke was applied.[3] He was a fine portraitist, painting small portraits that successfully caught the likenesses of his subjects. He taught his students, by example, the need for serious application in painstaking and meticulous work. Despite the fact that the workshop was untidy and disorderly and work was frequently interrupted by visitors, Ilya studied under Bunakov for two years.

He studied and worked in the company of L. I. Persanov, the "Raphael of Chuguev," whose landscapes were well known in the region. As Repin recalls, one evening Persanov saw the boy diligently copying a reproduction of a conventional landscape—a castle reflected in the waters of a park lake—and rebuked him for copying another's work when he could see from his window the waters of the Donets flowing by.[4] The admonition to use his own eyes and vision was an important one, as was the entire two-year period with Bunakov. In later years Repin told Igor Grabar that he was indebted to Bunakov for his basic training in the technique of painting.

After leaving Bunakov's, Repin was self-employed. His religious painting attracted attention in Chuguev and neighboring towns, as did his portrait painting. Among his many portraits of this time, those of his mother and his aunt,

A. S. Bacharova, are particularly noteworthy. Both are painted in the style of the miniature popular in the early nineteenth century, *en face* with the models sitting in like positions, draped in shawls with hands crossed. The sixteen-year-old also continued his self-education by reading the works of Pushkin and Lermontov and subscribing to St. Petersburg art journals, all the while carefully planning a course of action which would eventually take him to the Imperial Academy of Art in St. Petersburg.

Between 1859 and 1861 Repin accepted commissioned portrait paintings and engaged in occasional art work for churches. The certain opportunity to earn sufficient funds for his prospective journey to the capital came in the next two years. In August 1861 he signed on with a contractor for a full winter's work on a church interior and was well paid for his work. Similar contracts followed, climaxed in 1863 with his restoration work of an ancient sanctuary screen in a church in Sirotin, Voronezh province. Here Repin labored thirteen hours each day on a scaffolding thirty feet above ground. While his fellow craftsmen were puzzled by his dedication to work, the contractor was impressed by the quality of his painting and paid him in full the agreed-upon 100 rubles, a significant amount at the time. With it, Repin had finally accumulated sufficient savings to depart for the capital.

The trip, as Repin recalls it in detail, left an indelible impression. In Kharkov, after waiting a week, he found a seat on the roof of a decrepit double-decker coach which left him exposed to rain and bitter cold. When precipitous hills were to be toiled up and then descended in one swaying plunge, Repin's terror was overwhelming. As the coach approached the province of Orlov it suddenly slowed and Repin, who had dozed off from exhaustion, awoke with a start to the clamor of voices. The coachman, cursing and struggling to control the frightened horses, bellowed threats at a swarm of peasants clawing at the sides of the coach, begging for a crust of bread. Repin had never before seen such emaciated people, even among the poorest of Chuguev.

These were the "free" peasants whose plight was a paradoxical consequence of the liberation of the serfs in 1861. The members of the working committee who had drawn up the Act of Emancipation were landowners and serfowners whose interest was to gain the utmost benefits from a reform dictated by the political and economic conditions of the time. About twenty-five million, to count manor serfs alone, were freed from feudal ownership; but the lands on which they lived and worked were bought from the landowners by the Crown. They were then turned over to peasant communes with the stipulation that each peasant must pay interest to the government for forty-nine years. The peasant was also permitted to buy a parcel of land outright, but the cost for most was prohibitive. Or he could stay on the land for nine years, paying the landlord either in money or in labor for the privilege of keeping his home and the land on which it stood. The reality of the situation was that the peasant found himself still in bondage. Bewildered and in anguish, the serfs reacted to these

"reforms," so evidently weighted in favor of their oppressors, with mass revolts. Arson, looting, and murder were rampant in villages all over Russia. Those most affected as a class were the servants of the manor, for they were simply rendered destitute. There were landowners who, deprived of free labor, sold or abandoned their estates, and the peasants who had depended on them for food and shelter for centuries were now left to fend for themselves.

Having fought off the horde of hungry peasants, the coach continued its journey until at last the driver brought the horses to a halt before a station house. Here a scene was enacted which was to occur many times during Repin's long journey. Attendants at once appeared, welcoming the well-to-do passengers, carrying their baskets of provisions as they ushered them into the warm inn. Gnawing at his stale loaf, not able to afford ten kopecks for a glass of hot tea, Repin watched while a steaming samovar was brought and a lavish buffet was set up. At length surfeited with food, the travelers started back to the coach, making their way with considerable difficulty through a sea of upstretched, begging hands. Someone flung a copper coin and a savage crush ensued. When all were aboard, the coach moved on, pursued by the peasants. Repin heard one passenger remark that to throw money to these poor creatures was corrupting to their morals.

During Repin's childhood, he had watched gruesome pageants on the broad Kalmytskaya highway of the town: the procession of political prisoners on the way to Siberia. First would come the men, their heads half-shaven, their limbs shackled; then the carts bearing those too ill to walk; then the wives and children. There was bitterness and despair in the eyes of the condemned. Yet they accepted with quiet gratitude any food, coins, or words of prayer given by the settlers who walked beside them through the town. Along with anguish, there had been the humility and compassion of the Chuguev populace.

Repin's departure from the Ukraine in 1863 marked his transition from youth to manhood. He carried the indelible memories of the humiliation of his family's civil status; the deprivations and the loneliness occasioned by his father's absences; the forced labor of the settlers; the helplessness and subservience of the townspeople; the autocratic power over peaceful populations and political prisoners. The subject of his first major painting, *The Volga Boatmen*, expressing his concord with the subjugated, would thus be a logical consequence of the experiences and impressions of his early years.

3

St. Petersburg

From its inception to the present day, St. Petersburg (now Leningrad) has occupied a unique place in the national history of Russia. Peter the Great, determined to make Russia a strong member of the European family of nations, ordered a city built to connect East and West. Begun in 1703, it was built in stone according to plan on the marshes of both banks of the Neva river. Peter, a physical giant with enormous energy who had resolved to revolutionize the outmoded ancient Russian customs, politics, and trade, was driven by a passion for westernization of the "barbarians." By 1712 St. Petersburg had not only become the capital and seat of government, but it was rapidly developing in trade and commerce and its population swiftly increased, coming to number over half a million by the time Ilya Repin arrived on November 1, 1863.

Throughout the eighteenth and nineteenth centuries St. Petersburg was enhanced by the ornamental structures of illustrious architects: Rastrelli (the Smolny Convent, the Winter Palace), Rossi (the Senate Building, the Arch of Triumph), Voronikhin (the Kazan Cathedral), Zakharov (the Admiralty), Richard de Montferrand (the Cathedral of Saint Isaac), and many others, foreign and native, whose styles—Baroque, Rococo, Neoclassical, and some others that fused with the Russian—made St. Petersburg a splendid city of wide boulevards and streets joined by 501 bridges. The Academy of Art, to play an inordinate role in Repin's life, was built by de la Mothe and Kokorinov (1765–1772), a stately three-storied structure on Vasilievsky Island facing the Neva.

But St. Petersburg had another face shaped by the physical structures which sprang up not in the center of the city but around it—the tenements without stylistic orientation in which the population of humble clerks, tradespeople, students, and paupers swarmed. These sections played a cogent part in the works of Gogol, and especially those of Dostoevsky, who blended the city's atmosphere with his main themes in twenty novels and stories. To the youthful Repin, the outskirts of the city seemed a churning conglomerate of strange people, sounds, and smells. With forty-seven rubles to his name, he sought out inexpensive quarters and found a room at five and a half rubles per month on Maly

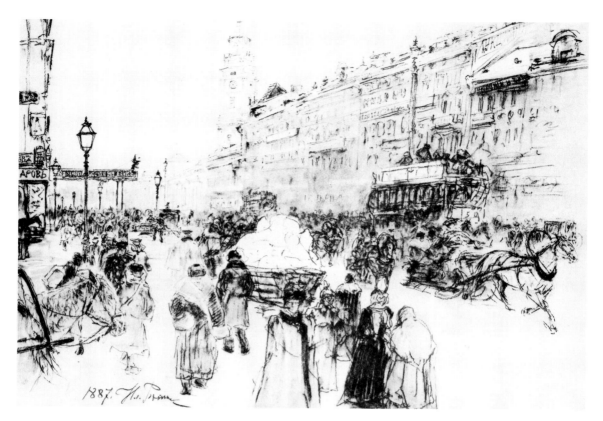

Nevsky Avenue.

Prospect. He then went from shop to shop confidently offering his services as an icon painter, soon discovering that either there were too many icon painters in St. Petersburg, or else the city residents were less religious than those of Chuguev. He was able to induce hardly anyone even to take his name in the event of future interest.

Tremendously discouraged, he wondered whether he should abandon his attempt to transform a dream into reality and return to Chuguev. He confided his misgivings to his landlord, who replied that since Repin had already crossed his Rubicon there was no returning to Chuguev. He also counseled Repin to visit the Hermitage, read *The Iliad* and *The Odyssey*, and enter a drawing school. Repin, however, decided to try the Academy first and obtained an appointment with the conference-secretary. After glancing at a few of Repin's drawings, F. F. Lvov also suggested that the young man enroll in a school of drawing.

Thus Repin registered as a student at the school administered by the Society for the Advancement of Art, which employed P. I. Tserm and R. K. Zhukovsky as teachers.[1] Like the other students Repin was first put to work drawing burdock

leaves from a model in gypsum, but Zhukovsky detected talent in his work and soon transferred him to drawing from plaster of Paris masks and figures under the supervision of the notable painter I. N. Kramskoy of Sirotin. Kramskoy's arrival at the school a few months before Repin's registration is now recognized as a milestone in Russian art. His gracious personality, unquestioned talent, and devotion to art attracted crowds of worshipful students.

One notable day Repin was astonished when Kramskoy gave him a slip of paper with his address and an invitation to visit him. A few days later Repin found himself timidly ringing the bell of Kramskoy's apartment only to be told that the artist was out, but that he was expected back in an hour. Repin walked the streets until the designated time, but still Kramskoy was not at home. On the next attempt he found the artist home. Seeing that Kramskoy was fatigued, Repin wanted to leave, but the artist would not permit it. A steaming samovar was brought in and the painter started to talk with the young Repin like a fellow artist. He was painting a picture of Christ, a picture in which he was going to show the deep humanity of Jesus, and how, like all mortals, He too was tempted, He too had suffered. Repin was astonished at the familiarity with which Kramskoy referred to that figure who in Repin's childhood had been referred to as "the Lord." Speaking of him as a human being, Kramskoy was bringing Christ into fellowship with them. What had sounded supernatural to Repin in his childhood was here transmuted into a tale of enchantment by Kramskoy's interpretation, and while he listened, absorbing every word, he lost all sense of time. When midnight struck, and Repin took his leave, he remained under the spell that the painting had cast. One week later, Repin began his rendition of *The Temptation of Christ in the Wilderness:* on a cliff, against a background of distant seas and cities, he depicted a tragic Christ, garbed in a short chiton with bare feet, shielding His closed eyes with one hand as He repudiated the thought of earthly fame and power with the other.[2]

Repin's progress at the drawing school was rapid, and he was soon advised to apply to the Academy of Art. Admission requirements were a passing grade on an entrance examination and an admission fee of twenty-five rubles. The latter posed the greatest difficulty for the impoverished youth. It was necessary to obtain a wealthy patron, and through the efforts of his mother, who knew an old lady in the service of such a person, an interview was arranged. On the appointed day, when Repin stood in General F. I. Pryanishnikov's reception room and heard the general agree to pay his tuition, Repin was so deeply moved that he fell to his knees sobbing and kissed the hem of the general's robe.

Absorbed in his private affairs, Repin was not aware that a rebellion destined to have a lasting impact on the history of Russian art had started in the Academy just two weeks before he enrolled. Russia was seething with social unrest, the foundation for which had been laid earlier. The stratification of Russian society into two distinct classes, the gentlefolk and commonfolk, was paling and that veneer of Europeanized culture demanded by Peter the Great ceased to serve as

a social mark of the privileged class. A new class was coming into being: in the post-Napoleonic years secret societies formed in the north and south of Russia led not by peasants or military settlers, but by the sons of the nobility who had long enjoyed the life of privilege. These men had become familiar with Western thought and forms of government and their consciences were troubled by the absolute power of the Tsar which still kept the huge peasant population in feudal bondage. On December 14, 1825, Royal Officers of the Guard led an uprising against the Tsar demanding the abolition of serfdom and the supplantation of autocracy by either a constitutional monarchy or a republican form of government. The revolt was crushed in one day by Nicholas I, and the Decembrists, as they have been historically remembered, were executed by hanging or exiled.

By mid-nineteenth century the noble Decembrists were being replaced by a more rugged class of commoners of various social ranks, the "raznochintsy," who pressed hard for an educational and intellectual affirmation of progressive social philosophy. Nikolai Chernyshevsky's dissertation *The Aesthetic Relation of Art to Reality* (1855) made a profound impression when he advanced the idea that "true beauty is precisely that which man sees in the world of reality, and not that beauty which is created by art," and therefore the essence of art, he reasoned, was the representation of life, the explanation and interpretation of it. Art for art's sake had no validity for Russia. His friend Nikolai Dobrolyubov criticized the ineffectual heroes of Russian literature in his essay *What Is Oblomovitis?*, accusing them of too many words and too few deeds. Dmitri Pisarev went even further in expressing a nihilistic philosophy advocating the destruction of everything.

The question of the function of art was a major one for the Russian intelligentsia, yet the Academy of Art stood aloof as the citadel of conservatism. Major policies consequential to the Academy, its faculty, students, and curriculum were imposed directly by Tsar Nicholas I, who reigned for thirty long years (1825–1855). He relegated the post of the president of the Academy to a member of the Imperial family; he instituted curriculum revisions repealing liberal arts as instructional subjects; he made a sharp reduction in funds assigned to the Academy; he adjudicated the artistic merit of paintings; he chose the pensioners; he determined faculty promotions; he pursued, in short, an unmistakable aim of molding artists to be servants of the government.[3] Since most Academy students came from the lower social stratum, they lacked the ability to change or loosen the rigid controls over their lives and destinies as men and artists. Nor did they have the support of a public schooled in the appreciation of the visual arts.

What was true for painting was not, however, true for literature and music. The majority of Russian writers and composers, beginning with Pushkin and Glinka, were of the privileged, educated class. During this period, despite the autocratic rule of Nicholas I, Pushkin completed his *Eugene Onegin* and wrote

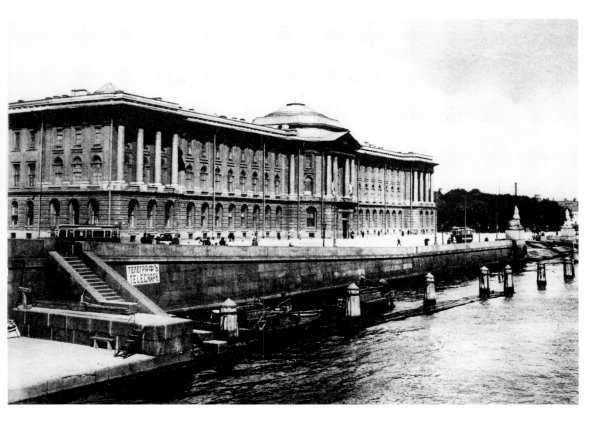

Photograph, The Academy of Art, St. Petersburg.

The Bronze Horseman and *The Captain's Daughter*; Gogol, *The Inspector General* and *Dead Souls*; Turgenev, *A Sportsman's Sketches*; Lermontov, *A Hero of Our Time*; and Mikhail Glinka composed *Ivan Susanin* and *Ruslan and Ludmilla*. The Tsar's censorship was not as detrimental to these arts as was his absolute hegemony over the Academy of Art, a solitary institution located in his capital, the city of his residence.

So strong was the Tsar's power that even after his death, though the reforms of 1859 restored liberal arts subjects to the curriculum, the Academy in 1862 began restricting the artist's freedom to choose the themes for competitions, which were vital in the internal system of recognition through step-by-step awards. Under the pretense of a need for an objective criterion in the evaluation of an artist's work, the Academy decreed that all competing students paint on the same prescribed theme. But now, by the 1860s, the students were prepared to revolt. The preliminary explosion occurred on November 9, 1863, when fourteen students led by Kramskoy submitted individual formal petitions respectfully expressing their opinions that it was unreasonable to expect a student with talent for historical painting, portraiture, or genre themes to compete for honors

by a rendition of such an archaic subject as *Odin in Valhalla*, as prescribed by the Academy, even though it also conceded a contemporary subject, *The Liberation of the Serfs*. They asked permission for each student to submit for the competition the type of painting which he could best execute. The professors and authorities of the Academy refused the "insolent" petitions. Their demands rejected, the fourteen rebels had no choice but to leave the Academy.[4] They were listed by the infamous police division known as the Third Section as "suspicious" and any mention in the press of their revolt was forbidden.

On his first day at the Academy Repin was unaware of the recent events. For him the Academy was a confluence of hopes and dreams, with the goal already discernible. To obtain the utmost profit he decided to take all the courses offered, attending classes from seven in the morning until seven in the evening. Along with the art and drawing classes, his curriculum also consisted of geometry with Professor Thomas, history with academician Sidonsky, architecture with Professor Grimm (about whom it was said that his hair had turned grey overnight when a bridge he had built collapsed), physics and chemistry with Professor Lavrov, and Russian literature. Repin recalled with particular pleasure the comradeship enjoyed by the students who pooled their course notes for examinations and who frequently engaged in spontaneous song to pass the time when the professors frequently were late for class or altogether absent. For the young and humble Ilya these times shared in closeness with fellow artists and students were of particular value.

In April 1864, Repin's drawing *The Cry of Jeremiah on the Ruins of Jerusalem* was judged Number One, which qualified him for a transfer to a higher class, where it also won first rating. At the end of the year he was well prepared in all subjects but one. During the geometry examination Repin took his place at the blackboard and was directed by the professor to dissect a horizontal line with a perpendicular, and to prove it. With naive sincerity Repin attempted to assure his examiner that no proof in this case was necessary. Nonetheless, on September 7, 1864, Repin was admitted to the Academy as a matriculated student. To mark the occasion the Shevtsovs, the people with whom Repin was living as one of the family, sharing the companionship of their two sons and the affection of their nine-year-old daughter Vera (whom he was to marry eight years later), gave a party in his honor.

Each succeeding year now brought more work; eight hours a day attending classes in addition to preparation for quarterly, semiannual, and annual examinations, with monthly sketches and finished drawings to be submitted. But most difficult for Repin was the problem of earning sustenance. Although he was able to accept a few small commissions and pupils for tutoring, he found it necessary to cut classes in order to earn his irreducible ration of black bread and tea.

At the end of the first matriculated year, on May 8, 1865, Repin won the Silver Medal for his study *The Angel of Death Smites the First-Born Egyptians*. Encouraged by his modest success, he painted a genre picture that summer,

Preparing for an Examination, in which the Shevtsov brothers were depicted in their room, one asleep on the couch, book in hand, the other sitting at a window throwing a kiss to a girl sitting at a window facing him. On another canvas Repin painted Vera sitting in a green armchair in contrast to her brown jacket and orange dress; her childish face framed with brown hair, with one braid thrown over her left shoulder, bears a pensive expression.

While enjoying the progress he was making, Repin sought work. He had lost his few pupils and had considered taking a job as a model at the Academy. The official model, Taras, had died and the job paid fifteen rubles a month with a free room in the cellar. Repin's friends, horrified at the thought, pooled their extra kopeks to forestall Repin's decision. In desperation Repin wrote a letter to the Academy authorities: "For a long time I was reluctant to ask the Academy for assistance, but my impoverished condition has finally forced me to do so. I humbly request the Council of the Academy of Art to interest itself in my poor situation, and in some way to secure the continuation of my course. On my part, I promise to study seriously the art and academic courses which I shall continue. In any case I shall try to attend at least the evening classes. However, I cannot guarantee how long I can withstand all the privations which are noticeably weakening my health."[5]

In his struggle for existence, Repin had neglected his academic studies and had lost the right to compete for the Second Gold Medal, which could have led him to the Grand Medal. Only after much trouble was he able to convince the Council that he would make up all his work. His letter, however, went unanswered.

During the summer and fall of 1868 and the winter and spring of 1869, Repin concentrated on painting *Job and His Friends,* a theme prescribed by the Academy. The startled spectators, including the noted critic V. V. Stasov, viewed a rendering that was not a conventional academic representation but a canvas that bespoke a profound understanding of human suffering. The complaining patriarch, at last humbled, listens to "the voices of the Lord," despite the human voices of Eliphaz the Temanite, sitting wrapped in a huge mantle at Job's right, the ornamental Bildad, the Shuhite, and the handsome Assyrian Zephar, the Naamathite. Painted with unusual sensitivity, the face of Job's wife expresses intense suffering while in the distance the sun's rays gild the rose-colored mountains with promise and hope. On November 1, 1869, Repin was awarded the Small Gold Medal.

That same autumn Repin was induced by a fellow artist to take a boat trip on the Neva river. He gazed at the gentlefolk promenading along the fashionable streets on the shore in the noonday sun and watched the ladies' parasols dotting the landscaped gardens. Though the sky was cloudless, it suddenly seemed to him that a dark stain blotted part of the brilliant sun. The sweet scent emanating from the shore suddenly gave way to the pervading stench of human sweat. A loaded barge drew alongside the excursion boat, pulled by a group of harnessed,

ragged men. Repin scrutinized their faces and observed childish smiles that were directed toward the richly attired young ladies on the shore. His eyes followed this human herd until it disappeared from view. He had had his first sight of the barge-haulers and painted a watercolor sketch which he dated June 29, 1868.

On Thursday evenings it was customary for many artists, writers, and others of the young intelligentsia to gather at Kramskoy's home. At one such gathering in 1863 it was decided to organize an *Artel* (guild) on a business basis by hanging out a sign informing passersby of the services offered. The necessary government permits were obtained and the group of Academy schismatics were now banded together, executing various commissions ranging from family portraits to tavern decors. With unity and a sense of purpose the group soon rented a large apartment into which most of the members moved. There they conducted their business, while in the summer they would return to their native villages to paint the local scene and then return to sell their canvases in St. Petersburg. Their activities attracted wide attention and support and it became common for a group of fifty people to gather in the evening to read, discuss, and argue the latest writings—such as Chernyshevsky's *Aesthetic Relationship of Art to Reality*, Pisarev's *The Destruction of Aesthetics*, Proudhon's *Art, Its Basis and Social Significance*, Robert Owen's *Formation of Human Character*, and the works of Buckle, and Büchner. The heady intellectual atmosphere riveted Repin's attention, and though he would subsequently be inspired to devote himself to the amelioration of the human condition, the young artist knew that he first had to resolve his own predicament.

His constant concern for simple subsistence continued to consume most of his time and his academic work continued to be neglected. The spring 1870 announcement of the Grand Medal competition, open only to those who had satisfactorily passed the prescribed academic work, carried his name on the list of expelled students. Angered, he wrote a letter to the Council of the Academy inquiring whether they would graduate him as a "free artist" since he had studied for four years and had earned various medals. He took the letter to P. F. Iseev, the secretary of the Academy, and was assured by him that the Academy's primary function was to produce creditable Russian artists and that Repin thus would not be barred from the competition.

Repin's brother, Vasily, having come to St. Petersburg to study music, was now living with the artist. For some time both he and Repin's artist friend F. A. Vasiliev had been urging Ilya to join them in a summer spent traveling down the Volga. Once again Repin turned to Iseev for help and once more the Academy secretary offered it. He not only provided free transport for part of the journey, but also provided some ready cash by buying Repin's copy of a painting by the Belgian artist Halle. At the end of May 1870 Ilya, Vasily, Vasiliev, and an artist friend, E. K. Makarov, set out on the tiny boat *Samolet* slowly sailing down to Saratov. The young men loved the expanse of the Volga and filled their notebooks and albums with their impressions. At Stavropol they rented a row-

boat to cross to Zhiguli. Then after two weeks of slow passage and much painting, they proceeded down the river to Shiryaevo where they rented part of a hut for thirteen rubles for the entire summer, and settled down to work.

The first and most difficult obstacle to be overcome was the peasants' attitude toward posing. While engrossed in sketching a group of children, Repin was startled one day by the screams of peasant women who descended upon him cursing and shouting that "the devil" was robbing their children of their souls. They demanded to see Repin's passport, and when he explained that it was in his hut the crowd of irate peasants followed him there, forgetting in their fury that not one of them could read. A "scribe" was sent for as the crowd stood around Repin watching him with suspicious eyes. At length a peasant arrived and after examining the document declared, with reverence, that the passport bore the seal of the Imperial Academy of Art. At the word "Imperial" some of the peasants made the sign of the cross while others mumbled their apologies and hurried away. This was but the first of many such experiences which Repin had with the superstitious peasantry.

The same week, a few days later, Repin caught his second sight of the barge-haulers. At work not far from the river bank, he recalls in his autobiography, he suddenly saw them and rushed excitedly toward the river. One man in particular caught his attention, standing out from the rest and yet typifying the common wretchedness of the group: eyes burning beneath a broad forehead, long shaggy curls bound up with a white rag, a large sinewy body straining against the harness straps. Repin was spellbound by this man, whose long worn shirt and tattered trousers failed to detract from an inner dignity. He approached the man, whose name he later learned was Kanin, and promised to pay him handsomely if he would pose for the painting. Kanin refused, invoking the peasant refusal "to sell his soul." Repin persisted and tracked him during the following days, learning in the meanwhile that Kanin had been a priest and choirmaster. Accosting him on his day off, Repin's perseverance won out and Kanin accepted the fee though still convinced that one year later on July 19 the Devil would come to fetch his soul. That same day, strapped and tied to a small barge, he posed for Repin and his figure later became the commanding one in the *Burlaki*, the central figure of the first three in the first row.

Late in the fall Repin returned to St. Petersburg, where Iseev could hardly restrain his impatience to see the products of the voyage. With all of Repin's latest works, including a large and notable sketch, *Storm on the Volga*, spread out on the floor of a huge hall in an informal exhibit, Iseev invited artists and critics to view them. Handsome tribute was paid. Among those invited was the Grand Duke Vladimir, president of the Academy, whose enthusiasm was so great that he commissioned Repin to paint for him *The Volga Boatmen*.

But the Volga receded somewhat from Repin's consciousness when he returned to his duties at the Academy and to academic requirements. He still had to submit for the Grand Medal competition a work on the theme *The Resurrec-*

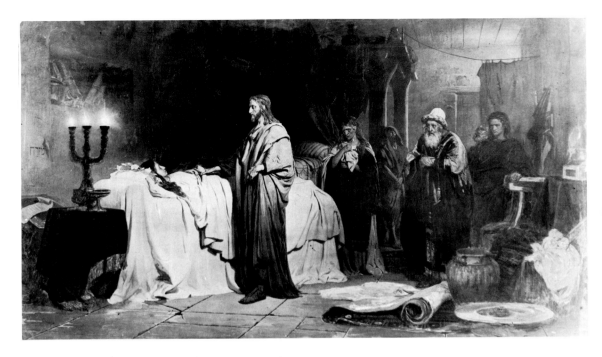

The Resurrection of Jairus' Daughter.

tion of Jairus' Daughter. He worked on it for a time, pondering the theme and making various sketches, but was dissatisfied with all his attempts. During the winter of 1870 and the early months of 1871 he worked on the *Volga Boatmen*. *Jairus' Daughter* continued to resist all efforts. As he struggled with its composition, memories of his sister's death slowly began to pervade his consciousness. He visualized the room where she had lain, the candles which shed a dim light, the deep and solemn silence, the painful moments of the last farewell. The concept and execution of the required work was finally realized. On a huge piece of canvas which he had recently obtained, a great luxury for the impoverished artist, Repin created his interpretation of *The Resurrection of Jairus' Daughter* with a simplicity and depth born of understanding. Repin chose the moment before the resurrection. The candles' light falls directly on Christ. He stands next to the girl almost in the center of the painting, draped in a blue robe which complements the white rich folds of the bier coverings. The group on the right of the painting is subdued by the brown tones of the dark interior not reached by the yellow light of the candles. Christ stands majestically in His simplicity and authority. His right hand is placed on the girl's right hand, which He has begun to lift. The atmosphere of solemnity is perfectly preserved. Not entirely finished, the painting was entered in the competition and on November 2, 1871, was awarded the Grand Gold Medal, which provided a scholarship for six years of study, half of it abroad, at government expense.

This success was followed by another financial windfall. A hotelier commissioned Repin to paint a large group portrait of Slavic composers for the sum of 1500 rubles. It was an enormous amount and obliterated many of Repin's objections to the project: the repelling personality of the hotelier, the difficulty of obtaining the necessary materials, and his own lack of interest in this type of painting. He accepted the commission hoping that Stasov, who had become his warm admirer, would supply him with information and photographs of the deceased composers. But from the very start he regretted his decision. He wrote the hotel owner on February 26, 1872: "One may speed up a wretched horse by the whip, but not a trotter. You spoiled my creative mood, and because of it, work went poorly and I began to spoil the painting. Of greatest importance for every painting, particularly for this type, is the first impression. If the first impression is bad, then no corrections will help, which means that both of us will be the losers. I dare not suggest anything to you, but I don't intend to spoil my reputation just because of your 1500 rubles. I would rather destroy the painting and return the money to you."[6] However, Repin had no choice but to continue and conclude the project. The list of Slavic composers, living and deceased, which had been submitted to the hotelier by A. Rubinstein, included Glinka, Dargomyzhsky, A. N. Serov, N. Rubinstein, A. Rubinstein, Smetana, Chopin, and other composers of lesser stature. Tchaikovsky was apparently omitted because at that time he was a professor at the Moscow Conservatory and not yet enjoying a high reputation as a composer. Musorgsky at the time was still working on *Boris Godunov* and was also relatively unknown.

In early 1871, at the exhibition sponsored by the Society for the Advancement of Art, Repin's *Burlaki* was exhibited for a brief period. Upon his return from his second trip to the Volga in 1872, Repin took that very painting and painted his final version of the *Burlaki* over it. He resolved the artistic objectives but in the process of working on it for three years he acquired an unfortunate habit of repainting parts of his paintings or of painting one painting over another. Since no photograph of his first painting was taken, there was no certainty of the changes made by Repin until expert examination of the canvas, undertaken by A. N. Savinov,[7] established two significant differences: the sky in the first version was painted in pure blue colors and the boatman on the right of Kanin wore a cap shielding his face, his head bowed deeply to the chest. In the final version, the white, almost silvery tone of the background is artistically enhanced; the upraised position of the boatman's head exhibits an open face looking directly at the viewer; his head covering, placed high on top, is fashioned out of rough linen and fur. The boatman's look conveys intelligence and strength. The upraised position of the hauler's head harmonizes with the other two haulers, the most prominent figures in the painting.

Eleven boatmen form the group portrait: the first three, right to left, are Ilka "the sailor," Kanin, and a herculean boatman with luxurious hair, beard, and mustache; then the boatman with the pipe; the muzhik wiping his brow with his

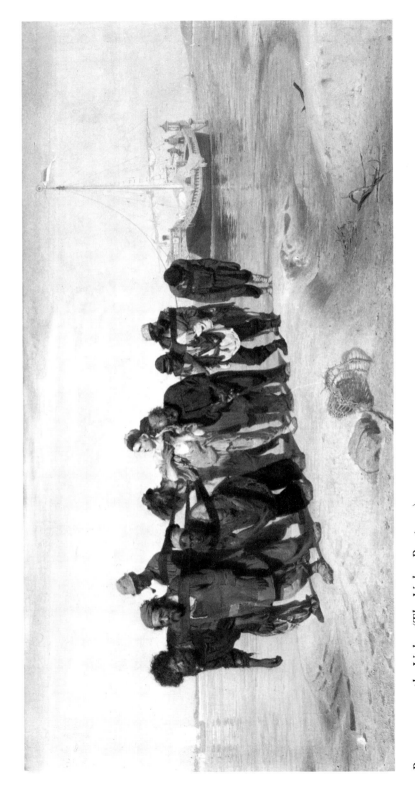

Bargemen on the Volga (The Volga Boatmen).

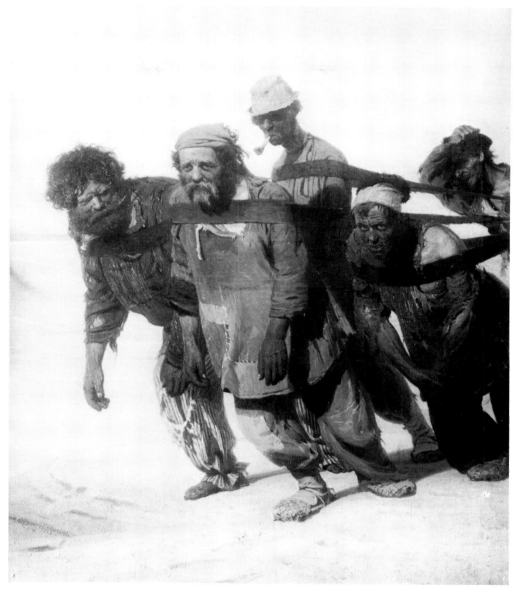

Detail of *Bargemen on the Volga (The Volga Boatmen)*.

sleeve; the young lad Larka; the old experienced boatman with tobacco pouch; the soldier in boots unfamiliar with hauling; the tall fearsome Greek; and two boatmen, one stooped over and one whose head is hardly visible. Each is depicted as an individual, while the strap provides the unifying element of their common labor. With *Burlaki* Repin opened a new page in Russian art. For the first time in Russia, a realistic painting depicted human beings of the "lower depths" as strong, self-respecting, and optimistic.

Dostoevsky instantly realized the innovation. He appreciated Repin's master-stroke when he saw the painting at the exhibition. He wrote:

> As soon as I read in the newspapers about the burlaki of Mr. Repin, I immediately became frightened. The very subject is horrible: we are conditioned to believe that the burlaki more than others are capable of conveying the well-known socialist idea about the unpaid debt of the privileged class to the people. In expectation of this I was prepared to meet them all in uniforms with appropriate labels on their foreheads. What happened then? To my joy all my fears turned out to be in vain. Not one of them shouts to the viewer from the painting: "Look how miserable I am and how great a debt you owe to your people!" Just for this alone the artist deserves the greatest merit. Good, familiar figures: the two front burlaki are almost laughing, at least they aren't crying at all, and by no means are they thinking about their social condition. . . . It is a pity that I don't know anything about Mr. Repin. It would be interesting to find out, is he a young man or not? How much I would want him to be very young and only a beginning artist.[8]

Its exhibition in 1873 brought popular fame, largely stimulated by the voluminous praise of the influential Vladimir Vasilievich Stasov. Repin's association with Stasov, beginning with their first meeting in 1869 and continuing over many decades, was exceptionally important in the development of the artist and man. Stasov's position in the cultural history of Russia was that of fierce proselytizer of realism. He was an art critic, art historian, and researcher in ancient Russian art. His writing dealt with literature, architecture, sculpture, music, and painting, and he continued the tradition of Russian critical thought in the spirit of Belinsky and Chernyshevsky. He was an intimate of all the writers, musicians, and artists of the time, and wielded considerable personal and national power in the art world. He waged an uncompromising battle against the classical traditions while castigating the Academy as a citadel of conservatism and a threat to the vitality of native art, and at the same time encouraged young deviationist rebels at their studios and gatherings. Perhaps his finest contribution was his laboriousness in the cross-pollination of the diverse artistic media which encouraged a true Russian national art form. He brought together musicians, painters, writers, critics under the same banner of art for man's sake, and Repin, as a man of his time, was greatly affected by the national conscience and consciousness which Stasov typified.[9]

At the moment at which Repin unveiled his *Burlaki* a new and dynamic force was at work in Russia's world of art. The *Artel* led by Kramskoy gradually dissolved; internal quarrels and defections were capped by Kramskoy's own departure from the group. In Moscow the Society of Traveling Exhibitions, the *Peredvizhniki*, replaced the *Artel*. The leader, G. G. Myasoedov, a noted artist, and fourteen others signed a code of regulations on November 2, 1870. Dedi-

cated to publicizing the cause of Russian national art, the Society held its first exhibition in 1871.[10] Exhibitions opened in St. Petersburg or Moscow, then were taken through various distant cities of Russia. With Kramskoy, who soon became its leader, the Society attracted most of the original Academy dissidents and became the strongest force in the service of Russian national art.

The times were propitious for this development. The liberation of the serfs was the impetus in the industrialization of backward Russia. With industrial and commercial growth there came societal changes. The labor force expanded and gained in strength. The raznochintsy, of peasant and petty bourgeois stock, took on an increasingly important voice in Russian cultural life, and a new class of merchants and industrialists, having amassed fortunes through their enterprises, were aiding the arts. This was a most phenomenal aspect of the societal changes—the transfer of the sponsorship of art from Court to wealthy merchants and financial magnates. A few of the most notable of these new sponsors and collectors were Kozma Terentievich Soldatenkov (1818–1901), collector of Russian paintings for the art gallery in his home; Savva Ivanovich Mamontov (1841–1918), whose interest and fortune permitted sponsorship of various branches of the arts; I. A. Morozov and S. I. Shchukin, industrialists and collectors of Russian and French art; and Pavel Mikhailovich Tretyakov (1832–1898), friend and sponsor of Russian artists, who from the start of his collecting activities aimed to create a national gallery.

Tretyakov was probably the most important patron. His ambition was to leave for future generations a visual representation of the men who so richly contributed to the cultural heritage of Russia. He commissioned numerous portraits—from Perov, portraits of Pisemsky, Ostrovsky, Dostoevsky; from Kramskoy, portraits of Goncharov, Shevchenko, Griboedov, Fonvizin, Koltsov, and the painter F. A. Vasiliev; and from Repin, he commissioned portraits of Turgenev, Pirogov, Tolstoy. Moreover, Tretyakov was buying paintings by Russian artists which he considered worthy of being hung in his gallery. It was common knowledge that he purchased art not for speculation or from simple ardor of collecting and possessing, but rather with a national purpose. Undoubtedly, Tretyakov's activities had a stimulating effect upon the group of young artists who were putting on canvas scenes of contemporary Russian life and historical scenes which had a bearing on Russian reality. Tretyakov met Repin at the beginning of 1872, acknowledged Repin's talent upon viewing *Burlaki*, and from then on became not only the major acquirer of Repin's canvases, but also his devoted friend.

Repin's own natural endowment, the formal training he had received from the Academy, the friendship with his student peers—Antokolsky, Vasnetsov, Polenov, Kramskoy, Kuindzhi, Shishkin—intellectual and cultural growth under the guidance and stimulation of Stasov, Tretyakov, and the Prakhov brothers filled his first Petersburg years, 1863–1873, with abundant content which transformed the provincial raw youth into a fine artist and a cultured man. He had become an avaricious reader of Russian and world literatures and

Portrait of P. M. Tretyakov.

his curiosity had fed his interest in medicine, science, and other branches of knowledge beyond his own artistic realm.

The milieu in which Repin mingled in the first stage of his artistic and ·cultural development was also comprised of a group of young men who were fated to make the 1860s the Golden Age of Russian music. By the time Repin was commissioned to paint the *Slav Composers*, he was already a close friend of the "Mighty Five"—Balakirev, Borodin, Cui, Rimsky-Korsakov, and Musorgsky. He was a constant participant in the evenings at Stasov's where the Five and other composers, singers, pianists, and musicians would gather to improvise, listen to new melodies, sing new Russian songs, discuss the role of art in Russian contemporary civilization. Musorgsky was finishing *Boris Godunov* and working on *Khovanshchina*; Rimsky-Korsakov was completing *Pskovityanka*; Borodin, *Prince Igor*. Aided by Stasov, and sharing his faith in Russian national

Portrait of N. A. Rimsky-Korsakov.

music, Repin wished to include in his painting not only Balakirev and Rimsky-Korsakov but also Borodin and Musorgsky and was greatly disappointed when the hotelier denied the request. Repin particularly admired Musorgsky as a musician of great promise and shared with him the belief that the Russian people was "an inexhaustible ore from which much genuine can be extracted." Musorgsky's biography referring to this time speaks of a man who found his source and his inspiration in the Russian people and his surroundings.

The various elements [in Musorgsky's music] had already shown themselves separately: the sympathy with the peasants as "real human beings," the pantomimic possibilities of music in the "Intermezzo," the humorous possibilities in "Kalistrat," flagrant disregard of musical convention in the "Harper's Song," leaning toward naturalistic *parlando* recitative (liberal musical translation of the speaking voice, as it were) in a little piece "The

Outcast" for voice and piano, written in 1865. Now all these different elements were crystallizing into some sort of unity to provide a medium of expression for a man who, with all his weaknesses, partly perhaps because of them, was a subtle psychologist with peculiarly keen insight into the weaknesses of human nature.[11]

Whereas every other Russian composer of importance except Balakirev traveled extensively, Musorgsky never left Russia—and only once went farther from Petersburg than Moscow. Nothing, therefore, shook his conviction, expressed in more than one chauvinistic letter of this period, that the Russian was far superior to all "Germans, Jews, Czechs and Poles." He was of the young Russia of the sixties, of the age of reform, full of "facing facts" and "going to the people," contemptuous of beauty and art-for-art's-sake. They were also Repin's precepts and he collaborated with Musorgsky by painting the title page for a cycle of Musorgsky's children's songs.

As a student at the Academy of Art the best in music was available to the artist: Schumann, Liszt, Wagner, Beethoven, Glinka, Dargomyzhsky under the baton of A. Rubinstein, Balakirev, Berlioz, and the operas of Mozart, Rossini, Bellini, Meyerbeer, Glinka, Cui, Dargomyzhsky, and A. N. Serov.[12] Admission price to the upper tiers of the balcony was sufficiently low to allow even an impoverished student like Repin to attend the capital city's opera and concert performances. A letter Repin wrote to Stasov shortly after his arrival in Paris conveys his appreciation and feelings for his personal contact with the world of Russian music:

> Perhaps you are now revelling in the opera of Modest Petrovich [Musorgsky's *Boris Godunov*]—you lucky man! At present I too would have liked so much to listen to Russian music, especially the music of Musorgsky, the essence of Russian music (I dare to think). In my memory so frequently arises his melodies, as of many others. I recall your marvellous, poetic evenings which we spent together in the company of many. The pale blue light of daybreak already lighting the room fused harmoniously with the light of the candles, and it too, it seemed, wanted to listen to these wonderful pieces, the dawn of a new epoch in music. And the sounds of music flowed more magnificently, more entrancingly, and no one wanted to leave. Returning home at sunrise, everything around us seemed so strange, so charming. Life seemed so full of meaning that the old ideals seemed funny in comparison with the existing, real people. Could such a marvellous period of life, so full of meaning, national, original, in the circle of friends, be repeated?[13]

And though now in distant Paris, filled with new impressions and busy at work, Repin remembered the Russian composers, followed their progress, corresponded with some, and never failed to include greetings to Musorgsky in his letters to Stasov.

In the summer of 1872 the Society of Traveling Exhibitions together with the Moscow School of Art, Sculpture, and Architecture held an exhibition in Moscow. Repin went to view it and sent Stasov a letter, an educated discourse concerning the two major schools of art in Russia—the Imperial Academy of Art in St. Petersburg and the Moscow School. The competition between the two was keen, and as Repin so perceptively puts it, the stories of the two cities reflect strongly upon the art which each had produced. He wrote Stasov:

In regard to the St. Petersburg painters and my loss of faith in them, I am guided by the following observations: art always went hand in hand with the intelligentsia and answered its interests, creating for it its paintings. From the time of Peter I the intelligentsia concentrated around the Court (selling junk as always). I'll be brief. During the time of Alexander I, the Russian noblemen so advanced that they acquired national pride and love for their motherland; even though they still were blue-blooded noblemen they comprised the intelligentsia (Pushkin, Lermontov, and others) and especially the Decembrists because of their nobility of heart. Forms for the artist (attracting his interest) were only in St. Petersburg and abroad. There appeared a whole phalanx of artists of whom the brilliant representative was Briulov. The national pride of Nicholas grew to the extent that he gave encouragement to Russian music in Glinka and Russian art in Fedotov, and even commissioned Briulov to paint a Russian Pompeii, the "Siege of Pskov," and approached the architect Ton, who it seems refused (the despots sometimes have capricious lackeys who get away with much). Such an intelligentsia could not exist long because it is locked in its own aristocratic circle and looks upon the surrounding life with much disdain, foreigners excepted, and thus becomes depraved and falls.

Another intelligentsia emerges, this one before our eyes, a bureaucratic intelligentsia which has some people's blood in it, is familiar with work and poverty, and is therefore humane and is supported by the best Russian strength (Gogol, Belinsky, Dobrolyubov, Chernyshevsky, Mikhailov, Nekrasov). Many good paintings appear: the first works of Perov, the *Sermon in the Church*, *Dilétante*, and others; Yakobi's *Convicts*, Pukirev's the *Unequal Marriage* and others. This intelligentsia holds on tightly to St. Petersburg, strives toward one center and to the same interests, but the means of communication are poor, it remains secluded. In the meantime it develops universal thoughts and wishes rationally to arrange the whole country (even though it has not sufficient knowledge). It begins its struggle but perishes in 1862, on April 4, and *nechaevshchina*[14] is nothing but a spark in a diminishing fire.

Now that I have my meals in the students' dining room together with the youth, I see with pleasure that these are not the fashionable students with excellent manners, speaking loudly in complex phrases, but these are the

grey-footed, dirty muzhik children who cannot put together a few words, but are people with a deep soul, people who treat life seriously and who develop by themselves. This whole crowd drags home for holidays and feels happy with a third class railway ticket (like in heaven). They go to their dirty huts where they commune with their relatives and friends who will understand and believe them, and in case of trouble they will find support. This is why the artist must not cling to St. Petersburg where more than in any other place, the people are slaves, and the society is confused, old, obsolete. There is a lack of folk forms. . . .

While the pure stream of folk life running in St. Petersburg was fouled by the putrid puddle of the Monarchy, the stream was forming a large reservoir in Moscow. All the best of Russian art assembled here. Folk life was better preserved, supported materially here by merchants. Here are the Tretyakovs and Soldatenkovs. Viewing the paintings held by Tretyakov I became convinced that he is richer than the Petersburg Emperor (half-German, they sponsor only German art). I was overjoyed moving from one to another treasure in his truly remarkable collection of paintings. The *Unequal Marriage* by Pukirev; *Troika* and *Village Church Procession on Easter* by Perov, *Princess Tarakanova* by Flavitsky, the *Convicts* by Yakobi, and many, many more Russian paintings so that I am amazed and amazed at the riches of this person.

And the Rumyantsev Museum! Fedotov is there and finally, the most genial and most Russian folk painting, Ivanov's *The Appearance of Christ Before the Multitude*. At first glance it is a loobok [a popular print], but this first impression disperses and before you appears the Russian colossus. . . . Everytime, whenever I pass through Moscow, I (like a Mohammedan to Mecca) go in to bow before this painting, and each time she seems greater.[15]

The Academy of Art had been a commencement for Repin, and helped him to achieve distinction as a Russian artist. It was still the institution upon which he was fully dependent, as it was about to provide a subsidized period of study abroad. In February 1872 he married Vera Shevtsova, the marriage taking place at the Church in the Academy, where he was residing. With the honorarium received for the *Slav Composers* and the Academy stipend, Repin looked forward to new vistas in the realm of art which would enlarge and enrich his own capabilities. He was seeking personal knowledge of the Western world from which Russia had borrowed so much of its culture.

4

Paris

Ilya Repin made his first trip abroad, with his wife Vera Alexeevna and six-month-old daughter Vera, in May 1873. His itinerary led him from Vienna to Venice, Florence, and Rome. During the first rapid stop he visited Vienna's Belvedere, the Barock Museum, and the International Exhibition of Art. He was pleased that his *Burlaki*, exhibited in the Russian Pavilion at the International Exhibition, was prominently displayed and drawing considerable attention. But he was less enthusiastic about the Austrians, feeling that these "Germans" deprecated humane ideas, as if art were divorced from life, while seeking the absolute through science. He gladly left Vienna for Venice, where he was thoroughly impressed by the canals and palazzi, the doge's palace, and gondolieri. He admired the ornamented architecture and the eccentricities of light, color, and atmosphere which had inspired centuries of art. Time past, present, and future seemed to blend in an infinity of beauty. He wrote to Iseev: "On the piazza of St. Marco, before the Palace of the Doges, one wants to sing out and inhale deeply. It makes no sense to describe these objects; here the chimney of any house seems to have been built by a remarkable architectural genius."[1]

Florence also overwhelmed him at first with the riches bequeathed by the Medici, but after three days the total effect of the city's art struck him as too stern and grandiose. He longed for Rome, the seat of Italian art and the residence of several of his Academy friends—Antokolsky, Semiradsky, Kovalevsky, and Polenov.

He arrived there in June 1873 and immediately embarked on a feverish expedition through galleries and studios. "In the Academy, Veronese and Titian are in all their glory and one is hesitant who to name the greater; they are so overwhelming that you don't take note of a beautiful Tintoretto," he wrote to Iseev.[2] But to Stasov his tone was subdued and contrary, as if to reassure his friend that the splendors of Western art had not subverted his loyalty to Russia. Thus he wrote:

> What shall I tell you about celebrated Rome? I don't like it at all. Rome is
> a dead city that has seen its day. Only Michaelangelo strikes with force. As

for the rest, including Raphael, it is so old and so childish that one loses the desire to see it. . . . There is so much poverty even in its environs. As for heaven on earth here, as some proclaim, I find no inkling of it. This is simply an *Eastern City*, hardly capable of motion. No! Now I respect Russia more than ever. In general this trip will be very beneficial to me, even more than I expected. But I shan't stay here too long. One must work on native soil. I feel that I am now experiencing a reaction against the sympathies of my ancestors; as much as they despised Russia and loved Italy, that is how repugnant Italy is to me now with its utterly conventional beauty.[3]

It took several years of growth and experience before Repin retracted his words about Raphael and acknowledged his faulty criticism and hasty youthful judgments. That summer the Repins spent at the shore near Naples and the autumn in Albano near Rome, where Antokolsky was living. Following the Academy rules, he did not paint during the first year of his sojourn.

Repin and his family arrived in Paris on October 10, 1873, and remained for three years. There is no evidence to suggest that on his arrival he was concerned with the results of the Franco-Prussian War or with France's payment that year of an agreed indemnity to terminate the German occupation. Nor is there evidence that an earlier event, the formation of the Commune under the red flag of socialism, provoked a response from the Russian democrat. Only ten years later when he returned to Paris in the company of Stasov were these events recorded in sketches and a painting.

The first year was spent in utmost squalor. With the money that came from the Academy, however irregularly, and the occasional sale of his works, Repin hoped somehow to manage. The studio which he rented for himself vied for dinginess with the tiny flat he rented for his family several houses away. As he hustled through the wintry cold he was but one of a seemingly endless stream of artists, shivering, on the verge of being dispossessed, desperate to sell their works or accept any sort of commission. The birth of his second daughter, Nadya, on October 30, 1874, brought additional financial worry.

Once again his old friends Iseev and Stasov came to his aid. Iseev, in the name of the Academy, promised to purchase one of Repin's large paintings. Stasov advised Repin that his brother was eager to buy the variation of his *Burlaki*, and also suggested that Repin visit the financial magnate Baron Ginsburg, then residing in Paris, to secure a commissioned portrait of the baron's wife. Stasov enclosed his brother's personal card, which would serve as an introduction. Repin recoiled from the suggestion, having developed an aversion to the rich and powerful. He was willing to risk hunger but could not face the humiliation he had felt when pleading tuition money from General Pryanishnikov. Nonetheless of necessity he went, presented Stasov's card, and was refused the lady's portrait commission to the great embarrassment of the Stasov brothers.

His need for money grew desperate. There was no place from which to borrow, and no place where he could earn. He could not afford to spend ten francs a day on a model, nor did he have much for canvas and paints. He sent letters to his friends in Russia explaining his plight. He had left behind three watercolors which they were to sell, if need be, for a total of one hundred rubles to provide money to feed his family.

Help came from P. M. Tretyakov. On March 6, 1874, Tretyakov wrote Repin: "By the way, Ivan Sergeevich Turgenev lives permanently in Paris, why don't you try to paint his portrait? As you know all his portraits are unsuccessful, and you perhaps will paint a successful one. One never can get stuck with his portrait, and if yours will turn out successful, I would acquire it with pleasure."[4] Repin readily agreed and Tretyakov instructed his Paris representative to give him 1000 francs in advance for the Turgenev portrait.

It was Stasov who had first drawn Turgenev's attention to Repin when the famous writer visited the Russian capital for a brief period during the winter of 1871.[5] Turgenev exhibited little interest in the unknown twenty-seven-year-old artist, notwithstanding the glowing description of *Burlaki* given by Stasov: "It seems to us that if the whole population of St. Petersburg were to come to see the new picture of the talented artist, no one would leave without being affected to the depth of his soul. We firmly believe that a very significant future awaits Mr. Repin, if he will not stop but proceed to go forward, as he has done up to now from one talented work to another." A letter from Turgenev to Stasov came the same month in which he said: "In *Peterburgskie vedomosti* I read your article about the competition at the Academy and about Repin. I was very pleased to learn that this young man so briskly and quickly moves ahead. He possesses great talent and unquestionable artistic temperament which is most important."[6]

When Nicholas Ge also regaled him with praise for the new, young artist, Turgenev's curiosity was sufficiently aroused to go and see for himself. Repin's recollection of this event was put to paper many years later; as he remembered it: "My studio at the Academy was visited for the first time by Ge accompanied by Turgenev. I was painting *Burlaki* at the time, and when they entered I did not know whom to look at first. This was the first time I had seen Turgenev. Following Parisian custom he did not remove his suede gloves. Sitting before my painting, Turgenev spoke in detail of his trip to Tivoli with A. A. Ivanov and gave an able imitation of Ivanov's manner of speech. His words jarred upon me for it seemed that he was treating this great painter in a somewhat patronizing, comical manner."[7] He makes no mention of Turgenev's reaction to his work.

The following year, 1872, Turgenev was again in Russia for a brief stay. Repin had by this time won the Grand Medal for the *Resurrection of Jairus' Daughter*, and was now known as the painter of *Slav Composers*, the mural which was to be unveiled in June at the Concert Hall opening in Moscow. Turgenev was in Moscow at the time and came to the opening. He expressed his candid disapproval of the work, being particularly displeased with the group-

ing of the dead composers together with the living on the same canvas. Though himself dissatisfied with the work, Repin nonetheless felt that Turgenev's criticism reflected a personal antipathy toward him.

Now, in 1874, Repin was in Paris and was commissioned to paint a portrait of Turgenev. With the inception of this commission Repin saw much of the author during his stay. As was his custom, Turgenev made his home with the Viardots; he either lived with them or near them. His love for Pauline Garcia Viardot dated to October 28, 1843, when he first heard the twenty-two-year-old mezzo sing the part of Rosina in *The Barber of Seville* with the Théâtre-Italien of Paris on tour in St. Petersburg. She was ecstatically acclaimed, and after meeting her on November 1, he loved her until his death in 1883.

Pauline's husband, Louis Viardot, who had been the director of the Théâtre-Italien and who was to engage Pauline to sing in his company, married her in 1840, though much her senior. He soon relinquished his post with the opera and became her impresario. Though he served his wife first, he maintained an interest in art and published several books on collections of paintings in the famous museums of Spain, England, Italy, Belgium, and France. He was also a publicist and a translator, as well as a man of social conscience. Turgenev and Louis Viardot shared many common interests and spent much time together, seeing each other almost every day in the course of two decades.

Turgenev's Parisian life centered about the Viardots' sumptuous establishment. The illustrious of France—Gounod, Saint-Saëns, Flaubert, Hugo, Zola—and celebrated foreign personages would be received at the Viardots' on Thursdays and Sundays. Turgenev was one of the stars in this galaxy and it gave him pleasure to invite his compatriots to these evenings, to meet them at A. P. Bogolyubov's on Tuesdays, or to receive in his own quarters the most famous Russian writers, artists, scientists, and revolutionaries.

The commission to paint Turgenev had urgency for Repin, and in March and April 1874 he was busily engaged in this work. In the history of this famous portrait Repin had but one regret, that of having had to abandon the first sketch of the first sitting, with which the subject and the artist were both enormously pleased. Much to Repin's surprise, an hour before the second sitting, he received a long note from Turgenev imploring him to start a new canvas and to paint him in another pose. Fifty years later Repin still regretted giving in to this demand. He explained to Sergey Ernst in 1925: "Mme. Viardot, whose taste and judgment Turgenev unequivocally accepted, rejected the first variant and recommended that Turgenev be painted from a different position."[8]

Repin had no choice and began a new canvas, for which Turgenev sat every morning between ten and noon. At the end of April, Repin was able to write Tretyakov:

> The portrait is almost finished. One more sitting remains and I shall then take it to my studio and look it over. Ivan Sergeevich is very pleased with it;

that is, he says this portrait will bring me much acclaim. His friend, Viardot, considered a connoisseur, and one who really understands art, also approves and praises it. Madame Viardot said to me: "Bravo, monsieur, the resemblance is faultless." Bogolyubov is in exaltation, he says that it is the best portrait of Ivan Sergeevich and is especially attracted by the nobility and simplicity of the figure. Turgenev wishes to exhibit it here in Paris for a short time. He has many friends, and besides, at the present time the French are greatly interested in him because of the publication of *Zhivye moshchi* (Living Relics) in French translation in the newspaper *Le Temps*. This little thing has attracted much attention here, and he has received many compliments and letters from French luminaries.[9]

The portrait shows Turgenev wearing a dark jacket with a blue scarf around his neck. His legs are covered with a greenish plaid, the hands resting on his lap while in the right hand he holds his eyeglasses.

It was not long, however, before Turgenev began to express his disappointment both with the portrait and with Repin.[10] His lack of esteem for Repin may be explained, in part, by his concern with another Russian artist, A. A. Kharlamov, who was two years older than Repin and also a pensioner of the Academy. Kharlamov was studying in Paris with the popular French painter Leon Bonnat. From Bonnat he learned to achieve a glamorized likeness of his subject, a technique that brought commissions. There was apparently no attempt to convey the inner character of the subject, nor did the wealthy subject seek such possibly disturbing undertones. Bonnat had become the rage of Paris, and Kharlamov followed profitably in his footsteps. He threw off the mantle of Slavic heaviness in favor of Western charm. With Paris his home, Turgenev, it seems, appreciated the alteration. He was delighted with Kharlamov and acclaimed him as a protegé.[11] Not only did he sit for the artist but also induced his friend Mme. Viardot to do so.

Long before her portrait was finished, Turgenev tried to gain some favorable publicity by inviting Emile Zola to visit Kharlamov's studio under the pretense that the portrait was nearly completed. The portrait of Pauline Garcia Viardot was exhibited in Paris in May 1875, and Turgenev spared no effort to have Kharlamov's work publicized in both the French and Russian press. Zola had begun to publish his monthly "Letters from Paris" in the *Vestnik Evropy* and Turgenev had graciously been providing the French writer with suitable themes for this unaccustomed medium. In a reciprocal manner, Zola's letter for the month of May was devoted to praise of Kharlamov's portrait of Mme. Viardot. Turgenev wrote Stasov: "Here Kharlamov painted a wonderful portrait of Mme. Viardot. There is no doubt at all that now there is no other portraitist in the world like him, and the French themselves are beginning to affirm this."[12]

In St. Petersburg Stasov indignantly refuted the designation awarded Kharlamov as foremost portrait painter. Turgenev scornfully answered: "That which

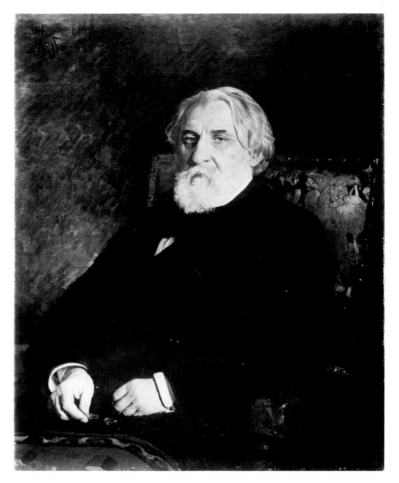

Portrait of Ivan Turgenev.

you say of Kharlamov did not surprise me. It is understandable knowing the radical difference of our views on the subject of art and literature. . . . Therefore, I do not hesitate for a moment to declare my belief on the worthlessness (to my eyes) of Mr. Maksimov's paintings, whom you have so hastily added to the ranks of your favorites—Dargomyzhsky, Shcherbachev, Repin, and *tutti quanti* . . . in whom you see the 'very essence.' By the way, concerning Repin: It is time for him to be back under your wing, or better yet, to proceed to Moscow. There is his true soil and environment."[13]

Unlike Stasov, Turgenev felt strongly that Russian artists, especially painters and musicians, had to learn much from West European culture if they were to find successful expression of their own way of life. Repin was a disciple of critical realism, a product of the internal evolution of Russian painting, and under the direct, partisan influence of Stasov, Kramskoy, and Tretyakov. It is

understandable that he reacted strongly against Turgenev's sensibility. At this moment in his artistic career, pure art, *ars gratia artis*, was inconceivable to him. Critical realism was one phase in the revolt against classicism in Russian art.

By the time Repin met Turgenev in Paris in 1874, Turgenev had already become an ardent collector of paintings. He collected primarily the canvases of the Barbizon painters with whom he had a deep affinity. The walls of Turgenev's apartment in the seventies were decorated with the canvases of Millet, Díaz de La Peña, Charles Emile Jacque, Jules Depré, as well as Théodore Rousseau, Camille Corot, Charles Daubigny. In 1874, the first independent exhibition of the Impressionists took place in Paris: the works of Monet, Sisley, Pissarro, Degas, Renoir, and Morisot attracted attention, but Turgenev scoffed at the innovators. He did not buy a single canvas then, or at the sale at the Hôtel Droit in spring 1875 where the Impressionists were offering their canvases for sale for a pittance, or at the Manet exhibition. It is strange that Turgenev failed to accept the new art form, but it was only after Emile Zola's article in 1876 in praise of the Impressionists, as Repin reported to Stasov from Paris, that Turgenev agreed that "the future belongs to the Impressionists."

Although attracted to French Impressionism, Repin needed time to understand it fully. He admitted readily that "the Frenchmen have a new realism, or rather a caricature of it; it is strange, yet they have something there." Breaking light and light reflections down into a dazzle of pure spectrum colors in vivid little strokes, the Impressionists were able to convey the spontaneity of their own feelings. Repin appreciated the "new realism" but accepted with difficulty the principle that a chiaroscuro based on the theories of prismatic color should be used in place of the traditional tones founded upon black and white. Moreover, he felt the subject of the painting was overly obscured by making the depiction of light through color predominant. For Repin the subject of a painting was most important even though he soon created a work where light and subject are successfully blended into a harmonious whole.

He painted *The Beggar Girl* in Veules where he and his family were spending the summer of 1874. It portrays a peasant girl standing in a field against the background of a cloudless sky. Her eyes are downcast; the white skin of her face lightly burned by the sun; her tousled hair the color of wheat; her hands large and rough.

The next year, inspired by Manet's art, Repin painted his two-year old daughter in one sitting. Here his brush strokes are free and color plays the dominant role. The child sits in a huge armchair upholstered in green and gold brocade. Perked on her head is a small straw hat with a flower of pale rose on top. She wears a dress of subdued blue intersected by three perpendicular white stripes over a white blouse. Repin himself entitled the work *Portrait of Little Vera à la Manet*.

The rough edges of Repin's Russian bumptiousness yielded to the charm and

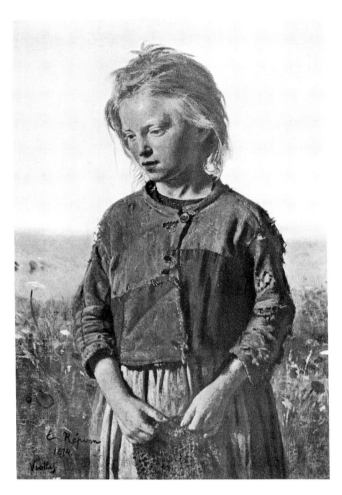

The Beggar Girl.

verve of Parisian art and Parisian life. It can be seen in the metamorphosis of the themes which he conceived of painting. In the first year of his Parisian sojourn he selected the character of Sadko, an endearing Russian folk hero, seen as he selects his bride. As a guest of the water king, at the bottom of the sea, Sadko watches the most beautiful women of all nations pass before him, then selects a Russian maiden as his bride. The background was to be a fantasy world of oceanic flora and fauna and the women were to represent the ideals of the great masters of art. A year later Repin's enthusiasm for Sadko had waned as he turned instead to painting a Parisian cafe.

With customary energy he plunged into his project, spending every available franc on models, impressed by the grace and simplicity of the Parisians. He was immersed in his work, painting feverishly, not knowing whether either the French or the Russians would be interested in buying the painting. At the same

Portrait of Little Vera à la Manet
(the artist's daughter).

time he began work on *Sadko*. He had learned from Bogolyubov that the Russian Heir Apparent had offered to purchase the work. Repin was now in Veules, on the Normandy coast, away from the frustrations of the city. His work was prodigious: aside from *Sadko* and *Paris Café*, he concluded numerous landscapes, fifteen of which were later shown in his one-man show in 1891.

Returning to Paris in September, the Repins took a new flat at 12 rue Lepic though Repin retained his studio at 31 rue Veron. There he continued work on *Paris Café* and *Sadko*. The exciting exhibitions which were held in Paris during the busy winter season of 1874–1875—especially the exhibition of Carolus Duran, whose portraiture greatly impressed Repin—kept the artist in constant mobility, with his mind often on paintings other than his own.

As a pensioner of the Academy, Repin was obligated to send all his works to the Academy. He was forbidden to participate in foreign exhibitions. Nevertheless, on February 24, 1875, he sent an appeal to the Academy requesting permission to participate in European exhibitions in order to gain experience and to evaluate himself in comparison with European artists. When the Academy denied his request he decided to defy the injunction, risking a complete break with the Academy and the loss of financial support. Still, he had not been punished when a year earlier he had defied the Academy and permitted some of

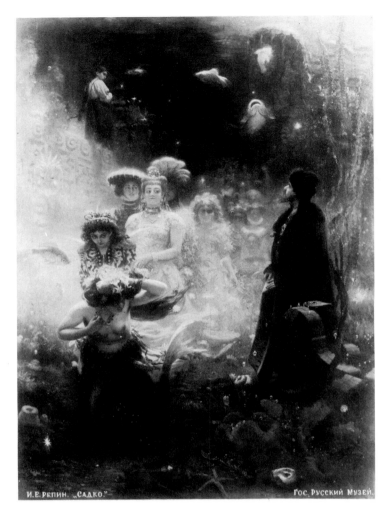

Sadko.

his works to be shown at the Society's exhibition at St. Petersburg. Kramskoy in that instance was jubilant since Repin's participation in the exhibition had been a victory for the new forces in art. Now, although deeply shocked and disturbed by Repin's independent action, Iseev expressed rare forbearance by taking no punitive measures against Repin, moved by the thought that Repin must remain a pensioner of the Academy. As a result of the incident, however, Iseev and Repin stopped their correspondence for two years.

The completion of *Paris Café* filled his friends with alarm. The first explosion occurred when his artist friend A. I. Kuindzhi[14] returned to St. Petersburg from Paris in 1875 and carried the news to Kramskoy that Repin's *Paris Café* exhibited in the Salon had little success. Kramskoy wrote Repin that to paint on such

a theme one must be a native Frenchman and must understand his "language." Repin heatedly retorted in a crisp, concise statement: "On the question of language you are wrong. An original voice is always sooner heard, and here is a perfect example of it: Manet and all the Impressionists."[15]

Yet Repin soon began to entertain serious doubts as to the value of *Paris Café* in his artistic career. Moreover, he became less enthusiastic about *Sadko*. He confessed to Stasov on April 7, 1876: "I am making a secret confession. I am terribly disappointed with my painting *Sadko*. I would destroy it with pleasure. It will turn out to be such trash, from every point of view. Please don't tell anything of this to anyone. I have decided to finish it despite everything, and then return to Russia. It is time to start working seriously on something better. Here my affairs are not worth a penny; it is simply painful. My conscience bothers me. All my art represents a form of gymnastics, nothing else, for it lacks feeling, it lacks evidence of a single thought."[16]

Immediately after the Salon Exhibition, on May 30, 1875, Repin went to London with friends: two Americans, Bridgeman and Pierce: two Poles, Szyndler and Tseitner, and Polenov. They spent a week in London, touring the city, visiting museums, and thoroughly enjoying each other's company. Upon his return from London, Repin could no longer find an excuse for not returning to *Sadko*. To ease his boredom with it, he began to work on other paintings at the same time. One of them, *The Jew at Prayer*, which depicts an elderly praying Jew, wrapped in his *tallis* (prayer shawl), was bought by Tretyakov for his gallery sight unseen on the recommendation of Bogolyubov.

When Repin's three-year pension abroad was over he wrote to Iseev asking for permission to return home. Iseev, responding as if nothing had happened, granted the request and wrote of a possible commission for a series of murals in the Cathedral of the Savior in Moscow. Repin was elated: *Sadko* was finally finished, his Paris apprenticeship was over. His longing for Russia was like that of an exile rather than that of a privileged traveler. Farewell to foreign "gymnastics." He would return to the serious business of recapturing Russia on canvas. In an earlier letter to Kramskoy, dated March 31, 1874, he had summed up his experience:

> French art now stands in its true bloom having cast off all imitative and academic elements, as well as all kinds of superficial shackles, and now it is genuine. Genuine French art finally reigns, attracting the whole world by its brilliance, taste, lightness, gracefulness, and in art the French are true to their national peculiarities as in all else.
>
> Speaking of the future of Russian painting you very tactfully turned to literature as an art more free because of its independent existence and one not at variance with the sympathy of its people (herein lies its advantage). "It adhered to content," you say, which is true. Our literature pursued artistic ideas of our world view; it hardly contains anything imitative. Paint-

ing and sculpture, however (impoverished!), never touched the people even though the Russian intelligentsia was not much richer than its folk. Our nobility took these poor sisters in art under its patronage since they had the means, and everyone knows that our nobility was educated in Paris and accepted every Parisian whim as law, so that there was the consumer on the one hand and the Academy on the other who made themselves felt. But nature takes its own course, there is a beginning of the awakening of a national stream which will swell wider and wider and fall into the great river Volga and then our national painting will no longer be afraid.

And then Repin, the epitome of the man of his time, concluded his letter: "You say that we must move to light and color. No. Even here our aim is content. The face, the soul of man, the drama of life, nature, its life and meaning, the spirit of history—these, it seems to me, are our themes. Paint is our tool to express our thought, express not graceful spots, but the whole mood of the painting, its soul, winning the viewer's favor and totally capturing him like a chord in music. But first we must learn to paint well."[17]

On July 19, 1876, the Repin family left Paris for St. Petersburg.[18]

5

Independence

Shortly after Repin's return to St. Petersburg, at his first encounter with Stasov, he learned of the latest developments in the sphere of Russian music. Rimsky-Korsakov had composed *Snow Maiden* and *Sadko* and Musorgsky had completed *Boris Godunov* and was continuing work on *Khovanshchina*, which particularly interested Repin. Their affinity had been made explicit in a letter which Musorgsky wrote to Repin in Paris on July 31, 1876, after he had had his first view of *Burlaki*. "What I really want," wrote Musorgsky, "is to represent our people. In my sleep I see them; I eat, and think of them; I drink, and see their illusory images. Only the masses, huge, untinted and untinseled have true integrity. The life of the Russian people is an inexhaustible ore from which everything genuine can be extracted."[1] The sentiment matched Repin's. At a time when Russian society had not yet acknowledged Musorgsky's genius, Repin did. For his part, Musorgsky esteemed Repin as an artist and admired his personal qualities. During his short stay in St. Petersburg, Repin saw much of the composer. "Last Friday," Stasov wrote to his brother on July 31, 1876, "I was visited by Musorgsky and Repin. The latter was in ecstasy at everything that Musorgsky had composed during the three years of his absence. Indeed, Musorgsky has been making remarkable strides all along; only the 'musicians' Rimsky-Korsakov, Cui, and such are unable either to recognize or understand the fact."[2]

While congratulating Musorgsky, Repin could not help but feel depressed at the meagerness of his own creative output, which seemed forced and poor next to that of his friend. He placed his own *Sadko*, which had recently arrived from Paris, in the corner of his studio. He knew it would not enhance his reputation and hoped that Stasov would not insist upon seeing it. Unfortunately, Stasov resolved to see the painting despite Repin's reticence. He called one day when Repin was out, examined the canvas carefully, and left very disappointed. Rather than telling Repin directly of his reaction, he wrote a diplomatic letter. And though Repin was pained by Stasov's words, they mobilized him: having long considered abandoning the city for the countryside, Repin now went ahead with his resolution to do so.

Repin's return to Russia coincided with the beginning of the Balkan upheaval. In 1875 the Serbs revolted against Turkey's extreme taxation and the next year the Bulgar peasants also revolted against her domination. Turkey responded by sending an irregular army to crush the revolts, an army consisting of the former Circassians of the Caucasus, the bashi-bazouks, whose atrocities against the Balkan civilian population shocked the civilized world. Landlocked Russia, which had long craved control of the outlet from the Black Sea to the Mediterranean, an area protected by the Straits Convention of 1841 prohibiting foreign warships in the Bosporus and the Dardanelles when she was at peace, saw an opportunity to secure greater power in the Straits for Russia by enlarging Bulgaria and making her autonomous. With this ambition in mind, Tsar Alexander II declared war on Turkey in 1877.

By this time the Russian people were sufficiently aroused over the reckless slaughter of the Balkan population by the savage bashi-bazouks that even the pacific writers, artists, and scientists were emotionally prepared to support a war in defense of the suffering "brother-Slavs." Tolstoy temporarily shelved his philosophy of nonresistance to evil and put forth bellicose, nationalistic pronouncements; the noted scientist Pirogov went to inspect the hospital situation at the front; Vsevolod Garshin, a talented young writer, enlisted in the army; Turgenev watched and bemoaned his advanced years; Vereshchagin left to paint battle scenes. The Slavophile I. S. Aksakov declared: "This war is historically necessary. This is a people's war, and never before has our people regarded a war with such conscious participation."[3]

But for Ilya Repin the overriding concern was to seek a peaceful spot where he could advance his art. First he took his family on a visit to his in-laws' summer home at Krasnoe Selo. Mementos of this 1876 visit include a beautiful landscape, *On the Grassy Bank*, an impressionistic rendering of a family group in a style similar to Corot.[4]

The Repins next set out for Chuguev and the artist's return to the familiar scenes of his childhood. There the "huge" village square, as Repin remembered it, seemed to have become much smaller, but the church on the corner of the square was still there as in his early years. For days he traveled through neighboring villages, always finding something to fascinate him in a familiar but forgotten way. Everywhere he entered in the spirit of the occasion, attending weddings, visiting bazaars, inns, taverns, churches. When nothing special was going on in the outlying districts Repin simply mingled with the peasants, listening and observing. In a few short weeks he had discovered numerous scenes that demanded painting.

He described his typical day in a letter to Stasov.[5] In the early morning he would go to the old hut in the yard, which he had turned into a studio, and look over the work of the preceding day. Then he would go back, have his tea, and continue his work for the greater part of the day. In the afternoons, even on the coldest winter days, he would go for walks lasting several hours. He would

visit remote villages, walking through snowy meadows and forests. There was always something new, always something different that he had not observed before. In the evenings, after dinner, there was reading to do, or he would spend time with his children. Chuguev, in fact, reversed the laws of nature. A sleepy provincial town in summer, Chuguev became a "sleepless kingdom," as Repin called it, during the winter months.

On March 29, 1876, a son was born to the Repins. Petersburg seemed blissfully far away. Yet in the communications and publications that reached him, Repin followed the frequent discussions and arguments, accusations and defenses which centered around Stasov, and also himself. Critics continued to attack Stasov's conviction that Russian art could grow and mature independently of European trends and developments. And they also attacked Stasov's championing of Repin. Turgenev's *Virgin Soil*, which appeared that year, contained an obvious caricature of Stasov in Skoropikhin, "an individual most harmful to young people." Stasov, moreover, without the artist's permission, had published some of Repin's correspondence from Europe, which invoked ridicule, particularly in reference to Repin's comments on Raphael. In Chuguev, Repin sensed the critics' disappointment in his failure to produce masterpieces after his lengthy stay abroad. In response, Repin began work on several notable paintings—*An Examination in a Village School, In a District Court, The Farewell of a Recruit, Vechernitsy, The Muzhik with an Evil Eye, The Timid Muzhik*—and one of his most famous canvases, *Religious Procession in the Province of Kursk*.

The winter in Chuguev was a lively one, filled with experiences immediately reproduced on canvas or stored for later use. Repin was visited by an old school friend from Academy days, Nikolay Murashko, then director of the Kiev Art School, and in a mood of ebullience painted his portrait.[6] In a more somber mood Repin painted *Under Military Conveyance* (1877), a sketch of a troika in which two soldiers with bared sabers escort a political prisoner. Although a minor work, it received excessive praise from liberal critics because of its subject.[7]

On April 24, 1877, despite the restraining pleas of the Western powers, Alexander II declared war on Turkey. Repin, in Chuguev, now felt the full reverberations of the conflict. As the Balkan War moved to its climax the artist studied the history of the Balkan Slavs at a series of lectures given at a Junker school in Chuguev. He received front line news from his friend Polenov and watched the young men of Chuguev going off and returning from the war. Repin caught the early Russian enthusiasm for the conflict in his painting *The Return*, depicting a wounded soldier just back from the war. The painting shows the interior of a hut; a young soldier is sitting on a bench and at his right stands an older, more mature comrade-at-arms. At the left, the young soldier's mother and father are gazing proudly at their son, who has returned with a St. George's Cross. The wounded son has his arm in a sling and his head bandaged, but on

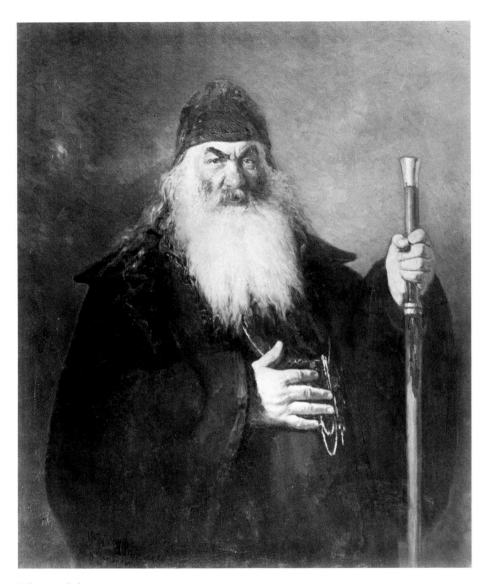

The Archdeacon.

his face is a devilish smile. When the painting was exhibited at the Eleventh Exhibition of the Society in 1883 it was enthusiastically received by the public.

The Archdeacon, another well-known painting, also dates to this period. On a visit to the Chuguev cathedral, Repin was struck by the imposing figure of Archdeacon Ivan Ulanov—luxuriant beard framing the face, thick bushy eyebrows, small piercing eyes, and a vast body. The man's dominating physical presence seemed devoid of any spiritual quality and thus he seemed to Repin the embodiment of the Russian clergy. Repin determined to paint him, and as

with Kanin for *Burlaki* was forced to assiduously pursue his model, wining and dining him, before gaining agreement to pose. Having followed his man so closely for so long, Repin was able to complete the portrait in only four sittings. It was to become the plum of the Society's next exhibit. Accompanied by the public's acclaim, Stasov, Kramskoy, and Musorgsky once again loudly hailed Repin as *the* great Russian national artist.

In May 1877, Repin went to Moscow, and then for a few days to Petersburg where he saw Stasov, showed him some of his Chuguev works, and received his warm approval. Returning to Moscow he visited the Tretyakov Gallery and viewed the paintings of Aivazovsky, Kiprensky, Tropinin, Fedotov, and the most recent works: Yakobi's *Prisoner's Stop-Over* (1861), Pukirev's *Unequal Marriage* (1862), Perov's *Village Church Procession on Easter* (1861) and portrait of *Dosto-evsky* (1872), Savrasov's *The Rooks Returned* (Grachi prileteli) (1871), Ge's *Peter I Interrogates Tsarevich Alexei Petrovich in Peterhof* (1871), Shishkin's *Pine Forest* (1872), Kramskoy's *T. G. Shevchenko* (1871), *L. N. Tolstoy*, and *Christ in the Wilderness* (1873). "I visited the Tretyakov Gallery with great pleasure," he wrote to Stasov upon his return to Chuguev. "Its works reflect depth in content, and the ideas which govern the artists. Nowhere, in no other type of art, have I been so impressed with the seriousness of purpose of every artist. . . . One may definitely state that a bright future awaits the Russian school of art."[8]

Repin's summer in Chuguev, while he was preparing to move his family to Moscow, was marred by an intermittent fever which he had contracted and which refused to leave him even after his arrival in Moscow. Suffering from a renewed attack while attending to the arrangement of the new apartment, he decided to leave his domestic duties behind and go to Petersburg. There he stayed with his friend Kuindzhi, and managed to paint his portrait. The fever had so disabled Repin, however, that after a week's illness he returned to Moscow without having seen Stasov and his other friends. He did find it necessary, however, to invite his patron, Tretyakov, to come and view his recent paintings. Tretyakov viewed *The Archdeacon* and decided that here was his chance to get rid of the Turgenev portrait for which he had advanced 500 rubles to Repin, and for which he nourished a distaste. He proposed to exchange the Turgenev for *The Archdeacon*. For an additional 1000 rubles, the artist averred, he would be glad to close the deal. A period of bargaining ensued during which Repin finally agreed to a reduction of 100 rubles, "for the Archdeacon's frame," as he put it.

From Moscow, Repin wrote to Kramskoy: "Now that the academic guardian-ship over me has ceased, I consider myself free of her moral pressure and therefore in accordance with my old wish, I wish to apply for membership to the Society of Traveling Exhibitions, a Society with which for a long time now I have had a deep moral tie. Only purely extraneous circumstances restrained me from becoming active in it from its very foundation." In consequence, he was enthusiastically elected to executive membership in the Society of Traveling Exhibitions.[9]

There was an upsurge of patriotism the following spring. On March 3, 1878, Russia and Turkey signed the Treaty of San Stefano enlarging Russia's Bessarabian territory and guaranteeing the independence of Serbia and Montenegro. Before this temporary mood of victory was broken by the revised peace terms imposed by Western powers at the Congress of Berlin on July 13, 1878, Repin painted A *Hero of the Past War*, showing a peasant lad in a soldier's uniform on his way home. He also wanted to paint the returning Russian army, but gave up the idea when he learned that Kramskoy had already been commissioned by Mamontov to paint on that theme. A colorful sketch of Repin's proposed painting still remains.

Many of Russia's momentary gains were lost at Berlin and an uneasy peace was restored. The national ego had been hurt and Russian youth had died in vain. People spoke out against the ruthlessness of Tsar Alexander II, especially the passionate Slavophile I. S. Aksakov. When he, as was to be expected, was banished from Moscow, Repin was commissioned by Tretyakov to paint the exile in the village of Varvarino. Repin painted Aksakov in three days, time enough for antipathy between the publicist and the artist to bloom. Repin was intolerant of Aksakov's Slavophilism, which exalted Russian orthodoxy and *sobornost'*, the belief in the organic togetherness of true (Russian) Christians.

All that spring and summer, Repin's Chuguev works had been winning new acclaim for the artist. Musorgsky was exultant. "My dear généralisme," he wrote Stasov on March 22, 1878, "I saw *The Archdeacon* created by our famous Ilya Repin. This painting represents a veritable volcano. The eyes of Varlaam follow the spectator incessantly. What a terrifying sweep of the brush, what abundant breadth! And the other painting, *The Timid Muzhik*, a rascal in disguise. But a turn of the head, and the result—a barbarous look of a man capable at the propitious moment of taking ten human lives."[10]

Repin had now reached a point of self-assurance in his abilities and no longer felt the need to remain in the provinces. With his newfound confidence he reacted scornfully to the Academy's rejection of his *Archdeacon* for the 1878 World Exhibition in Paris, and that same year his official ties with the Academy came to an end. His six years as a pensioner had elapsed, and with joy he wrote to Kramskoy on March 6, 1878: "Now I am all yours!"

Perhaps symbolic of his break with the Petersburg Academy, Repin now moved to Moscow, the Mother City, the heart of Russia. Its origins date to the annals of the Ipatyev Monastery in 1147, though recent evidence places its existence at a much earlier time. From a small frontier settlement it gradually developed into a major city. Situated on the river Moscow, with access to other Russian rivers, Moscow became the center of government, trade, and culture. Ivan III (1462–1505) and his son Vasili III (1505–1533) led a succession of Tsars who added to the city's appearance in order to reflect her growing stature with architectural monuments, cathedrals, stone palaces, and the imposing walls of the Kremlin. In 1547 Ivan the Terrible formally assumed the title of

On the Grassy Bank (Family Bench).

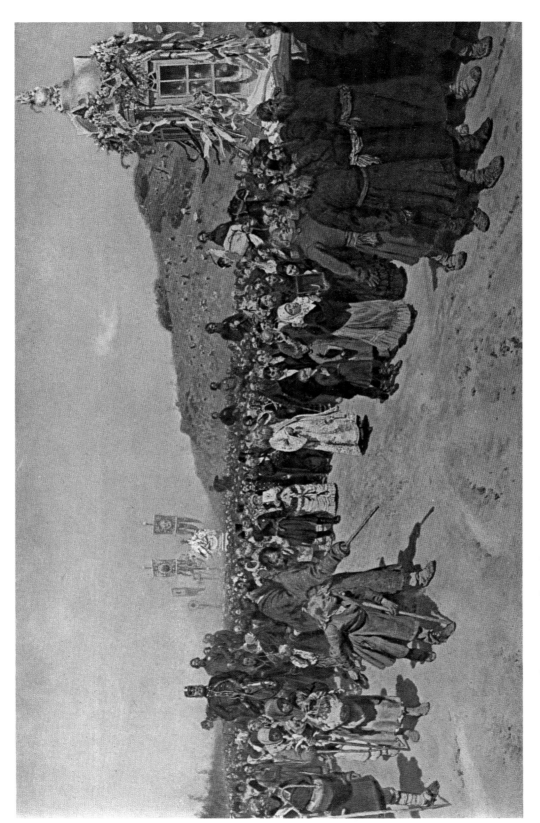

Religious Procession in the Province of Kursk.

Tsar and Moscow officially became the capital of Russia, a position she occupied until 1712, when Peter moved the capital to St. Petersburg. Although 206 years elapsed before Moscow once more became the official capital, she nonetheless remained the actual economic and cultural center of Russia, the home of Russia's first university, first newspaper, theaters, and great artists.

In Moscow Repin was a frequent visitor at the home of S. I. Mamontov, a wealthy patron of the arts whom he had first met in Paris in the spring of 1874. At that time Mamontov had been bringing his family back to Russia from Rome, where his wife and their ailing elder son had spent several winter seasons. In Rome Mamontov had become acquainted with M. M. Antokolsky and V. D. Polenov, both pensioners at the Academy of Art, and due to their shared interests in Russian art they became close friends. When the Mamontov family stopped in Paris, Polenov, having arrived earlier, introduced his friend and fellow artist, Ilya Repin. Offering the hospitality of his home, Mamontov urged all the young artists to return to Moscow, the center of national art, rather than St. Petersburg upon completion of their term abroad.

Savva Ivanovich Mamontov, a railroad-building and industrial tycoon, owned a palatial home in Moscow and a country estate, Abramtsevo, forty miles from the city. A singer, dramatist, director, and conductor, Mamontov made generous use of his fortune and his great hospitality to further the Russian arts. From the 1870s through the 1890s his homes were the *points de reunion* for the artistic personalities of his day. The first nucleus of the Mamontov circle, as it was later called, was formed when Repin and Polenov came to Moscow in 1877 and were joined a year later by two brothers, Victor and Apollinary Vasnetsov. The young Valentin Serov, who had come with his mother to Abramtsevo at Mamontov's invitation in 1874, was considered a member of the Mamontov family at that time, and Repin became his art teacher.

Over the course of years, literary readings at the Mamontov home were supplanted by ambitious theatrical productions which in turn gave way to productions of Russian operas with the founding of Mamontov's "Private Russian Opera" in 1885. There the synthesis of Russian arts attained its high point in the fusions of such operas as Rimsky-Korsakov's *Snow Maiden* and *Sadko* and Musorgsky's *Khovanshchina* and *Boris Godunov* with the splendor of stage settings and costuming by Victor Vasnetsov, Konstantin Korovin, Valentin Serov, and Mikhail Vrubel.

Repin remained in Moscow five years, from 1877 to 1882. He actively participated in literary readings and acted in four of the twenty Mamontov theatrical productions.[11] Every summer during his Moscow period he and his family lived in Abramtsevo or in its vicinity. Owned formerly by S. T. Aksakov, the Russian writer whose frequent guests included Turgenev and Gogol, Abramtsevo was purchased by Mamontov in 1870 and by 1890 had become the center for intensive research into Russia's medieval heritage, its architecture, painting, lore, and folk art.[12] Mamontov had new buildings constructed, including a

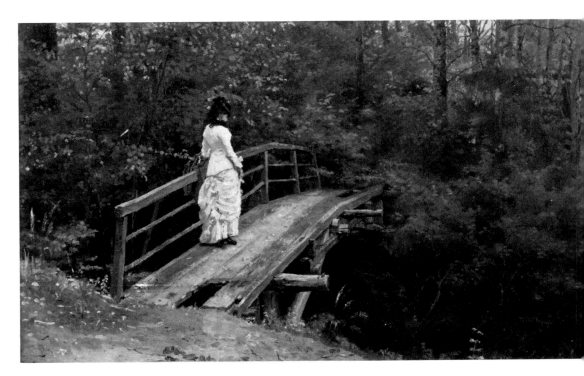

On a Small Bridge (the artist's wife at Abramtsevo).

hospital, school, sculpture studio, and living quarters for the artists. The decision in 1880 to add a small church propelled the colony into a special frenzy of activities, including numerous research trips in search of authentic art in all its forms. The little church, to a design by Apollinary Vasnetsov in the Novgorod style, was completed in 1882. Repin, the former master of church art, together with his fellow artists painted the wall-paintings and the iconostasis.[13] The little church at Abramtsevo was a work of communal effort and the Slavic revival which it engendered was of lasting duration in the work of Repin and his friends: Polenov, artist and archaeologist, contributed to the scientific knowledge of medieval Russian art; Victor Vasnetsov kept his fascination with icons and fairy tales; Apollinary Vasnetsov devoted his life to the study and painting of medieval Moscow; and Ilya Repin was soon to paint his *Tsarevna Sophia* and *Ivan the Terrible and His Son Ivan*.

During this Moscow period, Repin's mood was expansive. His work on *The Farewell of a Recruit* was nearing completion and had already been purchased by the Heir Apparent (later to become Tsar Alexander III).[14] Notwithstanding this high honor, Repin began two paintings on revolutionary themes, *Refusal from Confession before Execution* (1880–1885) and *Arrest of the Propagandist* (1880–1889). The many variants of these paintings indicate the seriousness with which he worked his theme: the conflict between those who defied the

law in the name of justice with those who defended dynastic power through arrest and execution.

Refusal from Confession is a small canvas (48 x 50 cm) that captures the elements of the struggle. It depicts the interior of a prison cell where two figures are engaged in conflict: a young, resolute revolutionary and a meek priest. The canvas is painted in grey and brown shades and the use of color highlights emphasizes its meaning. The silvery spots of color on the fringes of the priest's fur collar draw the viewer's attention to the contrasting attire of the two figures and to its sociopolitical implications—the revolutionary shivering from cold, his hands thrust into the sleeves of his worn coat and the priest well-protected from cold by his winter coat. The highlighted cross on the level with the eyes of the condemned seems suspended in a static position, and the revolutionary views it impassionately, conveying no need for confession. The undelineated hands of the two figures accentuate the improbability of any rapprochement and the two figures remain frozen, as it were, each in his own faith. It is a painting of atmosphere, abundant in implicit psychological overtones.

Arrest of the Progagandist is a much more graphic canvas. It depicts the noxious moment when a Narodnik is caught and his illegal literature is being examined by the district police official and his helper. The tragedy of the prisoner lies in the fact that the very peasants he had come to enlighten fail to support him and show no interest in his fate. The deep brown tones make the interior very dark and the beam of light from a small window, falling on the diagonal from left to right, brings alive the central figures but leaves some figures on the canvas in dark shadows.

During one of his Moscow excursions Repin visited the convent of the Novo-devichy. It was here that the Princess Sophia had been imprisoned for life by her youthful half-brother Peter when he came of age and assumed the power of Tsar. A few years earlier the strong, scheming woman had managed to lead the revolt of the *Streltsy*, her faithful military garrison in Moscow, against Peter's kinsmen. Victorious in this bloody struggle, she was named simultaneously regent for both her feeble-minded brother Ivan and her half-brother Peter. The drama of Russia's seventeenth-century history excited Repin's imagination, and he resolved to render a historical canvas by painting Sophia as she would have looked in 1690, the year after her internment in the convent, the year the *Streltsy* were executed.

Repin immersed himself in historical literature, combing the Moscow museums, investigating all places connected with the tragic events in Princess Sophia's life. At the same time he began to seek a model for Sophia. Her characteristic features were not difficult to find, since in Repin's view her endurance, energy, and iron will were ubiquitous national characteristics. His models thus were many and varied.[15] The large figure of Sophia stands close to a small barred window through which can be seen the hung corpse of one of the *Streltsy*. A lit candle on the table accentuates Sophia's luxurious garments and

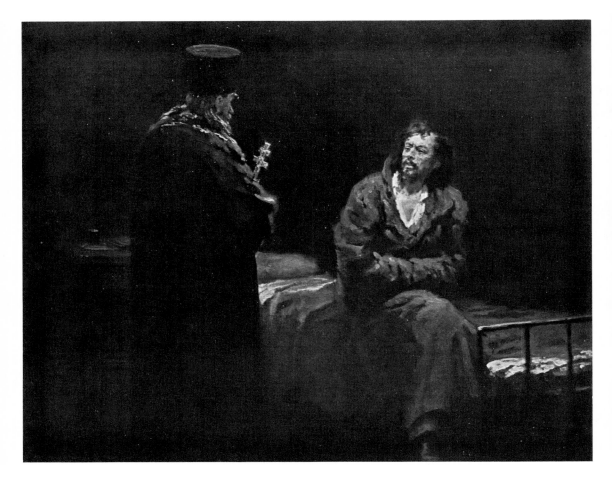

Refusal from Confession before Execution.

reflects on a huge icon in back of her. The drama of the painting is expressed through Sophia's eyes—frenzied and irate—bespeaking her crazed anger at her brother Peter.

Stasov was highly displeased with Repin's new choice of subject, and his campaign against the painting did not abate when *Sophia* first appeared publicly at the Exhibition in 1879. How could an artist-realist who had never experienced a violent outburst of human passion capture the madness of a strong-willed personality like Princess Sophia? Such was Stasov's challenge in his review for *Novoe vremya* in March 1879. Repin could hardly contain the pain caused by Stasov's adverse criticism when he wrote to Kramskoy on May 17, 1879. "To me personally, it is no news that almost all the critics are against me. This has occurred repeatedly with the appearance of each of my works. Can you recall the howl brought on by the appearance of *Burlaki?* The difference is that formerly Stasov was the exception and defended me. Now he too barks like an

Detail of *Refusal from Confession before Execution.*

old dog. Well, what can one do. They will bark a while, and cease. This is minor in comparison with eternity."

Repin was right in his prediction. Exhibited first at the Seventh Exhibition of the Society in St. Petersburg, "she" was sent to Moscow, then for a year to exhibitions in Russia's main provincial cities, creating a sensation wherever the painting went and winning plaudits in the press, even from America. It seemed that *Tsarevna Sophia* was exactly what was wanted by *Scribner's Monthly, an illustrated magazine for the people,* at the end of 1879, to illustrate a series of articles by Eugene Schuyler on the epoch of Peter the Great. Schuyler had served as American consul in Moscow, and for many years as secretary to the American Legation in St. Petersburg. He knew Russian well and had translated works of Turgenev and Tolstoy, both of whom he knew personally. During his stay in Moscow he had done research on the period of Peter the Great in the Archives of Foreign Affairs. When the editor requested Russian paintings of

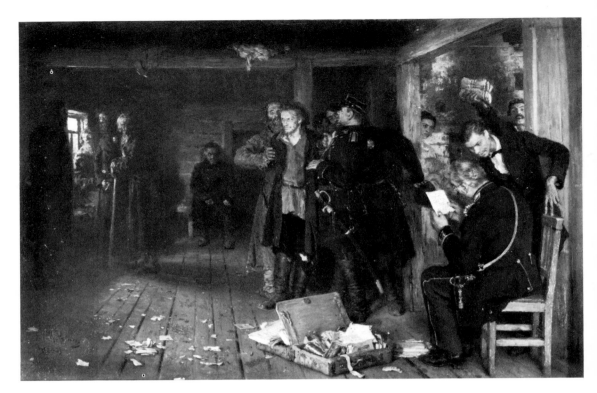

Arrest of the Propagandist.

Russian life in the seventeenth and eighteenth centuries as illustrations, Schuyler's first choice was Repin's *Tsarevna Sophia*. Richard Whyteins, *Scribner's* representative in Europe residing in Paris, was dispatched to obtain a drawing of the painting. Repin recounts the episode in a letter to Stasov dated January 12, 1880:

> About three weeks ago, Monsieur Richard Whyteins commissioned Vasnetsov to make a drawing of my picture "Princess Sophia" for his magazine which will publish the life of Peter I, and the drawing of my painting. Many more drawings dealing with the life of Peter will be needed. Since my painting of Sophia is not here (it is on tour), Vasnetsov turned over to me the commission, which I fulfilled partly from the studies which I had, and partly from memory. I made the drawing according to the size the American had requested, and sent it off within a few days . . . I requested M. Whyteins to send me a copy of my drawing immediately, but as yet I have not received it. The magazine is an elegant one, of small size, but well organized. I believe its name is "Scribner's Monthly." I was very careful with my work, but I don't know how well they will reproduce my drawing.[16]

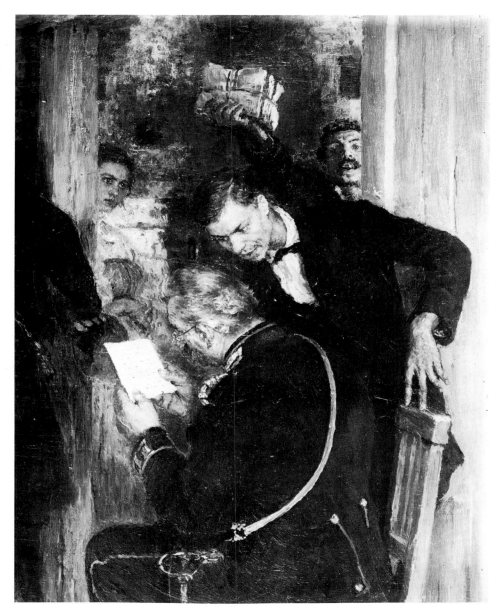

Detail of *Arrest of the Propagandist.*

In April 1879, Repin returned briefly to Chuguev to recover from the un-friendly attack by Stasov. Most of the spring he spent in travel throughout his beloved Ukraine. The summer he spent with his family at the Mamontov's home in Abramtsevo. The atmosphere there was warm and conducive to cre-ative work and Repin grew to love and respect his hosts. Evenings were devoted

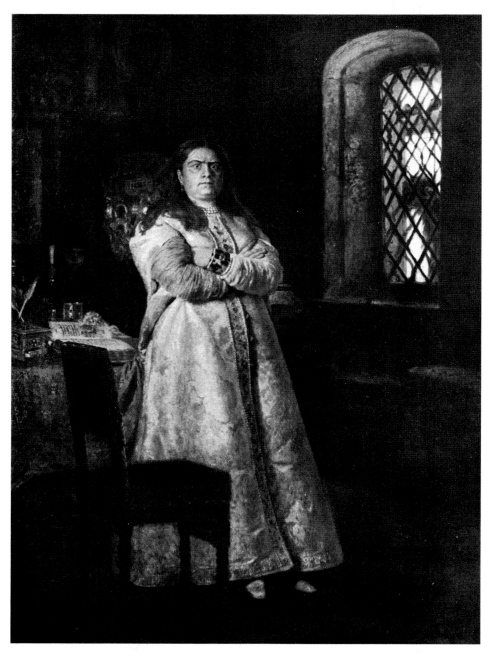

The Ruler Tsarevna Sophia Alekseevna, a Year after Her Internment in Novode-vichi Monastery during the Execution of the Streltsy and the Torture of Her Retinue in 1698.

to readings, painting, clay sculpturing, and impromptu renditions by noted singers, dramatists, and musicians. It was at Abramtsevo the year before that Repin had chanced to examine the contents of a letter sent in 1676 by the Cossacks to the Turkish Sultan. He was fascinated by the caustic humor, the crude language, and the daring of the Cossacks, who prized liberty above death, as exemplified by the letter. He now sat down to make his first pencil sketch on the theme of the Cossacks—the first strokes of a project that was to last nine years.

One October evening in 1880 a thick-set man with a fine grey beard, dressed in a long black frock coat, made his entry into Repin's modest studio in Moscow. The distinguished visitor was Count Lev Nikolaevich Tolstoy. For a moment Repin stood transfixed. Could this be Tolstoy, he wondered. Stasov had told him that he had urged Tolstoy to visit Repin's studio, which was a quarter of an hour's walk from Tolstoy's Moscow residence. But Repin knew Tolstoy only as Kramskoy had painted him; that is, a much younger man.

Almost at once, Repin recalls clearly in his memoirs, the great dissenter plunged into a diatribe on society's terrifying indifference to the horrors of life, its acceptance of a perverted manner of living, its refusal to better itself, and the maltreatment of those it kept in continuous subjugation. Society had lost its conscience. Repin sat engulfed in a torrent of words. The room grew dark while in Tolstoy's thundering phrases civilization was tumbling to its doom. Repin rose and lit a lamp. In the dim light this dramatic figure, with the large head, looked to him like a prophet on the eve of Judgment Day. After two hours had slipped by, Tolstoy concluded with a passionate plea for a better world and the brotherhood of man.[17]

Many paintings on which Repin was working were in his studio that day of Tolstoy's visit, and Tolstoy's reactions to them were as individual as the great man himself. Tolstoy was looking for a painting with a particular atmosphere, an expression in Repin's art in harmony with his own beliefs. He criticized some of the paintings, gave helpful hints on others, and favored *Vechernitsy* (Evening Party). This painting, which depicts the charm, simplicity, and spontaneity of peasants' evening festivity, seemed to coincide with his ideal of Christian art. From that first meeting, Repin, it appears, was under Tolstoy's spell. The writer's convincing manner, his deep-set, penetrating eyes under the bushy brows, produced on Repin a hypnotic effect. When in his presence it seemed to Repin that Tolstoy was indeed the prophet of Eternal Truth.

On the many walks which the two men subsequently took, Tolstoy would criticize his own art and the art of other men as being wasteful of its chance of promoting human happiness because of its exclusiveness and "artificiality." If art was to have a beneficial and moral effect upon the people, Tolstoy argued, it must of necessity utilize moral subject matter, since the delineation of immoral motifs was bound to result in an immoral art and defeat the very purpose of its existence. In *What is Art?* Tolstoy stated unequivocally his understanding of the

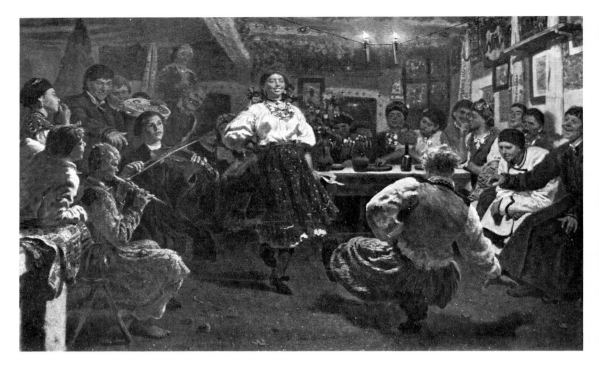

Vechernitsy.

ultimate meaning of art: "To evoke in oneself a feeling one has experienced; having evoked in oneself, then by means of movements, lines, colors, sounds, or forms expressed in words, so to transmit that feeling, that others may experience the same feeling—this is the activity of art." And Repin, as many another of his compatriots, would agree with him on the humanitarian aspect of art, but would at the same time plead with Tolstoy to return to the writing of literary works. Under Tolstoy's influence Repin set aside his *Cossacks* and worked on *Vechernitsy.*[18]

In 1880 Repin's third daughter, Tatyana, was born. Repin was growing restless in Moscow where conversations at gatherings too often degenerated from discussions on lofty subjects to personal animosities. Now that Repin was a popular artist and a favorite of Tretyakov, he himself sometimes became the target of malicious gossip. Angered, Repin now called Moscow "the belly of Russia," a city unsuited to intellectual growth.[19] Yet the winter in Moscow was in many respects an interesting one. Repin visited the current exhibitions with the detachment born of artistic maturity. At the exhibitions of the Moscow Society of the Patrons of Art, an organization formed to assist young artists, Repin sought evidence of what he had tried to express in his own works—grim, realistic life. "From the point of view of technique," he avowed in a letter to Stasov on January 2, 1881, "there are some good paintings, but as far as life is concerned, nothing! Oh, life life! Why do artists leave it out?"

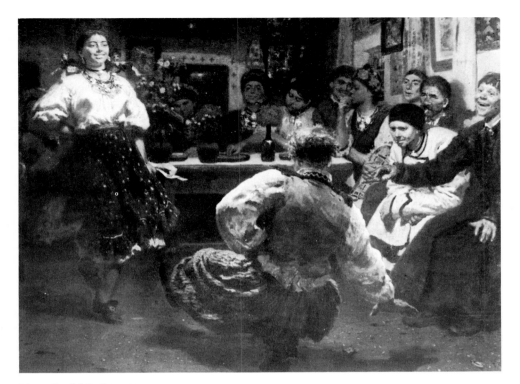

Detail of *Vechernitsy*.

That same year, 1880, at a dinner given by the poet A. A. Fet, whose portrait he was painting, Repin met the Russian philosopher Vladimir Soloviev and was struck by the Christlike beauty of the man. The repose of his countenance with its frame of long, curly hair, the grey eyes, the thin, delicate hands, all caught Repin's attention. Other meetings with the philosopher took place at the home of Nicolay Strakhov, a man of letters, who had sat for Repin. Strakhov's well-appointed home was a favorite gathering place for many celebrities, who seemed particularly at ease in his study surrounded by beautifully bound books, with lovely furniture on richly carpeted floors. Here Soloviev was most impressive in his discussions of literature, science, and religion. Some years later Repin again met him, this time at the home of Baroness V. I. Ikskul, just before a lecture by Soloviev. It was to be the feature attraction of one of the Baroness's Thursdays, and she had given Repin an album with the suggestion that he make some drawings of Russian celebrities. Repin amiably agreed to do so. He was eager to draw Soloviev, and completed two sketches. When some English friends of Soloviev came to St. Petersburg, the philosopher sent Repin a note, asking permission to bring them to his studio. Repin refused and later regretted exceedingly his temporary display of arrogance. Soloviev had agreed to sit for a portrait, but it never materialized. In his autobiography, Repin attributed his strange response to his fear of becoming "a visiting attraction for foreign tour-

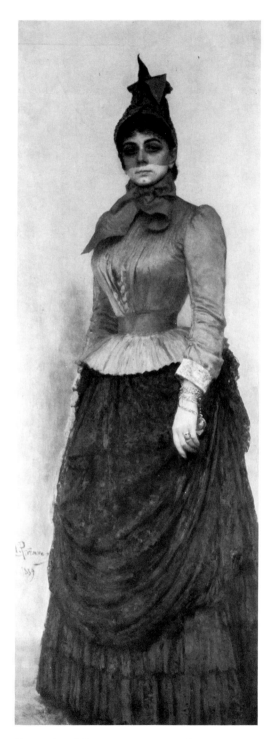

Portrait of Baronness V. I. Ikskul.

ists." The incident may or may not have been responsible for his failure to paint the immortal Soloviev.

The year 1881 was marked by the assassination of Alexander II; the world was impoverished by the deaths of Dostoevsky and Musorgsky. Dostoevsky's funeral, lasting two days, was attended by his foes as well as his friends. But his iconoclastic contemporaries, while paying tribute to his genius, totally rejected his philosophy of the relationship of Man to God. One of these was Repin, who expressed this thought in a characteristic way:

> Allowing full credit to his talent, his originality, and depth of thought, I hate his convictions. What an ecclesiastical wisdom! He frightens and limits our sad life, which is already narrow and full of prejudices. And why such sympathy toward monasteries (*Brothers Karamazov*)? "From them will come the salvation of Russia!" And why such weighty accusations against the intelligentsia? And his coarse hatred of the Poles, and his popish glorification of orthodoxy? Much of this sort is as obnoxious to me as Katkov himself. But Moscow drinks it all in. Yes, even our Petersburg friends sing strongly in unison: "This is an authority writing; who can dare to think otherwise?" Oh, to my sorrow, I have gone so far apart from so many of my friends in my convictions that I am almost alone.[20]

Repin, too, had concerned himself with the priesthood but, unlike Dostoevsky, he had come not to explain but to expose in canvases such as *The Archdeacon*. With his brush he had attacked weaknesses of the Russian ecclesiastics, clearly revealing their worldly interests. He wrote to Stasov in the letter quoted above that he admired Dostoevsky's talent, but hated his conviction that salvation for Russia will come from the monasteries, from the Orthodox Church.

The tragedy of Musorgsky's death was epitomized by Repin in a canvas that provokes today almost as great a response as it did in the hushed days following the composer's death in March 1881. For a long time Musorgsky had sought escape from various emotional problems through alcohol. In his later years he had taken to wandering for days about the capital, and turning up unaccountably ragged and penniless at the homes of friends or mere acquaintances. Finally, as a former military cadet, he had been sent to the psychiatric division of the Nikolaevsky military hospital in St. Petersburg. Informed by Stasov of their old friend's condition, Repin hastened to the hospital and on March 2 started to paint the composer's portrait. As if having a premonition of the musician's death, Repin managed to complete Musorgsky's portrait in four sittings, between March 2 and 5. It emerged a masterpiece in the history of portraiture. It is an arresting portrait of an alcoholic in whom degeneracy is somehow blended with goodness and simplicity with genius. Stasov hailed the work as one of the greatest contributions to the national school of art, and in his review of the Ninth Exhibition of the Society where the portrait was exhibited, he aroused the interest of the public to such an extent that about 2500 people came to see it the day after the article appeared.

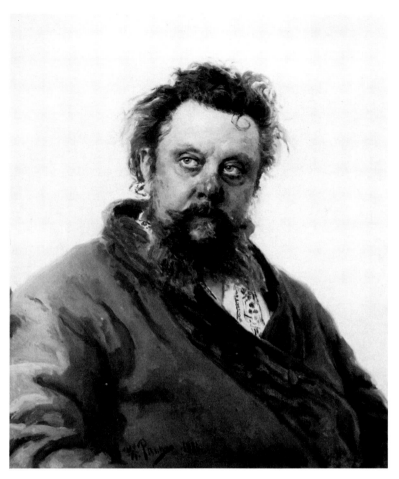

Portrait of M. I. Musorgsky.

Repin chided Stasov for the review, criticizing his failure to mention the exhibit of Surikov's first historical painting, *The Morning of the Execution of the Streltsy.* He also pointed out that Stasov's exaggerated and unbounded praise of him had helped to antagonize other artists. Repin's temperance was prophetic of what happened when the exhibition reached Moscow. Disregarding the Musorgsky portrait almost entirely, the Moscow critics lauded such items as Repin's portraits of Ge and of A. F. Pisemsky, painted in 1880. Repin's feelings at the death of Musorgsky had little to do with critical encomiums. Ruefully he pushed aside the 400 rubles received from Tretyakov for the composer's portrait. He could not keep the money, he insisted in letters to Stasov, and requested that it be used toward a memorial for Musorgsky.[21] He had not been commissioned to paint the portrait, he added, and there had been compensation enough in the joy of sitting with his late friend, who had been rational and at the same time

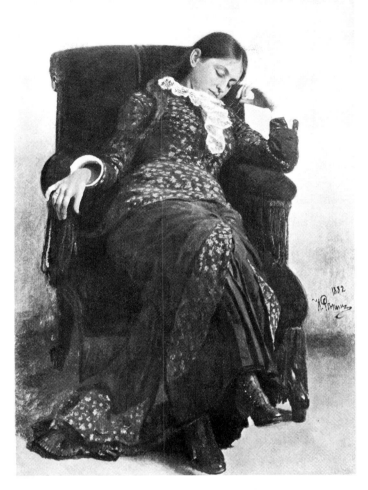

Rest (the artist's wife asleep in an armchair).

full of humor to the end. Not considering the money to be his, he begged Stasov, who had tried to return it, to understand his feelings in the matter and do as he requested.[22]

In another critical vein, Repin wrote to Tretyakov regarding a portrait of Katkov.

> Your intention to commission a portrait of Katkov and to place it in your Gallery does not give me peace, and I cannot help but write that with this portrait you will cast an unpleasant shadow over your excellent and fine collecting activity for such a priceless museum. The portraits which you now hold . . . denote personalities dear to the nation, its best sons who brought positive benefit by their selfless activity for the good and the flower-

ing of the native soil, men believing in their country's better future and fighting for this idea. What sense is there to place among them a portrait of the reactionary, who so long and so consistently and with vulgar frankness attacks any noble thought and one who branded with a stigma every free word. . . . Should such people be placed together with Tolstoy, Nekrasov, Dostoevsky, Shevchenko, Turgenev, and others? No, contain yourself for God's sake.[23]

In June 1881 Repin made a trip to Kursk, to the Korennaya desert, a place famous for religious processions. He had decided to paint two pictures with a similar theme, one describing a church procession of ancient times, the other a procession of his day. The first work was set aside through the years, and although the painting was started in Chuguev in 1877, it took the next eleven years to complete. On the other he started working that summer. With the shrewd eye of an art collector, Tretyakov appreciated even the minor versions of the church procession and realized that Repin was now approaching the peak of his creative powers. All that summer at Abramtsevo he watched the painting progress, then invited Repin to finish the work in the new halls of the Tretyakov Gallery, which were not as yet occupied. Repin accepted the invitation and spent many weeks working in the gallery, but at the end of the summer the painting was still unfinished.

Repin and Tolstoy continued to meet and take long walks together. That winter Repin suggested that Tolstoy set aside one evening a week for discussions and exchanges of views with a group of artists, including Surikov, Vasnetsov, and others, but Tolstoy declined the invitation.[24] Repin ascribed his refusal to the influence of the artist Perov, who had lately changed his views and philosophy, presumably in deference to Tolstoy, and devoted himself to the painting of religious themes. Nevertheless, when Tolstoy's *What People Live By* (1882) was first published it was illustrated by Repin at Tolstoy's request.

Repin's own hurried days hardly fitted the mood of another of his notable paintings, *Rest*, painted in 1882. There is but one figure, his wife, asleep in a cushioned armchair. The quiet atmosphere of repose is well fulfilled.

Early in September 1882 Repin made a decision not to remain in Moscow any longer. He would not wait to complete his *Religious Procession in the Province of Kursk*. He wished to bring his "self-imposed exile" to an end. That same month the Repins moved and thus it was that he finished his painting in St. Petersburg, exhibiting it at the Exhibition in 1883. And once more a Repin work was acclaimed a masterpiece.

The large and complex composition may be seen as a series of triangles. The lower triangle on the right is occupied by the privileged of the procession; the upper is taken by a hill with tree stumps. In the foreground of the lower right triangle, muzhiks carry a huge lantern which towers over the multitude and over the upper right triangle, jutting into the sky. The muzhiks are followed by

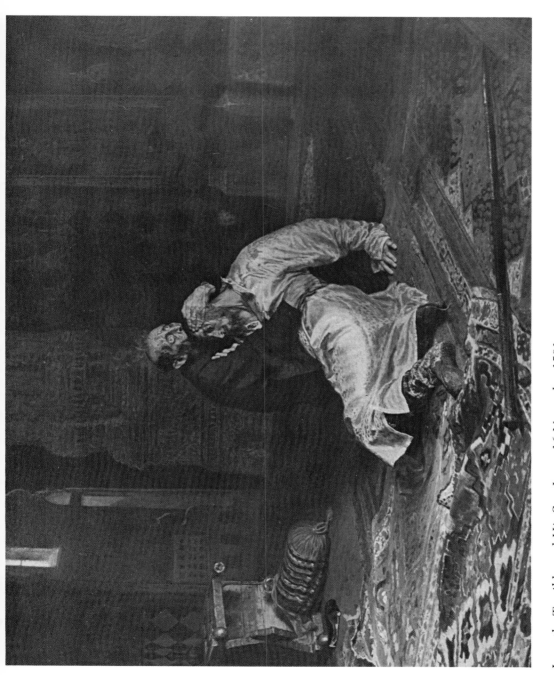

Ivan the Terrible and His Son Ivan, 16 November 1581.

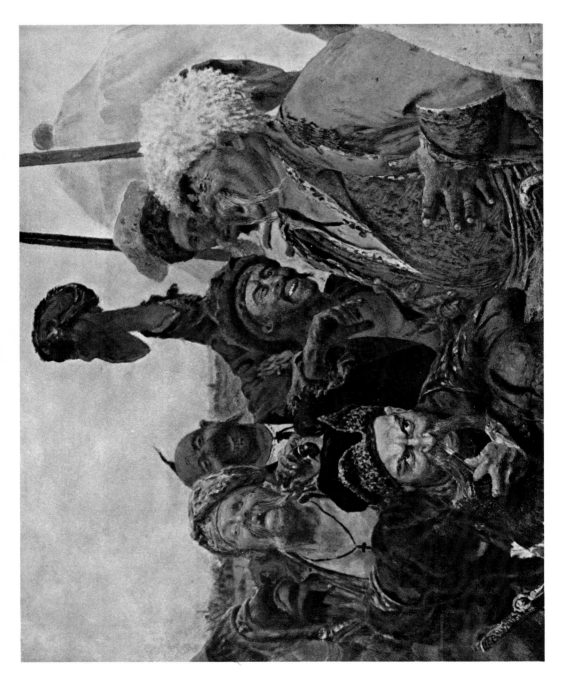

Detail of *The Cossacks*.

two lowly women carrying the empty wooden case of the miracle-working icon. They lead the eye to the deacon. The unoccupied space around him, his silver incense holder, his gold sticharion of brocade, and the fact that he is placed in the precise center of the painting give him special emphasis. A bit off-center, behind the deacon, a landed lady carries the miracle-working icon. She establishes a certain cadence, not permitting the anxious crowd in back of her to speed up her rhythm. From where she stands, two diagonals, from her left and her right, run to the forefront of the painting, separating the mass of people into two groups.

On the left, in the front, an adolescent hunchback, his face expressing unquestioned faith, moves quickly toward the icons despite his deformity but is thwarted from crossing the sunbaked road by the raised stick of a peasant. The marching people—the pompous and self-satisfied of the more privileged class, the peasants, and the poorly clad pilgrims—push from both sides and from the center. The figures on horseback, on two diagonals to the right and left of the canvas, jut out and go toward the vanishing point. The kinetic movement is achieved by means of several different levels of spatial planes.

The main color scheme of the painting is yellow-brown, which gives authenticity to the panoramic scene of Russian provincial society. The multicolored streamers on the lantern harmonize with the blue of the sky. Only three figures are accented by the use of a few vibrant colors: the woman with the empty icon case, the deacon, and the landed lady. The judicious use of accent helps to lead the eye to the center of the painting.

The picture is remarkably effective in two respects. First, Repin's employment of psychological and critical realism, with the sure skill of practiced observation, directs its barbs straight at a Russia of social contrasts and inequities. Second, and equally important, is the artist's success in conveying an atmosphere of air and light and movement. Alexander Benois, who otherwise judged Repin most severely from the vantage point of the new esthetics of the 1890s, expressed his admiration for the *plein-air* painting as follows: "In *The Church Procession* we were not attracted, of course, by the naive juxtaposition of religious pilgrims with uncouth gendarmes, but only by the beauty of a superbly expressed scorching day and the splendid depiction of the movement of the picturesque crowd."[25] Tretyakov purchased the painting for 10,000 rubles and the financial windfall allowed Repin to realize his hope of one day taking an extended tour of Europe in the company of Stasov.

In spite of occasional disagreements on esthetic problems there was a warm spiritual affinity between Repin and Stasov. Repin appreciated and valued Stasov's extensive knowledge of the West and his considerable travel experience. Stasov had visited the art centers of Europe a score of times, had attended the great world exhibitions, and had often served as Russian delegate to European scientific congresses. For his part, Stasov apparently had also enjoyed traveling with Repin when they had visited the International Geographic Congress in

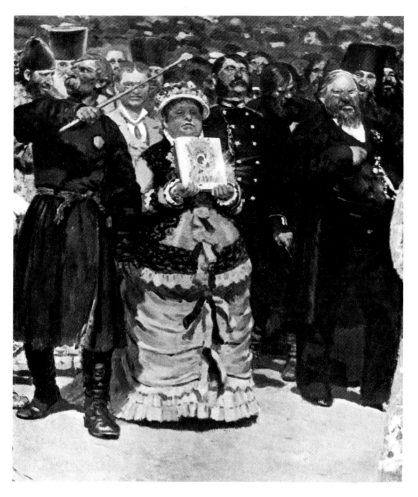

Detail of *Religious Procession in the Province of Kursk.*

Paris in the spring of 1875 and then spent weeks making the rounds of the French museums. At least twice since then Repin had been disappointed in his hopes of traveling with Stasov. On Repin's return to Moscow in 1878, when he learned of Stasov's proposed trip to Paris for the World Exhibition, he expressed regret that he was unable to accompany him. Again in 1881, when Stasov was leaving for Spain, Repin could not join him. Finally in 1883, Stasov was again making a trip and this time a joint venture was possible because Repin was financially solvent. On March 25 he wrote Stasov that now he would go to Europe consciously, with a passionate desire, "not like ten years ago, by government necessity."[26] This journey, recorded largely in Stasov's letters and diaries, gives an interesting, intimate, and revelatory view of both men.

On their first day in Berlin, April 28, 1883, the two travelers visited the Kaiser Friedrich Museum, the National Museum, and the Politechnikum where an

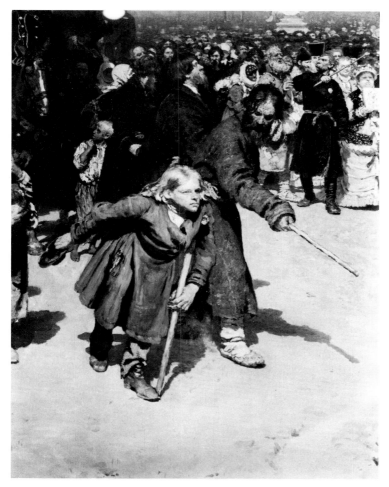

Detail of *Religious Procession in the Province of Kursk.*

exhibition of the Academy of Art was being held. Of particular appeal to the Russian visitors were the works of Václav Brožik, Emile Wanters, Franz van Defregger, and Emilio Marvili. The following day Stasov took Repin to a synagogue built in 1866 which he considered "the most remarkable architectural work of the nineteenth century." It was also at Stasov's suggestion that Repin went with him to the Aquarium and the Zoological Garden before leaving for Dresden the following day.

Arriving at the station after four hours of travel, they checked their luggage and went directly to the Dresden Art Gallery, after which they made a brief stopover at the King's Garden Museum. The reason for their hasty trip to the Dresden Gallery was the museum's famous Raphael collection, particularly the renowned Sistine Madonna. Years later, recalling this visit, Repin said: "My first impression of her was painfully disappointing, but when I understood the

historical background of the phenomenon, it became clear to me that it was a work of genius."[27]

Having accomplished their tour of the city, they made inquiries into connections to Kassel, and the opening hours in the museum there. To their dismay they learned that it was Pfingsten, Whitsuntide, and all the museums were closed. Stasov suggested that they spend a few days in Saxony but Repin refused. He decided rather to spend the time doing a portrait of Stasov. They bought some canvas and proceeded to turn their hotel room into a studio. Repin shaded one of the three windows with Stasov's plaid blanket and half of another with yellow wrapping paper. Repin seated his companion in a spot near the third window.

Three days later, on May 5, Stasov described the event in a letter to his brother Alexander as follows:

> Most probably all of you ladies and gentlemen know already from my letter to Dmitry, that because there was nothing else to do on Whitsuntide, since everything was closed and there was absolutely no place to go, Repin painted my portrait in Dresden. Repin definitely refused to go to Saxony and we have wandered through the city sufficiently. The portrait is excellent, a fine resemblance; I think that no other portrait of me, or any of my photographs, resemble me so well. Altogether, the portrait was painted in fourteen hours, perhaps a little more. Repin says modestly, "This is not such an unusual happening." But I don't agree; I still continue to repeat that this event is quite unusual. Something was gained by unremitting work, for the mood of Mister Artist was uninterrupted, and furthermore my pose was also unchanged. For the sake of comfort, my costume was as follows: merely a coat, and under it my nightshirt, which showed a bit at the breast. Of this I wasn't even conscious, and Repin intentionally did not say anything, fearing that I might try to correct it. I face front with my arms shown only above the elbows. The pose is quite impressive, the expression of a pleased, but very serious man.

The portrait came to be known as the "Dresden" portrait, and was preferred by Stasov and his contemporaries to the six other portraits which Repin had done of him.[28]

The Old German town of Kassel, where the artist and critic stopped over on May 3, 1883, gave them a feeling of the Dutch school on their way to Holland. While in general they were little impressed by the museums and galleries, they were appreciative of a number of Rembrandt paintings. Arriving in Amsterdam, Stasov was impatient to introduce Repin to his favorite Rembrandt, *The Night Watch*. However, instead of the anticipated paeans of rapture, Repin expressed mild approval and the casual assertion that a finer collection of Rembrandt was gathered in the Hermitage in St. Petersburg. "Yesterday we almost had a quarrel. *Ronde de Nuit*, Rembrandt's work of genius, which I have long worshiped, appealed only moderately to him," Stasov complained to his brother, and con-

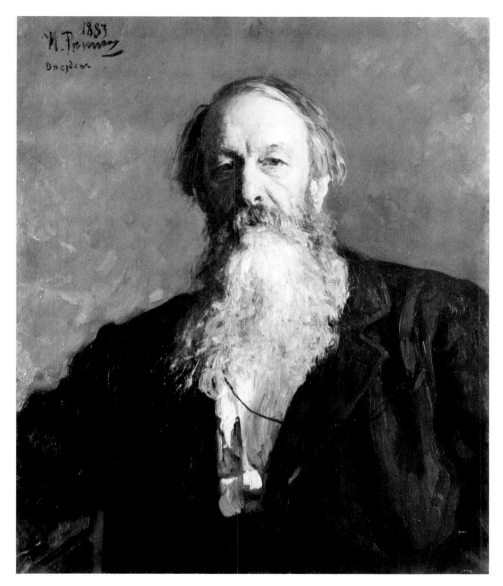

Portrait of V. V. *Stasov* (the Dresden portrait).

sidered this disagreement to be the first cloud in their trip. It hovered over them during the three days of their stay in Holland. Their reactions to the Rijksmuseum, the International Industrial Exhibition, and the Sixmuseum, were marked with a certain strain. Only in the evenings, when they visited the Rembrandtsplein, the Café aux 1000 Colonnes, and the Jewish Quarter, with the synagogue on Nieuwe Amstelstraat, did they yield to the charm of their surroundings, marveling over the beauty and uniqueness of Amsterdam.

They bade a swift farewell to Rembrandt in the Rijksmuseum, and were off for Haarlem and the Hague. In Stasov's diary appear references to the huge paintings of Frans Hals which they saw in the Hôtel de Ville, and to Rembrandt's *The Anatomy Lesson, The Bulls* by Paul Potter, and several portraits by Rubens and Van Dyke which they viewed in the Hague. Repin was particularly impressed by the paintings of Frans Hals, whose works appeared in a special collection in Haarlem.

Other clouds continued to gather on the horizon of the Stasov-Repin friendship. Repin's newfound independence in matters of art was becoming more than the older man could tolerate. He was accustomed to finding in Repin a kindred soul receptive to his own views. Now he discovered a rebellious spirit, and from peaceful discussion on art fierce arguments developed. Almost any triviality served as the springboard for the most violent verbal battles. Stasov nursed his wounds in a letter to his friend N. P. Sobko on May 7:

> Early this morning I did not write to you, and now I will write very little. Do you know why? It is because, lying in our beds, and almost ready to get up, Repin and I started a violent argument for the second time about architecture and architects. Each time we almost came to a fist fight. He would not give a penny for our new school of architecture and all the architects have created; at the same time, he considers excellent the architecture of our Kokorinov's Academy of Art (which I detest), and despises the Winter Palace of Rastrelli (a talented work, though in a bad form of Rococo). In addition to all this, he advocates only "quiet tones" in the coloration of architecture!!! You can just imagine, how I can agree with him! Of course, a violent argument.[29]

On their way to Paris they briefly stopped in Antwerp to pay homage to the paintings of Rubens, whom Repin later characterized as "the Shakespeare of art." In Repin's thought, however, was Paris, the city he had not forgotten in the intervening years. A decade earlier he had written to Kramskoy: "Paris is now exceptionally beautiful. It beats with life; everywhere is something new, inventions and effects which strike pleasantly against one's eyes, creating a vivid impression. The French possess this quality deeply and strongly, as is shown in the paintings of their artists. Yes, the mass of artists have a tremendous influence upon the whole of Paris, and uphold it, high above all other nations and cities. Everybody bows to the artistic impressiveness of Paris." And again: "Frenchmen are inimitable people, almost ideal. They have an unconstrained, harmonious language, delicate cordiality, swiftness, lightness, and immediate comprehension. Yes, they have the right to be republicans."[30]

In Paris they spent some time with Russian friends; met the famous revolutionary P. L. Lavrov; were disappointed by the absence of Antokolsky, who happened to be in Russia at the time, and of Turgenev, who had moved to

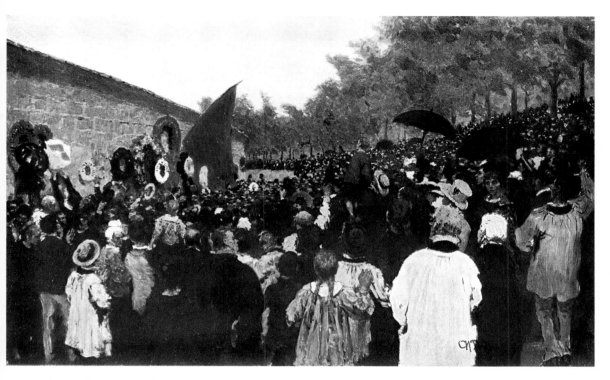

Annual Memorial Meeting at the Wall of the Communards in the Cemetery of Père Lachaise, Paris.

Bougeville two months earlier and was critically ill. They attended socialist meetings addressed by Lavrov and a meeting sponsored by the fiery speaker Mme. Hübertine Auclert, whose topic was "Review of the Constitution and Women." On the morning of May 15, Repin attended the annual celebration of the Communards in the Père Lachaise cemetery and marveled at the crowds who met openly to express their political opinions. When he set up his easel on the field to make sketches of the proceedings, the crowd made room for him once they understood his empathy with their cause. Within three days, from these preliminary sketches, he executed and completed in his hotel room a painting, *Annual Memorial Meeting at the Wall of the Communards in the Cemetery of Père Lachaise.*

In this work, the eye of the viewer is led to the main object of the painting, the red flag, through a diagonal from the largest figure of the right foreground, to the white of the upraised hand, to the red wreath, to the white wreath, to the red flag jutting into the sky above the brick wall. The mass of people in a semicircle is painted in black and grey-brown colors, circled by green trees whose branches bend toward the wall as if to create the union of spirit between nature and man in support of "Vive la révolution sociale! Vive la commune!"

On the surface things now seemed to be going reasonably well between the

old friends. They had political interests in common, they visited museums, attended the theater and the ballet, and even found time to go to the circus. But all this was hollow pleasure, as Stasov's letter to Sobko indicates: "Every day I inwardly regret the money and the time. Or perhaps, I myself am spoiled: Or perhaps, I have traveled too much in recent times. I don't know. But the present trip has not turned out too well for me."[31] The annoyance with Repin and a sudden heat wave influenced Stasov's decision to shorten their stay in Paris, and head for Spain. Repin offered no objections; his eleven-day experience in Paris had been rich in impressions. Although he admired the Louvre collection, he was deeply disappointed with the works exhibited in the Salon because the French artists, in his opinion, had given themselves to form exclusively.

Madrid overwhelmed Repin. "What a charming people the Spaniards are," Repin wrote to Tretyakov, "sweet and good, well-intentioned, like innocent children. Simply unbelievable. Up to this time I considered Frenchmen to be the best people, but the Spaniards are incomparably greater by their goodness, and innocence and affability. And how beautiful are the women and the men, too. But what is horrible is their public exulted killing of carefully tended bulls, and especially the killing of horses by bulls' horns!!! This is a shame for humanity. How can one tolerate this foul bloodthirstiness!!!"[32]

His esteem for Velásquez did not lessen when he saw fifty works against the native background in the Prado. Never had he seen such beauty. He began to make necessary arrangements to copy Velásquez by securing permission from Professor Raimondo Madrazo, the director of the museum, and then began painting. "Never before have I rushed with such ravishment to a museum each morning as I do here. What a museum in Madrid! Where else can you study Velásquez and Titian as well as here," he wrote to Tretyakov. Repin's great admiration for the works of Velásquez was a source of annoyance to Stasov. From his ultra utilitarian approach to art, art as a handmaiden to social change, he found Velásquez too limited in scope. To his brother Dmitry in a letter of May 30, 1883, he stated his position clearly:

> Velásquez has a great talent, but only in his own specialty. It has always seemed to me that he is very limited and poor in imagination or not possessing any; he isn't able to create anything, and in addition to that he is very prosaic. Nothing poetic or imaginative is within his reach. His very best work is his portraits. What of it? Whose portraits? Most of the portraits are of his king, the king's children, the king's court, the king's jester—and that is all. He was probably no less a court servant than was Rubens. And in addition, whom did he paint? The idiot Philip IV!!! How was he able to deal only with them all his life. This is a destructible limitation and subservience.[33]

Stasov's interpretation of Velásquez's art had no influence on Repin. In order to capture Velásquez's method of painting, Repin resorted to his particular

talent for copying. These were not copies in the ordinary sense of the word. Born of a flash of insight into the artist's original purpose and mood, these replicas were carried out with the swift, unerring strokes of genius. Gallery-goers and tourists thronged about him as he worked, amazed at the brilliance of the reproduction, the speed and accuracy with which he copied not only Velásquez but Titian as well. Engrossed in his work, Repin hardly noticed his admiring audience, but Stasov, who was occasionally present, noticed that young artists from the Spanish Academy left their canvases and stood for hours watching Repin.

While Repin was in the museum, Stasov was working in the library, gathering material for his book *Slavonic and Eastern Ornament According to Manuscripts of Ancient and Contemporary Times*, published in the following year, 1884. Even though both were kept very busy, they nevertheless indulged in explosive quarrels. Stasov had a peculiar mania for argumentation. Presenting his points of view as axioms, he never made any concessions, regardless of whether his debating point conformed with his own sincere opinion, and would hold his ground to his opponent's exasperation. Such an argument occurred one morning after they had gone from an annual exhibition in the Ministero di Ultramares to the Church of San Antonio de Padova, where they discussed the merits of the Goya frescoes they saw. Stasov describes the events in a letter to Sobko:

> Here is what happened yesterday. Having finished work in the library and in the museum, we went to a small church, not far from town, recommended to us by a young artist (very talented artist) Ricardo Madrazo, brother of the famous Raimondo Madrazo, director of the museum. In this church there are interesting, almost unknown frescoes of Goya, very brilliant in color, but very paltry in content. On our way back, we started an argument about art—not for the first time—but this time Repin became so furious and lost himself so completely, that he left me saying, "I can't speak with you, and never again will!" You see how my views, my new ones, my own, not borrowed from anyone else, react upon even a good, progressive artist; what would happen if I were to argue with ordinary backward people and artists? Until 7 o'clock in the evening I continued to walk around in order to give Repin time to cool off and to come to himself. At 7:30 we both met for dinner and both—as if nothing had happened. And in what fury and what madness he was two, three hours ago is disgusting to recall. This is the extent to which new ideas on art are harmful even to the best painters.[34]

And yet, in an article on Goya written immediately after his return from the trip, Stasov deplores the fact that Goya is almost unknown in Russia. "From the time of my acquaintance with Goya, at first from foreign books, articles and copies of his works, and then from his original works in Spain, I became

convinced that, firstly, Goya is one of the greatest artists of the last two centuries, and secondly, that he is one of those artists with whom our artists, and public must become closer acquainted."[35]

The rift based on differences in art appreciation was becoming increasingly acute, and Stasov began to complain in his letters about Repin's alleged lack of general comprehension, loss of memory, and mental dullness, omitting any reference to Repin's independent art judgment. "I made a big mistake in going with Repin," analyzed Stasov. "He is a wonderful person, an artist above reproach, with a fine and pure nature. But the thing is that there is a great difference between being with a person once a week or several hours in two or three weeks, and spending time incessantly with a person from morning till night, without intermission."[36]

While Stasov rationalized his growing aversion to Repin's company, he supported it with further bickering and squabbles. The most innocent act on Repin's part drew his ire. One day, going to a bullfight, which both considered "the most savage of man's inventions," Repin lifted his hat and bowed to the royal family, which chanced to be riding by. Stasov exploded with reprimands. What servile nonsense! Had Repin been seriously affected by the plumes and posturing of the Velásquez court portraits? What a betrayal of democracy! There was another furious quarrel, and the exasperated Repin walked away from Stasov.

After nine days in Madrid, the travelers wound up their grand tour in a flurry of sightseeing. They spent a day in Toledo, a day in Cordoba, and then proceeded to Seville to view the paintings of Murillo and Juan Valdés. How an experienced traveler like Stasov could have overlooked the exchange of their French currency into the Spanish is difficult to understand, but fiscal complications and troublesome incidents dogged their heels until at length they decided to see the Russian consul in Seville. Their eagerness to pour their story out to a sympathetic countryman is recorded in a letter to Stasov's sister on June 6: "When we were in Seville, I decided to look up the local Russian consul. His address we found in the 'guide.' Who did he turn out to be? A heavy old Spaniard, a hidalgo, who had grown so stupid at his desk (at which we found him), that even though I very plainly introduced myself to him, with rank—as was necessary for the good of our cause, and introduced Repin as an artist of name, it turned out that he had heard nothing, understood nothing and in a minute he began to question me about 'monsieur and fils.' "[37] Although the Russian consul could not tell the difference between Alexander II and Alexander III, he did arrange for the harassed travelers to see some bankers who exchanged their French gold currency for Spanish paper money. In Seville they stopped at the Hotel d'Europe, on Calle Sierpe. Immediately after breakfast and a quick tour of the city, Repin, inspired by the surrounding beauty, painted in oil a view of Sierpe street from the balcony of his room.[38]

On June 3, they arrived in Granada. Early in the morning they made a tour

of the city. The Alhambra was the focal point, and they visited it several times in the day and the evening. On one visit, after an extensive walk through the Alhambra, Repin's attention was caught by a young boy sweeping the sidewalk. In a few hours he had painted *The Spanish Boy*, to the full satisfaction of Stasov and a colorful crowd that had gathered to witness the artist's creation.

Both Repin and Stasov were reluctant to leave Spain, but yielding to their curtailed schedule they allowed themselves at least a few hours in Jaén and in Valencia. In Barcelona, while touring the city, the two tired travelers were once again at odds with one another, arguing passionately about the place of portraiture in art. There was wisdom in Turgenev's assessment of the futility of arguments with Stasov, which he had expressed in June 1878, in *A Poem in Prose*:

Whom to Argue With:

Argue with a person smarter than you. He will defeat you, but out of that defeat you can derive benefit for yourself.

Argue with a person your equal. Whoever may be victorious, at least you experience joy in the struggle.

Argue with a man of weakest mind. Don't argue because you want to win, but because you can be useful to him.

Argue even with a fool. Neither glory nor profit you'll gain. But why not have some fun at times?

But never argue with Vladimir Stasov.[39]

It was clearly time to part. After a hurried visit to a few northern Italian cities, they returned to Russia, arriving in St. Petersburg on June 19, 1883.

6

Ivan the Terrible and His Son Ivan

After the intense and emotional tour of Europe, Repin was happy to return to St. Petersburg. He was fully conscious of the new period in Russian history which had commenced even before his departure for Europe. The years immediately following the assassination of Tsar Alexander II brought a wave of suppressive measures, including the banishment of liberals and suspension of magazines and journals. The 1880s lacked the intensity and the revolutionary zeal for social change which had been so deeply felt in the preceding two decades. Once more an epoch of Russian history was characterized by reaction. The "people" no longer held a magnetic attraction; the cities with their industrial developments were taking on new prominence. The intellectuals had forsaken their "messianic" aspirations and had become more concerned with the problems of the individual than with social reorganization; attracted by Tolstoy's ideals of self-perfection and nonviolence, some were following in his footsteps. Society was weary of upheaval and reacted to severe repressive measures of the government with feeble objections. It seemed that even art, the most reliable expression of social change in Russia, had exhausted its social subjects and was adopting the concept of "art for art's sake."

But not Repin. A most striking fact about him is that his opposition to tyranny remained constant: as artist and man he was able to produce his greatest artistic works during the 1880s, testifying to his talent and dedication to the suppressed. His artistic credo is fully expressed in a letter to N. I. Murashko written on November 30, 1883:

> Beauty is a matter of taste; for me she is to be found in truth. I can't ridicule lightly, nor can I give myself to spontaneous art. To paint carpets which caress the eye, to weave lace, to busy oneself with fashion, in one word, in various ways to mix God's gifts with scrambled eggs, to adapt oneself to the new spirit of the times. . . . No! I am a man of the 60's, I

am a backward person for whom the ideals of Gogol, Belinsky, Turgenev, Tolstoy and other idealists, are not as yet dead. With all my small strength, I aspire to embody my ideas in truth; contemporary life deeply affects me, it does not give me peace, it begs to be represented on canvas.[1]

Upon his return from Europe he settled with his family in Martyshkino, a country estate not far from St. Petersburg. His first project derived from an idea he had held for some time—to depict the unexpected return of a political prisoner after a long exile. The choice of such a subject within the context of the times was testimony to his Russian consciousness. Through the summer and into the fall Repin worked on *The Unexpected*, making use of his surroundings and employing members of his family as models. He was working from nature and everything seemed to delight and inspire him—the models, the room, the summer light. The first draft depicted the exile as a young woman. The second draft, however, established the exile as a male whose sudden arrival triggers a dramatic tableau.

The first to rise upon the exile's entry into the room is his mother, who at once recognizes her son; his wife, seated at the piano, turns to look at him; the little girl—evidently too young at the time of his banishment to remember her father—views him with curiosity; the boy, who is older, knows his father and reacts to his arrival with extreme joy. In the background at an open door the maid and the cook stand watching. According to one critic, Professor G. H. Hamilton, "What gives the picture true artistic quality is Repin's masterly balance of form and expression, especially in his oblique, asymmetrical composition. The right-to-left direction in space, opposed by the sharpened perspective drawing of the floorboards, is so suggestive of Degas that we can believe the lessons learned in Paris ten years before had at last come to fruition. . . . In [*The Unexpected*] tradition and innovation are marvellously combined. The picture must be regarded as the finest artistic achievement of the social point of view of the Peredvizhniki."[2]

Repin finished *The Unexpected* in St. Petersburg where it appeared at the twelfth Exhibition of the Society. Stasov was elated, writing: "I consider this painting to be one of the greatest works of the new Russian school of art. Here are depicted tragic types and scenes from contemporary life as was never done before. Look at the main character; his face and figure express energy and strength which cannot be broken by misery; more than that, his eyes and his whole face speak of a mighty intelligence of mind and thought as no artist has attempted to portray in any other painting. Look at him! He is in a coarse muzhik dress. His outward appearance is miserable. His exile has made him age ten years (he is no more than 26 or 27), and already he is grey, but nonetheless, you recognize at once that this man does not at all represent what he seems to be by outer appearances. He has some high, extraordinary quality."[3]

The conservative critics, on the other hand, attacked the Exhibition and

The Unexpected.

singled out Repin's painting for special adverse criticism. Stasov's view was supported by progressives who hailed the painting as an eloquent expression of protest against the oppressive powers of autocracy, an expression of the courage and resolute spirit of man—a singular work of the Russian intelligentsia.[4]

The Unexpected traveled through Russia with the Society's Exhibition until February 1885. Moscow eagerly awaited its arrival. Tretyakov wrote Repin: "Now it has quieted down somewhat. People, many of whom had never before been in the Gallery, swarmed to see the painting, inquiring whether Repin's painting had arrived; when they learned that it had not, they left, not having the

Detail of *The Unexpected.*

curiosity to investigate what type of a Gallery it was."[5] When the painting did finally find its place in the Tretyakov Gallery, it was Tretyakov himself who was not quite pleased with the face of the exile, suggesting to Repin that it be repainted to represent a younger man. Repin's attempt to improve the exile's face succeeded only in detracting from the painting, and the original strength of the face was irrevocably lost.[6]

Another notable work of the period was the *Dragonfly*, executed and completed by Repin in 1884. The sky covers most of the canvas. Repin's daughter Vera is perched on a wooden pole that almost seems suspended in the sky. Repin employs a color scheme of blues and light browns to give the painting an exceptional feeling of light, air, and space. The blue of her dress unites the figure with the sky.

While working on *The Unexpected* Repin was already preparing for a painting which was to assume a preeminent place in Russian art. In 1881, in Moscow, Repin had attended a concert performance of Rimsky-Korsakov's *Sweetness of Revenge*, the second movement of his second symphony, *Antar*. His friend's music evoked in him a train of images recreating the bloody events of that year which had been precipitated by the assassination of Alexander II. These in turn evoked other bloody episodes in Russian history, all of which, it seemed to him, were epitomized in Tsar Ivan the Terrible's murder of his son, the Tsarevich. Repin decided that one day he must paint the murder, and his recent viewing of the dominant blood theme in the works of West European masters strongly renewed his interest in Ivan.[7]

As soon as *The Unexpected* was completed, Repin began to rearrange the

Dragonfly (the artist's daughter Vera in Martyshkino).

furniture in his studio in preparation for his new work. With extensive effort the studio soon was transformed into a dramatic set encumbered with sixteenth-century objects which he had located and borrowed. Once again his feverish search for models began. P. P. Chistyakov, an artist friend, wrote that he had seen in Tsarskoe, where he resided at the time, an old man who would make a good model for "Ivan." Repin left at once and painted the man, P. I. Blaramberg, and upon his return to the capital asked the artist G. G. Myasoedov to serve as a model. The choice of a model for Ivan's son baffled him until he thought of young Vsevolod Garshin, the sensitive Russian writer.

Repin had first met Garshin in 1882, in the midst of a group of writers who often gathered in Repin's apartment. The Christlike humility of the man, his large, soulful eyes which bespoke an unearthly innocence, attracted Repin. "In Garshin there was something touching and appealing; he attracted me more

than anyone else in the Pleiade of young poets. The main trait in his nature was something saintly, something pure. His kind and considerate nature took suffering upon itself for the benefit of peaceful and good relationships. All his young friends loved him as an angel."[8] Though he had committed no personal misdeeds, he had a guilty conscience for the evils perpetrated by the society around him, and he suffered from a depressive mania.[9]

Garshin agreed and proved to be a perfect model. He would walk quietly into Repin's studio, his eyes often clouded with tears, take his place, and try to engage Repin in a conversation in order to hide his embarrassing, uncontrollable emotional state. Occasionally he would relate a funny story over which Repin would chuckle for days. Sometimes Repin would ask Garshin to read, and Garshin would proceed to read so rapidly that the artist would beg him to repeat.

Repin worked on the painting like one possessed. At times he was frightened of his own creation. He had sleepless nights and strange visions. He would put the painting away, behind some piece of furniture, to free himself from it for a moment, but then he would be driven back to his brushes by an irrepressible force. Thus absorbed from 1884 to 1885, he finally completed the canvas and sent it to the Thirteenth Exhibition of the Society. Awed by political considerations, Repin and the artist Kramskoy rejected one title after another until they agreed on the unassuming designation *Ivan the Terrible and his Son Ivan, 16 November 1581*.

The appearance of the painting was equivalent to a bomb exploding in a peaceful village square. Women fainted at the sight of it; people flocked to see it, debating over it in private and in public; the newspapers and journals carried on polemical discussions. The conservatives spoke against it and the progressives praised it. The painting seemed a clarion call to action, to struggle, for the sticky, warm flowing blood of Ivan's son seemed to symbolize the bloody streak of 1881. The Academy of Arts expressed its opinion through some of its professors, one of whom devoted much time to criticizing Repin's knowledge of anatomy. A reporter of the newspaper *Minuta* emphatically wrote that Repin's student had first conceived the painting, to which Repin's response was swift and peremptory: he instituted a lawsuit, forcing the paper to issue an immediate public apology. Indignant critics launched vigorous protests against those who would impugn the preeminence of Repin. Only when the public excitement had reached its peak and the painting had reached Moscow, the very ground of Ivan's bloody history, did the authorities finally take a stand. In the name of Alexander III, the mighty Over-Procurer of the Synod K. P. Pobedonostsev ordered that the painting be removed from the Exhibition and no public exhibits of the painting be made. The ban, lasting three months, was finally lifted through the intercession of the artist Bogolyubov.

In his delight over what he considered Repin's greatest painting thus far, Kramskoy issued a statement proclaiming the genius of his famous pupil, at the same time giving a vivid description of it:

What is expressed and emphatically accentuated is the incidentalness of the murder! This most phenomenal aspect, an extremely difficult one to project, is achieved by means of only two figures. The father has struck his own son in the temple with the staff! A moment, and the father cries out in horror, dashes to the son and has seized him! Squatting on the floor, he raises him upon his knees, and firmly, firmly presses with one hand the wound on the temple (but blood flows in a gush between the finger slits), and with the other hand across the waist, presses him to his breast, and firmly, firmly kisses the head of this poor son (unusually appealing), and he roars (positively roars) from horror, in the helplessness of his condition. While throwing himself upon the son, tearing at his own head, the father stains the upper half of his face with blood—a touch of Shakespearian tragicomedy. This animal shouting from horror—and the sweet, precious son, resignedly dying, with his beautiful eyes and remarkably attractive mouth, his heavy breathing, his helpless hands. Oh, my God, could one quickly, quickly help! Whose concern that on the painting there is already a whole puddle of blood in that place where the son's temple has hit the floor; whose concern that there will yet be a full basin of blood—the usual thing! A person mortally wounded will certainly lose a great deal of blood.

But how it is painted, God, how it is painted! Indeed, can you imagine a pool of blood not being noticed, not affecting you because of the frightful, highly expressive grief of the father, and his loud shriek? And in his hands his son, his son whom he has murdered. And the son cannot any longer control the pupil of his eye; he breathes heavily, feeling the grief of his father, his horror, his shriek, and he, like a baby, wishes to smile at him as if to say: "It is nothing, father, do not be afraid."[10]

Such was Kramskoy's tribute to Repin's psychological realism.

The two figures are in the exact center of the painting. They form an organic knot which is placed against the architectural background, its geometric patterns repeated in the luxurious carpets in the foreground. The dark interior takes on an appearance of a sanctuary and contributes to a religious atmosphere where a crucifixion seems to be taking place. This is enhanced by Repin's use of color and light. The crazed evil figure of Ivan is painted in dark colors, brightened only by the red of his son's blood, while his son, the youthful innocent victim, is bathed in "holy" light.

Tolstoy too visited the exhibition and was much impressed with Repin's characterization of Ivan the Terrible, who in his opinion bore a similarity to Dostoevsky's elder Karamazov. A short note to Repin spoke of the emotional effect which the painting had produced upon him and his appreciation of its mastery.[11] Tretyakov bought the two paintings, *The Unexpected* and *Ivan the Terrible and His Son Ivan*, for 21,000 rubles.[12]

While absorbed in the painting of Ivan, Repin was commissioned by the

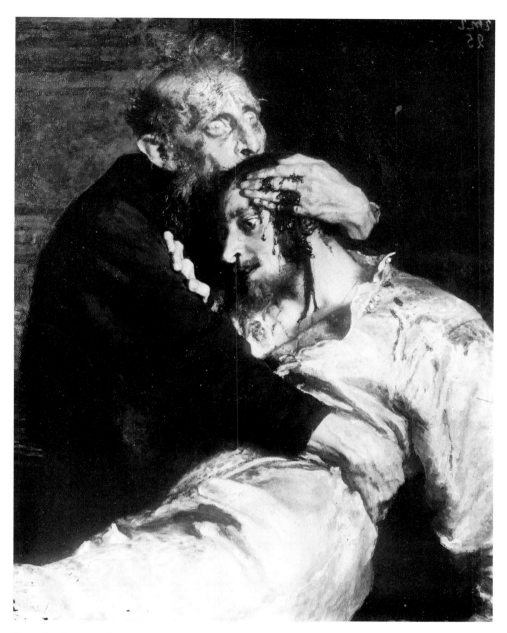

Detail of *Ivan the Terrible and His Son Ivan*.

court to depict the reception of the district foremen by Alexander III after his coronation in 1883, at which time the Tsar asked his subjects to follow the leadership of the nobility. Repin, as one of the liberal intelligentsia, considered the speech quite reactionary and consistent with other acts of oppression which he attributed to Alexander III. A refusal of the commission, obtained when his friend Bogolyubov thought he was doing Repin a good turn by recommending him to the court, was impossible, even though Repin was regarded at this time as the leading artist in Russia. His irritation with the commission grew. At first he thought he would be able to borrow some court costumes from the palace, but this was not permitted. To his dismay he discovered that he was expected to work at the palace where the strange, pompous, and unfamiliar atmosphere hindered his progress. And he was deeply irked by the necessity of placing the Tsar in the center of the painting with the muzhiks looking at him, their backs to the viewer. He worked on the canvas for almost a year, from July 1885 to June 1886, and was greatly relieved when the painting, *The Address of Alexander III to Rural Foremen*, was finally finished and delivered to the court, where it found its honored place within the palace on the banks of the Neva.

The year 1886 was a precarious period for the Society and for its founder, Kramskoy. A crisis had been precipitated by the strange new attitude on the part of this spokesman of Russian national art, the leader of revolts, the foe of academicism and autocracy. Not only did Kramskoy wish to cancel his membership in the Society, but he further urged the dissolution of the Society and a merger with the Academy, now showing works of its students in the provinces. As Kramskoy's fame grew, he had been besieged with commissions for portraits of the wealthy and mighty of Russia, commissions which he did not spurn. He disdained neither his clients' money nor their ways. Like them he was soon established in one of the most pretentious homes of St. Petersburg, dressing and fraternizing with them as well. Gradually his views on politics and art took on a conservative coloring. In July 1886 Kramskoy's friends from the Society returned to the city and persuaded him to remain a member. He was very ill and felt that his end was nearing, and as in former years his home once again became a gathering place for artists young and old.

The Fifteenth Society Exhibition in 1887 convinced Repin of Kramskoy's error of judgment. There was no justification, he felt, for the dissolution of the Society. Like the other visitors to the exhibition, Repin acclaimed Surikov's painting *Boyarina Morozova*, which became the foremost historical painting of the Russian School. Repin himself was represented by a group of portraits: *Garshin* (1884), *Belyaev* (1886), *Liszt* (1886), and *Glinka* (1887) (the latter two painted from photographs), and two other paintings—*A Walk with a Guide on the Southern Shore of the Crimea* (1887) and *The Making of a Bouquet* (1887). Also shown were Polenov's *Christ and the Sinner* and Makovsky's *On the Boulevard*. All impelled Repin to believe that this exhibition was exceptional.[13]

The Grand Duke Vladimir, president of the Academy of Art, accepted the

Society's invitation to attend the exhibition. Long an admirer of new vigorous trends in Russian art, despite his conservative position, he showed great interest in this diversified exhibit of paintings, asking questions about the artists and the workings of the organization. As the greatest possible tribute to the Society, the Grand Duke posed a question just before leaving: "When do you wish the Tsar to come, tomorrow or the day after?"

Another visitor was the young writer Anton Chekhov, who had that year published his third collection of short stories, *In the Twilight*, which was to win for him the Pushkin Prize the following year. Though only twenty-seven years old, Chekhov already held an honored place in Russian literature as master of the short story genre. He had come to St. Petersburg from his residence in Moscow to see Alexey Suvorin, critic and publisher of *The New Times*, a journal in which many of Chekhov's stories had appeared, to obtain an advance for a trip to the Don district to gather impressions of the Russian steppe (later conveyed in one of his finest stories, "The Steppe"). Chekhov attended the Academy exhibition, which he considered poor, and now found the Society's exhibition "marvellously rich."[14]

The empathy shared by the two men at their first meeting in Repin's studio might have led to more frequent contacts had not Chekhov's health forced him to live in Moscow, then Melikhovo, a small village fifty miles south of Moscow, and finally Yalta. Some three years earlier in 1884, the perplexed Chekhov noted his first symptoms of tuberculosis: "Over the last three days, for no good reason at all, blood has been coming from my throat. This flow prevents me from writing and from going to Petersburg. All this is quite unexpected. I haven't seen any white sputum for three days." But though their meetings over the following years were infrequent, Repin and Chekhov took advantage of every opportunity to see one another and to express their great esteem for each other. Three years later Chekhov would write: "If one were to speak of ranks in Russian art, then he [Tchaikovsky] occupies the second place after Leo Tolstoy who has long occupied the first place. (The third place I assign to Repin, and for myself, the ninety-eighth.)"[15]

The cultural life of the capital during this period was not static. While painting, buoyed by Surikov's *Boyarina Morozova*, was enriched, music had suffered a staggering blow with the sudden death of Borodin, a close and highly esteemed friend of Repin's, on February 15, 1887. Repin's interest in music had revived considerably when he left Moscow for St. Petersburg in 1882. Returning to his cultural home, he had taken up where he left off in his student days. With the assurance of worldly success, he began to attend concerts of the reigning celebrities, not with the shy passivity of a student, but with the critical judgment of a fellow artist in a collateral field. Music often served as the handmaiden to Repin's artistic compositions. Attending the concerts of Liszt, Tchaikovsky, Rimsky-Korsakov, Glazunov, Verdi, Berlioz, Schumann, and Borodin, and spending time at Stasov's "evenings" in the stimulating company

of the best creative minds of Russia, he acknowledged his indebtedness to them by his many portraits of the famous musicians. The portrait of Rimsky-Korsakov, showing him smoking a cigarette during a rest period, was particularly successful. With the centrifugal force of the former "Mighty Five" now broken, with Musorgsky and Borodin dead and Balakirev standing aside, a new generation of musicians was clustering about Rimsky-Korsakov, of whom one was Glazunov, enthusiastically welcomed by Stasov. Repin painted a portrait of Glazunov, and one of Cui, at whose musical "evenings" he was often present, and completed the portrait of Anton Rubinstein which he had started six years earlier.

7

The Cossacks

In 1887 Repin was an acknowledged master, enjoying wide popularity. He had loyal friends among the creative artists of Russia who admired his talent and cherished his generosity of spirit. He was an energetic person with simple and graceful manners. Though short in physical stature, he made a strong impression. Everything about him was miniature and elegant, from his small hands and feet to his classical head, framed with artistically careless, luxuriously curly hair. The lower part of his face was covered by a scanty, darkish beard, thick on the chin and on the cheeks. A bushy mustache protruded slightly forward, framing his small, well-lined mouth. The nose appeared polished, with a small hook and thin nostrils. The forehead was small with a bulge over the eyebrows. His mobile, expressive eyes drew attention.[1]

Repin had always enjoyed the stimulation of social-intellectual intercourse, and besides visiting his friends on their "evenings," he made his home a gathering place where on Thursday evenings artists, writers, and musicians enjoyed his hospitality. His wife Vera, despite her domesticity and lack of interest in intellectual pursuits, seemed to the visitors a pleasant person, but not one to engage in discussions on social or cultural subjects. A temperamental and impressionable man, Repin regretted his inability to share his thoughts with her, and was often indiscreet in his relationships with other women of various social position who served as his models. The indiscriminate choice of women with whom he had affairs made the atmosphere in the Repin household unstable. Even though Repin was moody, excitable, and restless, he seldom complained to his friends and kept the family quarrels confined to his own home, but at times Repin's irascibility erupted into an open embarrassment to his guests.

There are crisp references to his dissatisfaction with his domestic situation in some of his letters. To Tretyakov on November 4, 1883, he wrote that the family squabbles prevented him from working,[2] and to Igor Grabar several years later he bemoaned the lack of a wife capable of sharing his interests after long days at work. There seemed to have been many uneven intervals in the family's lamentable situation, with Vera, ten years younger than her husband, suffering

in silence, and Repin leading an unrestrained amorous life. Even though he felt that "a bad peace was better than a violent quarrel," his life was anything but peaceful.[3] Loving his family in his own fashion, he suffered from guilt, regretting his inability to overcome his own weaknesses. And notwithstanding his numerous infidelities, he had fits of jealousy when he observed that his young wife, small of stature and gentle of nature, attracted the attention of other men. Yet it was one such episode that he used as an excuse to effect a break from his family. When the nineteen-year-old artist V. V. Perov, son of the famous Russian painter V. G. Perov, fell in love with Vera and began to frequent their Thursdays, Repin demanded that his visits cease. In a momentous decision that life together with his wife was no longer possible, he purchased an apartment for his wife and children, depositing a large sum of money to their account. When to his chagrin he found that the freedom he longed for and now possessed weighted heavily upon him, he made another sudden decision to leave his troubles behind and go to Europe.

This was his third trip. Away from family discord, he now fully appreciated his solitude and freedom—not only the freedom of movement, but also the freedom to make his own judgments of art born from his own maturity.

In Vienna at the Belvedere he looked once more at Rubens' paintings and stood for hours in homage confessing willingly to his fallacious youthful judgment: "It seems as if I saw absolutely nothing in 1873. Yes, Rubens is the Shakespeare of painting!"[4]

Exhilaration accompanied him to Venice where he found everything new and exciting in the International Exhibition as well as in the museums. He began writing ecstatic letters from Venice about the Venetian sky, the gondolas, the people, the art! With the exception of Raphael and Michelangelo, Rome seemed to him a remnant of the once heroic city where ancient art was not enriched by new contributions. With this notable exception, his enthusiastic appraisal of European art alarmed Stasov who hastened to write a letter on June 24, 1887, to counteract the seemingly "invidious" influences of Western European art on Repin: "Rubens knows only the nobility; he is fully an artist of nobility, an artist of inventions and weighty parades. Real life (as it is to be found in Shakespeare, Lev Tolstoy, Borodin, Musorgsky, and Repin), life in its highest forms, he does not possess, not one bit of it."[5] But Stasov's interpretation did not now affect Repin's admiration for the Flemish painter's works.

Despite their disagreements on art, Repin hoped for and needed Stasov's friendship. While in Venice he wrote and asked Stasov to undertake the construction of a studio extension to his apartment. When he returned to St. Petersburg, cutting his European trip short to be present on Stasov's July 15 birthday, he found to his delight that the studio had been built according to his specifications—a luxurious and spacious atelier consisting of two sections with a high glass roof and immense windows. Grateful to Stasov for his aid and loyalty, Repin was now concerned about Tretyakov's attitude toward his separation from

his family. Knowing him to be an exemplary family man and fond of Repin's wife, he feared that his patron's relationship to him might change. These worries proved to be baseless, as Repin soon discovered, because to Tretyakov he was all-important as an artist.

In Abramtsevo, in the summer of 1878, as previously mentioned, Repin had come upon the contents of a mocking reply sent in 1676 by the Zaporozhie Cossacks to the Turkish Sultan, Mohammed IV, who had demanded their immediate surrender. He decided to do a work on the event and immediately made his first pencil drawing. In it Repin's artistic intent is already visible. The chiaroscuro in the sketch accents its circular composition. The nervous and sensitive quality of his lines, building texture on texture, juxtaposing the darkest shapes next to the lightest, give the first draft a vibrancy. Two years later, in April 1880, Repin undertook an extended trip to Zaporozhie to gather materials and sketch old Cossack types. Despite the rich amount of material he gathered, he hesitated to proceed with the painting until 1887 when Professor D. I. Evarnitsky, a noted scholar specializing in the history of the Zaporozhie Cossacks, supplied him with documentary materials, antiquities of the epoch, and materials from his own personal collection of ancient Ukrainian objects.

However, once established in his new studio he was not prepared to continue work on *The Cossacks*. Instead, a government decree aroused in him a virulent reaction, indeed, an emotional disturbance. The Ministry of Education decreed that the children of servants, waiters, cooks, laundresses, small storekeepers, and others were henceforth barred from entry into the *gymnasiums* (academic secondary schools). Commencing with Peter the Great, the history of Russian education was replete with governmental attempts to put people in school, sometimes by force, sometimes by bribes (stipends), and sometimes by threat. In the eighteenth century the population made a concerted effort to keep their children out of the schools since neither the method of instruction, reinforced by frequent corporal punishment, nor the remuneration after study secured a more advantageous position in society. Only in mid-nineteenth century did the sons of the poor, the tradespeople, and the peasants begin to aspire to academic secondary and university education. Those who had known poverty, deprivation, and discrimination soon became the antagonists of the government, the spokesmen for the lowly man, the fighters, the revolutionaries. The government knew, as all Russia knew, that the purpose of the decree in 1887 was to stop the lower classes from entry into universities by channeling them into trade schools.

Stasov spoke for the liberals in an article entitled "Can the Tsar-bell Ring Again?"[6] He affirmed that the huge bell could be restored in the same manner as similar bells were restored in Europe, to which Repin on August 1, 1887, responded in a letter:

> If first your article about the Tsar-bell seemed strange to me, having read it to the end, I was in ecstacy over the analogy which becomes so obvious in

the end. Yes, this excellent bell is silent in the world; it was damaged by the fall and cannot ring. (I can imagine how it would have "roared.") And the great Russian people is silent; it has received a knock in the face during years of serfdom, and so is silent. It is officially proclaimed that our drivers and cooks are a despicable people, that upon their children lies the curse of outcasts. And the whole people, which considers the drivers and other such already highly cultured, this whole numerous, mighty people, is silent. And it is debauched by its fall, having fallen several times from the height of free thinking to which it was raised more than once by its leaders. It has splintered and weakened. The odious, hypocritically brazen men like Katkov and Pobedonostsev try to cement the holes to show that the bell is whole and invincible. How the situation resembles Turkey, how irrepressibly our government leads us along a Turkish path.[7]

Repin understood the changing social and economic position of Russia, with "the drivers and other such already highly cultured," and knew that the cracks in the Tsar-bell were irreparable and the promulgation of the restrictive law futile.

Eight days after Repin's response to the "Cook's Children" Decree, as it came to be known, he was on his way to Yasnaya Polyana, Tolstoy's estate, evidently in need of a moral uplift. On this visit, however, Repin felt contradictory reactions to Tolstoy's preachings against "civilization" and expressed his thoughts in a letter to V. G. Chertkov, Tolstoy's friend and disciple, after his departure from Yasnaya Polyana:

Much and often do I think of Lev Nikolaevich. I recall our conversations. The influence of his strong, gifted personality is of such a nature that one definitely cannot disagree. Everything seems as irrefutable as truth itself. However, here thinking it over again, many objections come to mind, and now I constantly vacillate. At times it appears that I am right, and then later his conclusions turn out even more profound and more lasting. Principally, I cannot accept his negation of culture. It seems to me that culture is the foundation, the basis of good, and without it humanity would become contemptible and powerless, materially and morally. Great ideas are impossible without great collective effort. With his harness of rope and his wooden plough, Lev Nikolaevich seems pitiful to me. At the sight of the inmates of Yasnaya Polyana, in their black, dirty huts with roaches, without light, vegetating in the evenings near a kerosene wick, exuding only stench and soot, I was pained, and could not imagine the possibility of any bright, joyous mood in this Dante's inferno. No! Who can, let him follow the noble Prometheus! Let him bring the fire of the gods to these old, deadened creatures. They must be enlightened; they must be roused from their vegetation. To descend to this darkness for a minute and say, I am with them—is hypocrisy. To submerge with them forever—is a senseless

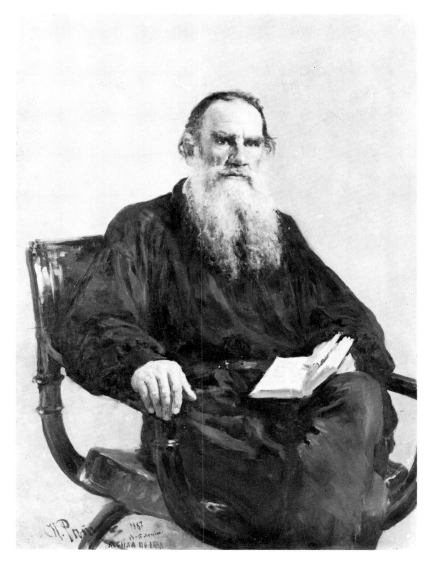

Portrait of L. N. Tolstoy in an Armchair with Book in Hand.

sacrifice. To raise them, to raise them to one's own level, to give life—this is a heroic deed![8]

This passionate outcry for the enlightment of the Russian people was not Repin's alone; it was the driving force of the intelligentsia of the sixties, the seventies, and subsequent decades, culminating in the Revolution of 1917, which produced heroic efforts and sacrificed lives in order "to raise them to one's own level."

In the course of this August week at Tolstoy's estate, Repin painted his two

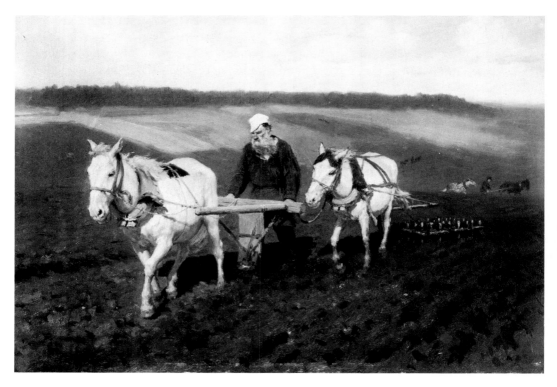

L. N. Tolstoy at the Plough.

famous studies, *Tolstoy in an Armchair with Book in Hand* and *Tolstoy at the Plough.*

Repin had asked Tolstoy's permission before departing from Yasnaya Polyana to reproduce some of the week's sketches and paintings in Russian and foreign publications. Tolstoy graciously consented, and Repin left elated. When the painting *Tolstoy at the Plough* was ready for reproduction, Countess Tolstoy, learning of it, expressed the fear that this might compromise her entire family, and made vociferous objection to the reproduction. On September 26, 1887, she dispatched the following letter to Stasov: "The news that you and Ilya Efimovich Repin intend to make a chromolithographic reproduction of Lev Nikolaevich at the plough, left a most unpleasant impression upon him and upon the whole family. Since he is not well, he has asked me to write you that nothing but discomfort can result from the reproduction of this painting, showing him in an intimate moment, sacred to himself alone. My older children were also indignant, and also requested that the picture be not reproduced, sold, or shown to the public."[9]

Other letters of this kind followed in quick succession. Repin was disturbed at the loss, both financial and moral. Chertkov, Tolstoy's confidant and Countess Tolstoy's adversary, wrote a consoling letter to Repin to which the artist replied: "You comforted me with your letter by informing me of Lev Nikolaevich's

attitude toward the interdiction of the painting. The ban did not really bother me since it is the will of the family and should be fulfilled. My indignation was aroused by Sophia Andreevna's letter in which she stated that Lev Nikolaevich gave me no verbal permission, that he does not remember giving it, and that I misunderstood him."[10]

Countess Tolstoy was anxious to underplay the "peasant" in Tolstoy, but Chertkov was standing at the opposite extreme, and Tolstoy himself, the unfortunate apex, was caught in this unholy triangle which played havoc not only with Tolstoy's private life, but with later developments in the public domain. Each constantly exerted pressure on Tolstoy to remain within his or her orbit, and few could approach the great luminary without clashing with these antagonistic personalities.

Tolstoy evidently regretted his wife's actions, for in a note to N. N. Strakhov on November 10, 1887, he wrote: "What troubles me is that because of these trifles I have brought distress to Repin whom I hold in great esteem and, like you, love dearly. Therefore, be good enough to tell him that I retract my denial and greatly regret if I caused him pain. I know he loves me as I love him, and will not be angry with me."[11] This personal intervention of Tolstoy brought the matter to a close, and the reproduction was made and widely circulated in newspapers, journals, and in single copies in Russia and abroad.

Repin took up his regular busy routine, resumed working on *The Cossacks*, writing his recollections of Kramskoy, partaking of the manifold cultural activities of the city, and supervising the work of a young artist in his studio. This was the twenty-four-year-old E. N. Zvantseva, granddaughter of the noted N. A. Polenov, who had come from Nizhny-Novgorod to St. Petersburg to study art. It was at the home of her aunt with whom she was staying, E. N. Gaevskaya, wife of a famous Petersburg attorney, that she met Repin. Impressed by her intelligence, grace, and beauty, he invited her to study at his studio. It proved to be a wrong decision, for Repin shortly became obsessed by a passionate love for her which forced him to humble and degrade himself for a long tortuous period of time. Repin followed her wherever she went, to the theater, concerts, and balls, curbing his desire to declare his passion. Zvantseva, conscious of his halting, embarrassed ways and his constant pleading gaze, was both flattered by his attention and frightened by the intensity of his feelings. Unable to control his passion, he expressed it in letters, some of which he would hand her timidly before her departure at the end of the day. "How I love you!!! My God, God: I never imagined that my feeling for you would grow to such a passion. I am beginning to be afraid for myself. Believe me, I never as yet in my life loved so deeply with such abandonment. Even my art is recessed; only you, you are every second on my mind and in my heart. Everywhere I see your image, your exquisite, ravishing look, your marvellous figure with heavenly fine graceful lines and most elegant movements! . . . Your slave, I. Repin."[12] Finally the frenzy of his pursuit compelled her to leave his studio and transfer to the studio

of Repin's friend, the artist P. P. Chistyakov. In letters that followed her in the course of the next three years, Repin spoke of his "insane love" and his desire "to be nothing more to her than her slave." The letters reveal one dominant force in his pursuit of the young woman, that of a deep physical attraction. When his crazed passion had finally died down, there remained for posterity Repin's letters and two portraits of Zvantseva, one in oil and one in watercolor.

Repin sought various means of escape from his tormenting passion. In May 1889 he went to Paris to the World Exhibition where he was later joined by Stasov. Once again he resented the Russian government's ineptness in sending works to the Exhibition of Art and Industry on the basis of one canvas per artist regardless of its artistic merit. He was, however, comforted by the uniform appreciation which the French and other West Europeans gave to Russian music at the concerts in the Trocadéro. Glazunov conducted his Second Symphony and the music of Rimsky-Korsakov, Borodin, Musorgsky, Lyadov, and Tchaikovsky were introducing to the world the beauty, vitality, and emotional appeal of Russian musical compositions.

At home governmental censorship was appearing in a still more truculent form: ironclad prohibitions against anything that might have hidden, dangerous meaning. Upon returning home from Paris, Repin was irate to learn from the Baroness Ikskul, whose portrait he had been painting, of the banning of Tolstoy's *Power of Darkness*, then in rehearsal at the Alexandrinsky Theater. Pobedonostsev persuaded the Tsar that the drama was "immoral and distasteful" and unworthy of production in any theater, public or private; thus both production of the play and sale of the work in the printed form were prohibited. Tolstoy's reaction to the ban was characteristic of him. He announced in the newspapers that anyone wishing to reprint his work need not concern himself with copyrights.

Repin's *Cossacks* still remained unfinished. His children, staying with him on and off, annoyed and provoked him, robbing him of the concentration which he found so necessary in his work. Nervous and abrupt, he would explode into fits of anger which would suddenly pass, to be followed by periods of affection; still, he had to work. He was now well-paid, a portrait often bringing 1000 rubles, but he was not financially independent.

Financial considerations brought sharply into focus his long-cherished desire for a one-man show. He felt that a propitious time for such a show would be 1891, for in that year he would be celebrating the twentieth anniversary of his First Gold Medal for *The Resurrection of Jairus' Daughter*. For the exhibition he needed one additional significant canvas never before shown publicly. Were he to complete his *Cossacks*, he could then proceed with his plans.

The preceding year, in July 1888, Repin and Evarnitsky had gone on a field trip to the Caucasus—to Tiflis, and from there by sea to Novorosiisk, Ekaterinodar, and the Pashkovskaya Stanitsa. Guided by Evarnitsky, Repin found the very types he had been seeking, but the deeper he penetrated into the heart of

The Cossacks, first sketch, 1878.

Russia, the stronger was the superstitious belief that to pose was to sell one's soul to the devil. Repin had to content himself with painting a group of lads, whom he found at a fair, waiting to be hired as hay mowers. Armed on his return trip with hundreds of drawings and sketches, he felt pleased with this adventurous and productive trip.

The year 1889, however, was a disturbing one for Repin and he could not return to the intensive work the *Cossacks* required. Not only was he engulfed in his love for Zvantseva, but he was now beginning to doubt the value of the Society of Traveling Exhibitions. The Society, it appeared, was being destroyed by its own bureaucracy and seemed no longer to represent a vital force in Russian art. He sent only one painting to the Society's Eighteenth Exhibition, the portrait of Baroness Ikskul. Aware of the social and historic effects such a move might produce, Repin nevertheless began to look upon a break as inevitable. For a time he had been noticing that some of his associates, formerly the fiery defenders of the Russian national school of art, were becoming increasingly placid while openly disapproving of what they regarded as Repin's toadying to the officials of the Academy. Alexander III expressed the desire to merge the Academy with the Society, appointing Count I. I. Tolstoy to carry out the necessary reforms with full responsibility to reorganize the rules and unite the

A *Cossack*, drawing, 1880.

two factions. Tolstoy sought Repin's involvement in the project, suggesting that the Academy arrange several exhibitions a year, and offering the exhibitors the unprecedented right to choose and judge the best paintings. In the face of the Society's disapproval, Repin accepted the invitation and resigned from the Society. In his wake followed Polenov, Kuindzhi, Myasoedov, Bogolyubov and Savitsky, also to become members of the Committee for the Reform of the Academy of Art.

The same year Repin was again traveling in search of more materials for his *Cossacks*, his itinerary indicating that he hoped to find some Cossacks who had settled in Turkey and Palestine. On his way he stopped to see Zvantseva, who was vacationing at her parents' estate near Nizhny-Novgorod, and it may well be that he used the *Cossacks* as an excuse to see her, since his painting, nearly finished, could gain little by the addition of inconsequential details, and by the time he reached Odessa he turned back, this time resolved to complete the *Cossacks*.

The motivating force which moved Repin to paint the *Cossacks* is perhaps best analyzed by him in a letter to Leskov in which he evaluates freedom as man's most precious right:

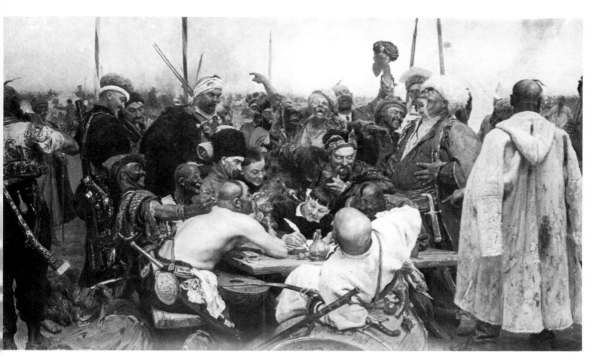

Zaporozhie Cossacks Writing a Reply to the Turkish Sultan.

I have always been interested in the communal life of citizens, in history, in art memorials, and especially in the architectural planning of cities—most often feasible only under a Republican form of government. In each trifle remaining from these epochs, one may observe an unusual spirit and energy; everything is done with talent and energy, and bears wide common, civic meaning. How much of such materials is found in Italy! To this day this tradition is preserved.

Our Zaporozhie Sech[13] delights me with this same love for freedom and heroic spirit. There the brave elements of the Russian people renounced a life of comfort and founded a community of equal members to defend the principles they cherish most—Orthodox religion and personal freedom. Today these will seem like obsolete words, but then, in those times, when thousands of Slavs were carried into slavery by the Moslems—when religion, honor and freedom were being desecrated—then, it was a highly stirring idea. And thus, this handful of daring men, of course the best of them (these were the intelligentsia, for most of them were educated), raised their spirit of mind to such an extent that they not only defended all of Europe from the rapacious Eastern plunderers, but menaced their strong civilization, laughing heartily at their Eastern arrogance.[14]

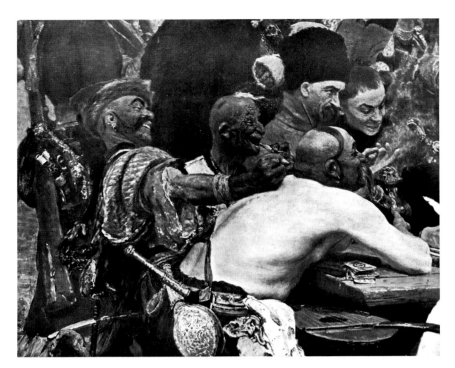

Detail of *The Cossacks*.

Repin's painting depicts the Cossacks' reply to Mohammed IV, a taunting reply from fearless, freedom-loving men, based on historic data that in 1680, when Mohammed IV lost 15,000 of his troops, who were annihilated under the walls of the Zaporozhie, he threatened to attack again with an even greater force unless the Cossacks replied at once with a surrender note. Despite the complexity of the painting each figure is clearly a Cossack type in a characteristic position, with a unique facial expression and individual gesture, giving the painting the impression of motion and sound. These elements and the detailed texture of Ukrainian dress and of authentic Ukrainian objects, together with the blending of abundant brilliant red with the greens and yellows, generate the excitement of the painting.

Repin spent the summer of 1891 at Yasnaya Polyana, his first visit with the Tolstoys after a lapse of three years. Apart from being a period of great productivity, he found in the Tolstoy household some sympathetic understanding of his own personal problems. An entry in Countess Tolstoy's diary, dated June 29, notes: "It was a beautiful, bright day, so many flowers, children were picking berries, and we were having interesting conversations; Repin evidently is a man broken by life."[15] To Tolstoy's daughter, Tatyana, Repin wrote that he dreamed of finding a female friend who would share with him all of his interests. It is thus surprising that his letters to Zvantseva do not touch upon his creative work or his intellectual preoccupations. During the three years of their

relationship Repin was intensively involved with his *Cossacks*; painted portraits of Eleonora Duse, Cui, Sechenov; spent a creative period in Yasnaya Polyana; traveled to Paris to the World Exhibition; and held his one-man show. Few of these events are reflected in his letters to Zvantseva. Even more striking is Repin's failure to share with her his life in art, since she was an aspiring artist.

His obsession with her finally subsided when in mid-November he lucidly analyzed the past. He wrote: "I ask your forgiveness, Elizaveta Nikolaevna! Thank God, the senseless, passionate feeling for you totally passed; now I look at you soberly. I see clearly that you did me no wrong, but it was I who offended you outrageously. What for, I don't know. Please forgive me, but don't think that I am trying to improve your opinion of me. Not at all. It is as if I awoke after drunkenness and saw what a foul act I performed in relation to you! I consider you a fine person who treated me with sympathy and trust and I, overcome by some absurd claim, brazenly insulted this fine person, and now I feel dejected, ugly, and am suffering from a bad conscience."[16] As if in compensation for his troublesome behavior, he offered her a choice of one of the two portraits which he had painted of her as an outright gift. Yet he continued, nevertheless, to be attracted to her, writing in August 1893: "If you knew, Elizaveta Nikolaevna, how painful my yearning for you was only two weeks ago!"[17] His exacerbating passion for Zvantseva actually ended only when another woman, the Princess M. K. Tenisheva, entered his life in 1896.

Repin found Count Lev Tolstoy transformed: Lev Nikolaevich, the peasant, was garbed in a black homespun peasant blouse, black trousers, white cap, and shoes worn over bare feet. At fifty-three years of age Tolstoy was a vigorous, energetic man in excellent health and as forceful as before in his rationalizations. Repin recollects the small river located about two versts from Yasnaya Polyana where the two men bathed. As soon as Tolstoy left his property behind, he would remove his shoes (products of his own labor), stick them in back of his leather belt, and proceed barefooted with fast, confident strides through the thorny, uneven forest path. The small, agile Repin could hardly keep up with him. Upon reaching the river, Repin, hot and breathless, would wait to cool off before plunging into the cold water. Not Tolstoy. He would impatiently undress and jump at once into the water for a brisk swim. Then he would immediately put on his clothes over his wet body, take a basket, and walk directly into the forest to pray, or perhaps to gather mushrooms. To observe Tolstoy praying was a rare privilege and on one such occasion Repin, taking advantage of the situation and having secured Tolstoy's consent, painted his celebrated work, *Tolstoy in the Forest at Prayer*.[18]

A week later Repin watched Tolstoy plow the field of a peasant widow for six hours on a hot July day. As the humanitarian pursued his deed of grace, Repin reverently followed him, making numerous sketches in his sketch book. Occasionally peasants from the Tolstoy estate would pass by, remove their caps, bow to the Count, taking no special notice of his work. But a muzhik, his wife, and

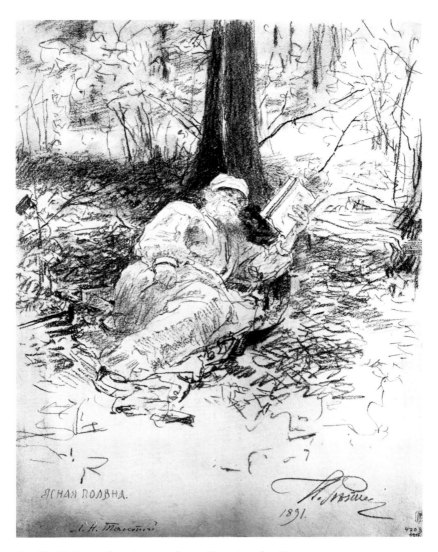

L. N. Tolstoy Resting under a Tree in the Forest.

a young girl from another district went by, stopped, and observed Tolstoy for a long time. "And strangely enough," says Repin, "never before in my life have I seen a clearer expression of irony on a plain peasant face as these passersby expressed. They finally looked at one another with a puzzled smile and went their way," perhaps mirroring Repin's own perplexity in the fact of the contradictions in Tolstoy's existence. The studies of Tolstoy executed by Repin that summer have since become the most cherished visual memorials of Tolstoy: *Tolstoy in the Forest at Prayer, Tolstoy in His Yasnaya Polyana Study under the Eaves, Tolstoy at the Plough, Tolstoy Resting under a Tree in the Forest.*[19]

The Cossacks, or as Repin titled it, *Zaporozhie Cossacks Writing a Reply to*

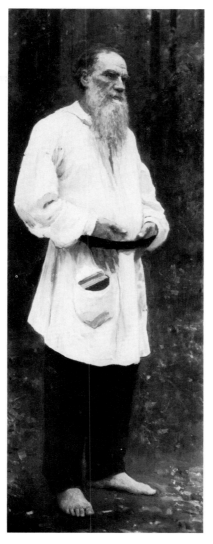

L. N. Tolstoy in the Forest at Prayer.

the Turkish Sultan, was the central work in his one-man show which opened that autumn (November 26, 1891) in the Hall of the Academy of Arts.[20] The canvas received full attention from the public and the critics. The general viewer who had come to regard Repin as the greatest Russian painter appreciated the skill with which the figures were delineated, the vivid expression of each face, and the unifying elements of the painting, the roundness of all lines provoking "the symphony of laughter." The attendance was huge and the public response favorable. The critics, on the other hand, were not in accord. Times were now different, the concept of "art for art's sake" was no longer a mere abstraction. It had become a forceful new movement in art, and Repin's real-

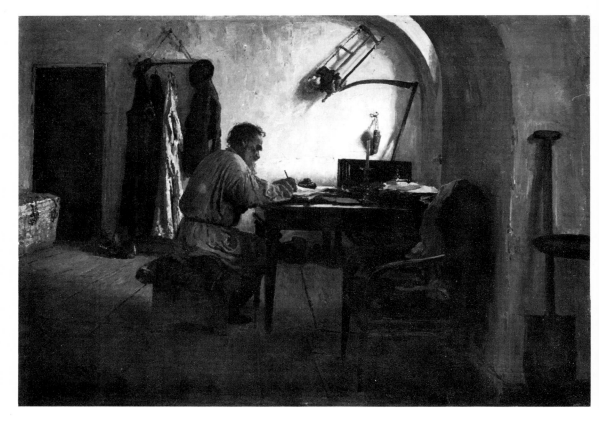

L. N. Tolstoy in His Yasnaya Polyana Study under the Eaves.

ism—"consciousness predominating over feelings"—was no longer acceptable to the avant-garde painters and critics.[21]

After the exhibition at the Academy, Repin's painting were moved to Moscow, to the Museum of History, where viewers filled the two halls in endless processions paying homage to the artist. *The Cossacks* was ultimately purchased by Alexander III for the Russian Museum, for 35,000 rubles, the largest sum ever paid an artist in Russia.

At the end of 1891, with the money received for his *Cossacks*, Repin bought a small estate, Zdravnevo, near Vitebsk. In May 1892 he and his children left St. Petersburg, impatient owners on their way to the new property. What had compelled Repin to invest most of his money in such an undertaking is difficult to assess. Perhaps he wished to identify himself with Stasov, Tretyakov, and Tolstoy, all estate owners. Or perhaps he was engaging in self-flattery—the son of a former military settler who was financially successful and able to aspire to greater material holdings. Whatever the reason, he evidently wanted a place to call his own. Zdravnevo was a picturesque holding of 291 acres, many meadows and forests, and forty head of cattle. The house, however, was dilapidated and

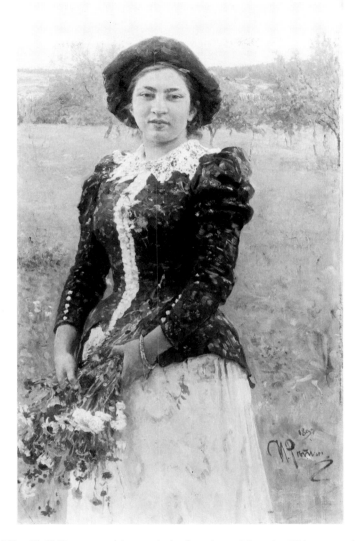

The Fall Bouquet (the artist's daughter Vera in Zdravnevo).

required extensive restoration. Repin's dream of solitude and quiet vanished as he took over much of the manual labor in the fields. Part of the property bordered on the western shore of the Dvina river and to secure it against flooding he personally constructed a rock barrier. Only toward autumn did he find time to return to painting, and then he painted an excellent outdoor portrait of his daughter Vera, calling it *Fall Bouquet* (1892).

Like *The Beggar Girl*, the figure of the young lady occupies most of the canvas and is placed against a distant horizon. The background is a field and trees in autumn colors but without any touch of red. The girl's velvet beret is

golden brown; her jacket is dark brown; and the flowers of the bouquet are mostly various shades of brown. The white of the lace and the white jabot intersecting the brown jacket lead the eye to the few white colors of the autumnal bouquet. The full white skirt with stitched garlands of flowers emphasizes the suppleness and fullness of the youthful figure but do not disturb the delicate and harmonious tonality of the painting. The picture can be considered one of Repin's finest works of the 1890s.

8

The Denouement

In the last decade of the nineteenth century the Russian autocracy was pursuing external and internal policies that led to its ultimate defeat and extinction while the Russian arts were experimenting and transforming themselves. A new art termed Decadent, Modernist, or Symbolist made a bold appearance and imprinted upon Russian culture an art that was both rich and original. The artists nullified the prevailing esthetic values and cut away from the social illusions of their predecessors. Their philosophy of individual expression—art for art's sake—was the fusion of many elements, among them the exotic, mystic, erotic, and romantic. Dmitry Merezhkovsky's essay *Reasons for the Decline of Russian Literature and Its New Trends*, which appeared in 1892, expressed a thesis in direct opposition to Belinsky's, condemning literary criticism grounded in sociology. Belinsky's esthetics, which dominated from the late fifties to that date, were attacked, and isolation from social concerns and glorification of Self marked the new art. A new poetic language came into being as well as a new galaxy of Russian poets and artists.

Alarmed over Repin's resignation from the Society and his cooperation with the merger at the Academy, Stasov in a lengthy letter to Repin explained his reasons for wishing to undertake a survey which would enable him to write on the growth of the Russian school of art, indicating its various stages of development. The "Europeanization" of Russian art had to cease. He had never denied Europe its position and achievements in the world of art, but he firmly believed that while knowing and appreciating these achievements, the Russian artist must emphasize what is most characteristic of his nation. Were Pushkin, Lermontov, Gogol, and Tolstoy less great than the famous European writers? Of course not, and yet they invariably preserved what was typical of the Russian scene, not only in subject matter but in manner of expression. What a wonderful tool was the Russian language, which expressed the very essence of Russian life. The European writers had to depend on invention, on make-believe, in order to make their language live. The speech of the Russian fictional character was marked by phrases, short sentences, sometimes by a mere preposition or exclamation.

European characters, on the other hand, used ten or twenty sentences in addressing one another. Was this true to life? Not at all.

What was true to literature was true of art, Stasov lectured in his letter of March 29, 1892. Why could not the Russian brush be as brave as the Russian pen? Why did the Russian painters still concern themselves with the accepted European plan of composition? What had they to do with European customs? Where were the painters with the courage to break with these established forms? The Russian national scene is gray, even in good weather. Let it be gray, not rosy or sunny or fancifully blue. Pushkin's literary colors, Turgenev's and Tolstoy's were robustly gray, robustly Russian. Only by yielding to these truths could Russian art achieve the preeminence of Russian literature.

Stasov wanted Repin to judge the national spirit of the rich collection of paintings at the Tretyakov Gallery and report his findings. Through this strategy he hoped not only to evaluate Russian art but also to ascertain Repin's future in relation to it. Stasov was, however, too late. He should have written his letter and given his assignment two years earlier. Repin was now going through his "art for art's sake" period and on May 7, 1892, Repin emphatically wrote to Stasov that *how* to paint was more important than *what* to paint.[1] To Stasov the assertion was tantamount to treason, but a final rift was postponed. Stasov went abroad and Repin continued to work through the summer on his estate until an accident injured his legs and left shoulder, confining him to bed. During his convalescence Stasov's letters were more welcome than ever, and Repin's replies were of a peaceful nature, eschewing art and dealing primarily with his landowning problems.

Repin's brief embracing of "art for art's sake" was verbal only, and was never reflected in his art. Form and content remained inseparable for him, as illustrated in a curious episode of January 1893 when Repin was apparently taken by the new esthetics. He was at work on a large painting of Christ in the garden of Gethsemane. He remarked to Chekhov, who was visiting at the studio, that he was unable to discover whether there was a moon in Gethsemane that night. Chekhov volunteered to make inquiries and inform Repin of his findings. On January 23 Chekhov wrote:

> I am sending you my hospital story ["Ward #6"] of which I spoke to you. Concerning the question was there a moon in Gethsemane Garden, I consulted a young priest-theologian who had studied ancient Hebrew literature and such subjects. Three days ago I had a conversation with him and he referred me to Genesis, Chapter XI, as the most significant literary source, and today I received a letter from him which I am enclosing. It has two or three references which you may find useful. The writer of the letter is a scholar and a sensible man. If he cannot answer this question then it could mean that other theologians cannot answer it either. As for astronomers, it is doubtful that they could tell you anything definite about it. At

any rate, I think it is safe to assume that there was a moon. I can see your painting very clearly in all details. This means it made a great impression upon me. And you were saying that it was a boring subject.[2]

Repin's reply betrays his enduring commitment to subject in art.

How very grateful I am to you for your "Ward #6." What frightful impressions this work produces! It is simply incomprehensible how out of such a simple, uncomplicated story, even poor in content, emerges at the end such an irresistible, profound and colossal idea of humanity!! But no, it is not for me to evaluate this marvelous piece. Thank you, thank you! What a powerful writer you are! May God give you health so that you can make us happy again with another work like this. This is truly a work of literature! Oh, let me also thank you for your troubles for the moon at Easter. I already found out. It was very simple. It was suggested that I look it up in the Jewish Easter calendar, and there I found out that their Easter is always at full moon. But these are mere trifles in comparison to "Ward #6."[3]

With the coming of winter Repin was once again an active participant in the affairs of the capital and of his nation. On February 3, 1893, Antokolsky's one-man show at the Academy of Art provoked a public controversy which profoundly disturbed Repin. Antokolsky was a sculptor and a Jew, and although he was converted to Christianity, on the occasion of his exhibition he was vilified as a Jew. Five years earlier, in 1878, at the Paris World Exhibition Antokolsky was awarded the First Prize for his sculpture *Christ before the People*, and he received the Legion of Honor; the Paris Academy of Art and the Academy of Art in Urbino, Italy, made him a member. When his sculpture of Christ appeared in St. Petersburg the critics Suvorin and V. P. Burenin led the press campaign with their maledictions and antisemitic invectives. In 1888 the Moscow municipal government commissioned Antokolsky to execute a monument to Catherine II; Burenin, in answer to Stasov's praise of Antokolsky's sculptures and of the forthcoming commission, then gave vent to his antisemitic prejudices, even accusing Stasov of Jewish origin. Now, five years later, the press carried the same sort of polemics.

Repin and Stasov were indignant at the malevolence of the attacks, as were most of the creative artists of the day. They welcomed Stasov's article accusing Suvorin and Burenin of ignorance and intolerance, likening them to bedbugs whose bite might not be dangerous but whose odor was obnoxious.[4] Repin, whose long friendship with Antokolsky dated to their student days, shared Stasov's sentiments and complimented him for the article, adding that "the snakes would now have to hide again in their crevices."[5]

One of Repin's interests at this time was an exhibit which was being assembled for the 1893 Chicago World Fair. For the first time Russian women were to have their own show. Biographies and works of Russia's outstanding women were being prepared under the patronage of a Russian committee which in-

cluded the Baroness Ikskul and Stasov's wife. Isabel Hapgood, a friend of the Stasovs and translator of Tolstoy, Turgenev, Dostoevsky, and Gorky, was the American representative assisting in the project. Repin served as a consultant, giving much time and energy in an attempt to present to the world the best samples of the intellectual accomplishments of Russian women.

While in Europe in the winter of 1893–1894 Repin provided the *Theatrical Paper* (Teatralnaya gazeta) with his *Letters on Art*. In his very first letter he affirmed himself a proponent of the doctrine of art for art's sake:

> I will speak only about art, and even only about art for art's sake, because, I must confess, only it by itself holds my interest now. No best intentions of a painter can make me stop before his poorly painted canvas. To me such a painter is the more repugnant for having undertaken a task in which he is not competent, and therefore he behaves like a charlatan in an unfamiliar realm, exploiting the ignorance of the spectator. And again I must confess: any useless trifle painted artistically with delicate perception, with refinement, with passionate dedication delights me utterly and I cannot cease to admire it, be it a vase, a house, a bell tower, a Polish Roman Catholic church, a screen, a portrait, a drama, an idyll.[6]

It is difficult to equate a church structure with a "trifle" but nonetheless his enthusiastic enumeration of the "trifles" served to accentuate his newfound convictions. And again that year, soon after the death of Nikolay Ge, Repin once more publicly announced that "in truth, the artist is obliged to study art for art's sake, first and foremost."[7] His attraction to this doctrine lasted from 1894 to 1898, and was marked by a production of inferior works. One can contrast his major canvases—*Volga Boatmen, Religious Procession, The Cossacks*—with the later *Marriage Ceremony* (1894), *The Meeting of Dante with Beatrice* (1896), and *Gethsemane Night* (1896) to be convinced that Repin painted masterfully only when he was committed to both form *and* content. His brief dalliance with the new esthetics was a concession to the times. His art grew out of his early experience, his temperament, his social and political orientation as a liberal democrat. He was able to paint well only that which reflected characteristic national traits of the Russian people: their will to endure, their struggle, goodness, aspirations for justice, freedom, and truth. Esthetics divorced from Russian life could not supersede his consciousness and ultimately Repin remained the practitioner of realistic art.

In May 1894, after a busy winter, he was back at his estate. To his amazement the land promised an abundant harvest, and he kept busy with transactions with peasants who came to buy grain, produce, and cattle. Although the estate was in better order, Repin having spent a huge sum of money for its improvements the preceding summer, it still left him unsatisfied. He now proceeded to build an expensive tower over the main house; when completed, it neither harmonized with the surroundings nor was architecturally suitable to the

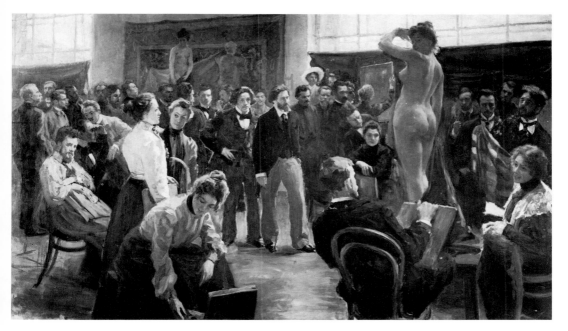

Placing of a Model in Repin's Studio. A Collective Work of Repin and His Students in Repin's Studio at the Academy of Art.

building. This fantastic venture was inspired apparently by Henrik Ibsen's *The Master Builder*, which had appeared in 1892. Perhaps for Repin his tower—as he put it, a tower à la Solness—represented his success and peace of mind: his domestic situation had improved, with his wife, Vera, now running the household at Zdravnevo through the intercession of the children.

When I. I. Tolstoy was promoted from secretary to vice-president of the Academy in 1893, he accepted the post with the understanding that he was to have full freedom in the proposed reorganization. His first official act was to offer a position as professor to Repin—which was promptly accepted. Replying to Stasov's criticism of his formal association with the Academy, Repin simply inquired, where else could young Russian artists study? He felt that he would be working in the best interests of the nation, particularly in light of recent changes in the Academy. The reforms of 1893 separated the Higher Art School from the course of the Academy, making it, in effect, a graduate school. After two years of study at the Academy, a student could apply for admission to the Higher Art School's various ateliers. It was here that Repin was to direct the historical art studio. Among other directors, all of them well-known artists, were V. E. Makovsky, in charge of the genre studio; A. D. Kivshenko, battle-painting; A. I. Kuindzhi and I. I. Shishkin, the landscape studios.[8]

In 1894 the Academy furnished Repin with comfortable living quarters and a newly built special studio. Workshop directors were free to determine their own pedagogical methodology according to their own esthetic and educational be-

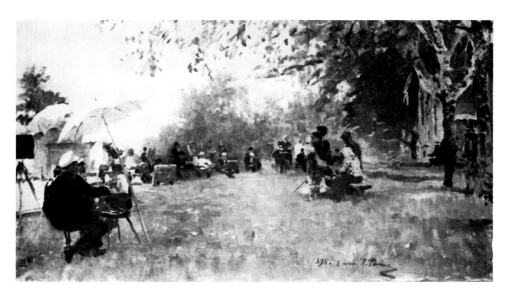

The Academy Dacha.

liefs. And students, regardless of their official appointment to one studio, were free to move from one workshop to another. Thus there were often as many genre students in Repin's studio as there were in Makovsky's. Repin permitted his students full freedom of expression. Not a strict pedagogue, Repin did not follow a definite course of instruction. Whenever he wished to make a specific point he would illustrate by visual demonstration. Having worked hard all his life, he kept his students working at an accelerated rhythm. While permitting self-expression, he nonetheless insisted that the students master drawing, visit museums, and copy from the old masters. To bring them in close contact with current events as they existed outside of the Academy, he instituted weekly meetings "at tea" to which many prominent men from the various branches of the arts were invited. In general, life was easier for his students than it had been for him, and Repin rejoiced in this fact. His famous name attracted numerous requests from students and often there were as many as seventy working in the atelier under his direction. Numerous testimonials indicate the inspirational nature of his instruction, as well as his often impulsive, emotional, and sometimes highly uneven approach to both teaching and students.[9]

This temperamental impulsiveness appears also to have been a characteristic of his personal relationship with his wife and children. Vera Alexeevna (1855–1918) was a student at the Marlinsky Institute when at sixteen, before completing her course of study, she married the artist. Scant remarks in the literature refer to her as a woman of "childish simplicity," "sympathetic and appealing," who "lived in the shadow of Repin," and who "gave the impression of hidden suffering." She meekly accepted Repin's idiosyncracies, of which two examples are typical. When their son Yury was four years of age, the father had the boy's

head shaven, leaving the long forelock of the Cossack fashion, which could be grabbed and pulled, bringing the child, no doubt, considerable physical and emotional discomfort. And she accepted Repin's fetish for sleeping with windows wide open in all seasons. He compelled his family to sleep in sleeping bags on the balcony or in their beds set by the window, and the winter mornings would find them covered in frost or snow. *Rest* (1882) was the last portrait Repin painted of his wife. For reasons that remain unclear he separated from her in 1887, reunited with her in 1894, and finally left her in 1900.

Following the first separation in 1887, ten-year-old Yury and seven-year-old Tanya went to live with their mother, while the two older daughters remained with Repin. His attitude toward them is suggested in his letters of the period to Zvantseva. "Nadya became ill while visiting her mother and remained there. Vera is afraid to sleep alone here at night and is also remaining there. In the evenings and at night I am completely alone." And again: "Now I am altogether alone. The children left for the dacha. All four of them spent two nights with me. We visited the Zoological Garden. We had a good time." And: "I formed some sort of friendship with Nadya. This daughter I loved less than my other children (not considering her to be mine), she being less able generally. But at the slightest sign of affection—old fellows melt."[10]

This first dissolution of the family lasted seven years. Now in 1894 his wife was the mistress of his household at the Academy apartment, but the harm done to his children appears to have been irreparable.[11] Although Repin loved his children and gave them much of his time, they were victims of his volatile and alternating nature. He missed them when they were apart but could not establish a close relationship when they were together. He often subjugated them to reprimand, insult, and abuse even in the presence of strangers. Generous with others, his frugality at home provoked petty squabbles. He demanded that his children live according to his own personal regimen and exploded in fits of anger when the patterns of behavior he set for them were not observed. In fact, he judged all four of his children as failures.

Vera, his oldest child, was his favorite. Not pretty, she compensated in energy and initiative. Being aggressive and knowing how to secure the most for herself from her father, who supported her education and travels abroad, she attempted to train in various fields hoping to make a career as actress, singer, artist. She failed in all and remained a superficial, self-centered person to the end of her life. Nadya, his second daughter, born in Paris and nicknamed "The Parisian," was least liked by her father. Sickly and a poor student with limited aptitudes, she managed to complete a medical assistant's course. Her behavior was often strange and erratic and was later diagnosed as schizophrenic. The youngest daughter, Tanya, was married and divorced. She and her children lived in the house in Zdravnevo, which was converted into a school, long after Repin abandoned it, and upon Repin's death she came to his home to secure her part of her father's estate after which she went abroad.

Yury, Repin's only son, was endowed with modest intellect and succeeded with time in becoming an artist, not of his own choice but because his father observed his ability to draw and strongly encouraged him to study art. Yury lived outside of his father's brilliant circle of friends and derived little benefit from the intellectual community. In the hope of enlarging his son's vision of the world and art, Repin took him in 1893 on an extended trip to Europe, and a year later Yury was studying art under his father's tutelage. At twenty, Yury was tall and good looking, but the most characteristic aspect of his personality was a complete absence of self-confidence. His father summed up his son's achievements with habitual blunt observation: "He fails in everything, he can't succeed, he is in a minor key." Yury studied at the Academy School from 1899 until 1905, striving throughout the period to be financially independent of his father. His one major achievement was the Gold Medal for his painting *Peter I in the Poltava Battle*, awarded him at the Munich International Art Exhibition of 1910.[12]

In 1897 Tretyakov commissioned Repin to paint Chekhov's portrait for his gallery. Chekhov expressed his willingness to sit for Repin, writing from Melikhovo to a friend: "About February 4 or 5 I will be free and will come for a short while to Moscow. I'll also be in Petersburg but not before March. Repin and I have friendly relations and correspond from time to time. I am quite ready to pose for him as much as he wishes. For this I am ready to forsake all my affairs and pawn my wife and children."[13] Regrettably, Repin never did paint Chekhov. Pressed with his own affairs, he recommended his student, I. E. Braz, who painted Chekhov twice but without success. Later that same year Chekhov sent Repin his story "My Life" and his play *The Sea Gull*. Repin responded:

> Thank you, Anton Pavlovich, for *The Sea Gull*, but I must say she is not deserving of the highest admiration in your art. "My Life" is what touched me and made a profound impression. What simplicity, strength, and the unexpected: this gray everyday tone, this prosaic approach to life are given in such a new, appealing light, that the whole story comes close to heart. The characters become like one's own and you pity them to tears. And how new your style is! How original! And what a language! Biblical! *The Sea Gull* did not appeal to me. You will forgive me for saying it, but I respect and love you to such a degree that I cannot be hypocritical. There are many spots which are boresome on the stage. I like the decadent scene and the quarrel between mother and son. Excuse my frankness. In this case I don't give my opinion special import, many don't even share it.[14]

Repin's perception of *The Sea Gull* was acute. He was one of the early few to recognize the merit of "the decadent scene," the play within the play, and to understand why the play was removed from repertory at the Alexandrinsky Theater in St. Petersburg.

Though Repin did not paint Chekhov's portrait, he did make a drawing some

years later for the jacket of a French edition of Chekhov's *Muzhiki*. Chekhov felt honored, and wrote: "To be illustrated by Repin is an unexpected honor, one for which I did not even dare to dream. To receive the original would be most gratifying. Tell Ilya Efimovich I am awaiting it impatiently, and he can no longer change his mind since I have already willed the original to the city of Taganrog where I was born."[15] Having received the original, Chekhov sent it on to Taganrog with instructions: "I am sending a few books for the Library, in one of which, namely *Lac Léman*, you will find enclosed a drawing by Repin, an original. This was drawn by Repin for the French edition of *Les Moujiks*, i.e., from my *Muzhiki*. See that the original drawing is safely hidden and preserved, or it should be framed under glass and hung."[16] Later that month Repin wrote to Chekhov: "I am very happy that my illustration to *Muzhiki* adorns to a small degree the dust-wrapper of the French edition of your excellent book translated by D. Roche."[17]

It was normally Repin's custom to spend summers in Zdravnevo, making only an occasional short trip to visit with friends. In the summer of 1898, however, he journeyed to Palestine, though subsequently he concealed all information concerning the trip even in his later years when biblical themes were the center of his attention. At the end of August 1898 he was back in St. Petersburg ready to resume his duties at the Academy of Art.

On September 13, Sergey Diaghilev, one of the leaders of the modernist movement in the Russian arts, visited Repin and invited him to participate in the new artistic group gathering around the *World of Art*.[18]

In France, Repin observed that Impressionism was on the wane and Postimpressionism was supplanting it; in Russia too he saw a new group of artists replacing the Peredvizhniki. This new group was inspired by the idea that each artist should work independently in his own individual style in any media, giving himself to the form of beauty. Sponsored by Mamontov, who built himself a private theater in Moscow where original and beautiful stage designs were created for theatrical and operatic productions, and guided by Sergey Diaghilev, a man of brilliance and impeccable taste, the new artistic generation of the *fin de siècle* was contributing significantly to the dimensions of Russian art.

Repin accepted Diaghilev's invitation and during the following year worked with the magazine in preparing an exhibition of Russian and foreign artists which was held in 1899. Three hundred and twenty-two items were shown, of which eighty-three were canvases by Russian artists. Among the foreign exhibitors were Degas, Monet, Puvis de Chavannes, Whistler, Lenbach, Böcklin, Aman-Jean, and Conder. Among the Russian artists were Bakst, Benois, Apollonary Vasnetsov, Golovin, Korovin, Levitan, Malyavin, Nesterov, Repin, Somov, Serov, and Polenov.

Repin's interest and efforts on behalf of the *World of Art* avant-garde exhibit contrast strikingly with his dedication to an exhibition he had sponsored two

years earlier. At that time he had devoted all his energy, spending months on arrangements, for an exhibition having nothing to do with *World of Art* esthetics. The exhibition, which opened at the Society for the Advancement of Art in St. Petersburg in December 1896, and which remained open until the middle of January 1897, was entitled by Repin "The Exhibition of Creative Art (Studies) of Russian and Foreign Artists and Students." The major Russian contributors were A. Vasnetsov, V. Vasnetsov, Myasoedov, L. Pasternak, and Repin. There were only two foreign exhibitors: Pradilla and Tiepolo.

In 1896, despite the new trends in art and the general contempt for thematic paintings, Repin had worked on *The Duel*. It enjoyed success at the Venice Exhibition that year, was purchased by an Italian, and few Russians had the chance to view it thereafter. Before leaving Russia, however, *The Duel* was shown at the Exhibition of Creative Art and had a special appeal to Tolstoy for its theme of forgiveness. Igor Grabar, who had seen it in Venice, described its artistic attributes as follows: "The action takes place early morning at sunrise, at the edge of a forest. An orange ray bursts through the trees and gilds its trunks, some foliage, the second standing in the interior at the left, and the grass near him, leaving the whole group around the wounded man in the shadow. The effect of the sun's ray was so successfully rendered, that the Italian artists spoke long after of 'the Repin light,' 'il luce di Repin.' Indeed, that extraordinary feeling of nature which Repin expressed in *The Duel* muffles all the 'buts.' "[19]

Repin collaborated with the *World of Art* for less than one year. He severed his connection when the journal printed harsh criticism of the Society and some of its representative artists. These were the illustrious and honored artists of the seventies and eighties: Shishkin, Vasiliev, Kuindzhi, Levitan, Vereshchagin, Surikov, and others. Shishkin painted the Russian forest reflecting peace and strength; Vasiliev, in the brief span of his life, chose the turbulent moments in nature; Kuindzhi omitted detail but added grandeur through color to his paintings; and Levitan endowed his landscapes with a lyric, poetic quality. Vereshchagin, the most traveled Russian artist, painted what he himself had experienced in warfare and became the recognized master of the battle scene. Surikov, of Siberian Cossack origin, painted in the 1880s two major canvases on historic themes of seventeenth-century Russia, *The Morning of the Execution of the Streltsy* (1881) and *Boyarina Morozova* (1887). The authenticity and color of costumes and background in both form an original multicolor pattern uniquely Russian. Based largely on these two canvases and other historical paintings which followed, Surikov gained fame as Russia's great historical painter. Repin characterized his artistic nature thus: "If a comparison is at all necessary, then Surikov should be compared with Dostoevsky, not Tolstoy. He has the same passionate temperament, the same ugliness of form at times, the same cogency, originality, impulsiveness and a gripping chorus of semi-mystical motifs and images."[20]

Now that Stasov saw Repin once again on the path of "truth," a reunion of

the two friends was possible. Six years after their rift had begun they met on April 10, 1899, at Stasov's home with embraces and tears. Repin did not wait long to assure his friend that he was indeed the Repin whom Stasov knew. In a letter dated July 27, 1899, he wrote:

> About myself I must repeat: I am the same as I have always been. Despite the many people, following your example, who either buried me or resurrected me, accused me of all sorts of evolutions or of apostasy or of repentance, I can't make sense of all this attentive research into my personality. As in my early youth, I still love the universe, love truth, love goodness and beauty as the most precious gifts of life and especially love art! I love art more than virtue, more than people, more than family, more than friends, more than any happiness or joy of life. I love it secretly, jealously as an old drunkard—incurably.[21]

In the first years of the new century Russia was thrown into chaos. When Tsar Nicholas II had been enthroned in 1894 the Russian intelligentsia continued its independent course with no illusions that the ideals it so long cherished would now be realized in a government capable of bringing justice to the Russian people. But the government could no longer control events through imprisonment, banishment, and execution. In 1901 out of the populist movement a new party came into being, the Socialist Revolutionary Party, which considered the peasantry and the peasant commune as central in the coming revolution. The party was commonly known as the Eser Party, deriving from the two initials sounded in Russian. The extreme wing of the Eser fought the government with acts of terror, and in rapid succession capped its anarchistic efforts with the assassination of the Minister of the Interior in 1902 followed two years later by that of the new Minister of the Interior, V. K. Pleve. Then in 1905 they murdered the Tsar's uncle, the Grand Duke. Mass executions were in progress as the intelligentsia watched with intensity the tragic and disastrous war with Japan, the traumatic events of "Bloody Sunday,"[22] and the coming of the first Revolution.

In March 1905 Repin made a special trip to St. Petersburg to add his signature to a proclamation signed by 113 artists demanding immediate changes in the judicial and administrative governmental structure through elected representation from the whole Russian people. A few months later, in May of the same year, responding to the shocking news of the annihilation of the Russian Baltic Fleet by the Japanese in the Strait of Tsushima, Repin wrote to the physiologist I. P. Tarkhanov: "What times! All seems dark and the nights seem tortuously endless. Depressing thoughts, dismal mood. And who is responsible for all this?" Repin answers his own question by placing the guilt upon the Tsar and coins a nickname for him: "Vysokoderzhimordya," the "highholdingsnout."[23]

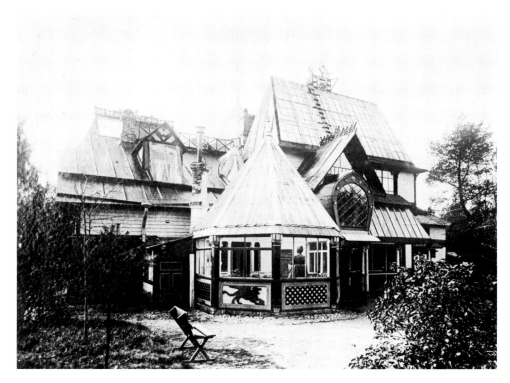

Photograph, Penaty, Kuokkala, Finland.

Repin's artistic and personal life had also changed with the beginning of the new century, and his last thirty years (1900–1930), which saw the decline of his art, may be divided into two periods: the first fourteen years spent in union with his common-law wife, and the remainder of his years spent in self-imposed exile abroad.

In the winter of 1899–1900 his Academy studio was destroyed by fire and within the year his interest in teaching began to lessen.[24] But the catalyst for a sudden and new turn in his life was a woman he met accidentally in Paris in 1900, where he and Stasov were attending the International Exhibition.

Natalya Nordman was a writer whose works appeared under the pseudonym Severova. She was a cultured person of the privileged class, versed in music, architecture, and painting; she spoke three foreign languages; she professed to be on the side of the oppressed. Her figure was buxom and her rosy face was framed with luxurious light brown hair. She was almost twenty years younger than Repin, but represented to him that ideal woman he had so long dreamed of meeting, about whom years earlier he had written to T. L. Tolstoy: "I dream that at one time I will finally meet such a woman with whom I shall fall in love for the rest of my life, gloriously, fully."[25] Repin deserted his wife and children, and for fourteen years lived with Nordman in her home, Penaty, in Kuokkala, Finland, where he remained until his death.

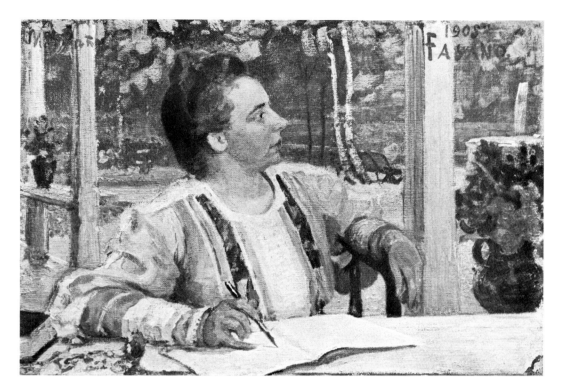

Portrait of N. B. Nordman-Severova.

On summer vacation in Fasano, Italy, in 1901 Repin painted one of his
many portraits of Nordman. The bright colors applied over a rough canvas and
the disposition of his brush strokes create a texture akin to tapestry. The garden,
the background of the painting, is done in an impressionistic style, but the
figure and the foreground are painted in a manner almost realistic. The trunks
of the trees repeat the vertical linear patterns of the dress and the pillars of the
terrace, giving the painting balance.

In Penaty, one year after their conjugal life began, Nordman burst forth with
a series of projects exhibiting energy, initiative, and industry. She compiled a
bibliography of reviews of Repin's art and arranged an album of newspaper
clippings about each of his canvases. She initiated the famous Wednesdays at
Penaty where Repin served as the centripetal force for the famed intellectuals of
Russia. In the same year she published a story illustrated by Repin. And when
Repin was about to begin *The State Council in Session*, she assisted him with
advice in solving many problems which he was to encounter.

Repin's great talent for portraiture was to have brilliant expression in a com-
missioned painting, *The State Council in Session on May 7, 1901*, marking the
first centenary of its organization by Alexander I in 1801. Finding himself once
again confronted with the unsavory task of painting the very monarchical offi-
cials whom he so deeply abhorred, he nonetheless accepted the commission on

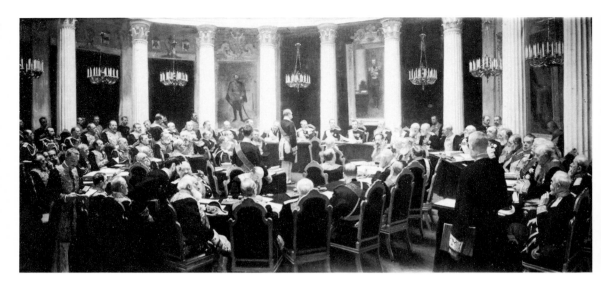

The State Council in Session on May 7, 1901.

the condition that he be guaranteed permission to be present at Council sessions to observe its seventy officials. Significantly, Repin enjoyed both official and public favor. By the directive of the Tsar the members of the Council came to sit for Repin in their customary places in the Council Chamber, individually or in small groups. Repin filled two albums with sketches, catching the most characteristic traits of the mighty personages, and proceeded to work on the major task, to harmonize the color scheme of the predominantly red chamber with the clashing hues of the order on the members' uniforms.[26]

Relying more on the use of color than line, in two or three sittings Repin executed studies with deep psychological insight. (Twenty-two studies were exhibited at the Thirty-Second Society Exhibition in 1904 and sixteen studies were shown at the Thirty-Fourth Exhibition in 1906.) Two portraits in this group are perhaps the finest in the gallery of Repin portraiture; that of the Supreme Prosecutor of the Holy Synod, Pobedonostsev, seen in full view, sitting at the table with hands folded at chest bearing an expression of hypocritical saintliness, and that of Count A. P. Ignatiev, showing his head at a sharp turn while his huge body remains motionless. *The State Council in Session,* completed in December 1903, had a spirited reception from the public and critics, and more brilliant canvases were expected from the venerated painter.

For Russian artists the year 1904 was memorable not only because of various political happenings, but also for the misfortune they suffered in connection with the International Art Exhibition in St. Louis, Missouri, that year. The Russian government, concerned with serious internal problems, refused to subsidize the costs of shipment of 800 canvases to St. Louis and delegated a certain Mr. Grunwaldt, the fur supplier to the court, to take charge. When the exhibition closed, the entrepreneur, using the excuse of the need to meet unconscion-

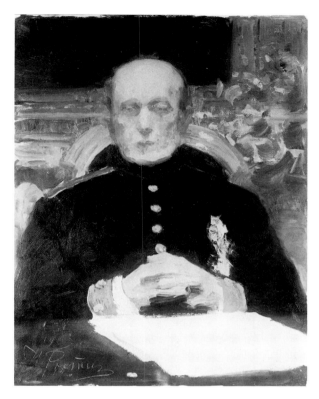

Portrait study of K. P. Pobedonostsev.

able American duty charges on the works of art, sold all the canvases. Some were sold in St. Louis, others in New York and Canada, and the rest in Argentina.[27] The artists, victims of the swindle, appealed to the Tsar to no avail.

This bitter experience colored Repin's attitude toward America and he was reluctant thereafter to accept invitations to visit the United States and to exhibit his art there. He wrote to an American art critic, William Peckham, in 1913: "Several years ago many Russian artists were totally ravaged by the sale of their paintings to cover duty costs. (I myself lost a painting valued over 3000 rubles.) After such a lesson I promised myself never to enter into a relationship with Americans in anything which is associated with art and artists."[28] The lost painting was Repin's portrait of E. N. Korevo, done in 1900 and entitled *Portrait of Madame K.* The portrait of this beautiful woman was exhibited at the Twenty-Ninth Society Exhibition in 1901. It produced a sensation in St. Petersburg because Petersburg society recognized the lady, "Madame K.," as being the illegitimate daughter of Grand Duke Nikolay Nikolaevich and thus the granddaughter of Nicholas I. Despite Repin's resolve not to enter into association with America and Americans, an Ilya Repin Exhibition was held in New York City in 1921.[29]

The Repin memorial literature contains few statements in defense of Nord-

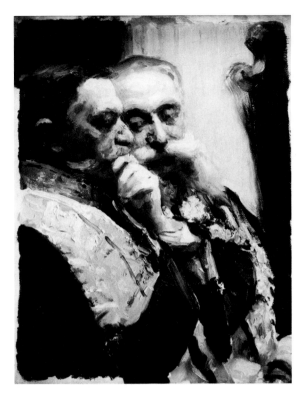

Portrait study of I. L. Goremykin and N. N. Gerard.

man's role in Repin's life. However, the Russian writer Korney Chukovsky, Repin's neighbor in Kuokkala, had the opportunity to observe at close hand their life together from 1907 to 1910, and his testament brings a certain balance in the appraisal of Nordman.

An impulsive, domineering woman with independent views and diversified interests, Nordman filled Repin's life with a myriad of trifling details. She introduced a peculiar regimen into their days. Visitors arriving at Penaty were met by a placard directing them, "Hit the gong, come in, and disrobe in the anteroom." Inside they were met by a second notice: "Proceed straight ahead." In evidence of her freedom from social prejudices, Nordman seated her servants at the dinner table along with her most honored guests, to the considerable embarrassment of the servants. The dinner table was built with a revolving tier enabling guests to serve themselves, and each guest was assigned an individual compartment in which to place his soiled dishes. Dinner was preceded by "rhythmic dances" required of everyone present to the accompaniment of music from a small phonograph. Gracing the dining room wall was a sign which read: "Equality and Self-Help." Since Nordman was a strict vegetarian—she wrote a slim book for the hungry peasants suggesting ways to prepare tasty meals from dried grass—the guests often were inclined to consume meat sandwiches at the

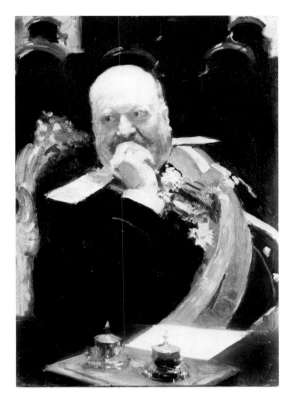

Portrait study of A. P. Ignatiev.

railway station soon after their departure from Penaty, an hour's ride to St. Petersburg.

Sundays at Penaty were given to public lectures on various subjects. About forty persons of differing backgrounds—clerks, cooks, farmers—would usually fill a large room and listen attentively to the lectures.[30] On one occasion Nordman was guest speaker on the subject of cooperatives, a favorite theme of hers. At one point she issued a notice which read: "A Peoples Cooperative House was acquired for all nationalities. The aim of the house: 1) Education (lectures, readings, library); 2) To provide an opportunity to form a cooperative; 3) To give the working population useful entertainment—lawn tennis, iced hills, dancing, dramatic presentations, choral singing; 4) And comforts of life—Turkish baths, bath house, dispensary, first aid, kindergarten, pre-kindergarten and so forth."[31]

Nordman had many idiosyncracies. Her impractical projects were no less fantastic than the peasant cookbook recipes calling for hay (which was plentiful) and rare fruits (out of reach for the poor). The bizarre customs at Penaty provided visitors with much material for extensive banter and numerous jokes.

Observing her idiosyncracies, Chukovsky labeled her a "sectarian," who pursues one or another belief with religious fervor. He also bears witness to the fact of Repin's contentment and even happiness. "In those years, 1907 through

1910, she and Repin were inseparable: the artist spent all his leisure time with her; painted and drew her portraits; spoke rapturously of her talents; and generally, as the saying goes, was crazy about her. I don't remember one occasion when he went to a concert or to visit without her. She accompanied him to Yasnaya Polyana to Tolstoy, and to Moscow to Surikov, Ostroukhov, Vasnetsov, and to other of his close friends."[32]

Chukovsky justifies Repin's admiration for Nordman's energy and drive by contrasting her intellectual interests and industriousness with Repin's own family's lack of culture and parasitical existence. Indeed, as late as June 1905 Repin wrote Evarnitsky: "Vera, Nadya, and their mother left for the Crimea to improve their health on the advice of their physician. All these persons have one source of income—my labor." And to the same correspondent he wrote in 1909: "My family lives in St. Petersburg. The older daughters are sick, they are all sick."[33]

He took Nordman with him to Yasnaya Polyana where Repin again tried to capture the robust charm of Tolstoy, his favorite model, during succeeding visits in 1907 and 1908. Sixteen years older than Repin, the spry philosopher was still executing difficult jumps over brooks on horseback, leading an energetic and vigorous life. One can only wonder what the author of *The Kreutzer Sonata* might have thought of the mercurial Nordman and Repin's relationship with her. Whatever the case, Tolstoy's dynamism eluded Repin's brush. A letter to his sister-in-law, T. A. Kuzminskaya, dated November 24, 1907, expresses Tolstoy's disappointment with Repin's work with a tone of injured vanity reminiscent of the writer's youth. "Sonya is fully absorbed in copying her and my portraits painted by Repin. The portrait is most humorous: it depicts a satiated and stupidly smiling old man; this is I. Before him there is a bottle of a glass (there was something of the sort on my desk); next to him sits his wife, or one may think his daughter (this is Sonya), and sadly and disapprovingly looks at the slumbering old man." And an entry in his *Diary* reads: "I am somewhat constrained in writing because Repin is painting my portrait, a useless one, a dull one, but I don't want to hurt him." Another brief entry: "Saw Repin off."[34]

Nordman lived with Repin as his common-law wife for over fourteen years until she became ill and left alone for Switzerland where she died of consumption in 1914. In her will she left Penaty to the Academy of Art. Upon her death Repin placed an announcement in a newspaper which read: "The writer Nordman-Severova died in Locarno, of which I. E. Repin informs with deep regret."[35] That was all. He went to Locarno to visit her grave, stopped on the way back in Venice, and upon return to Penaty (as evidenced by Chukovsky) declared to his visitors on the first Wednesday: "Now we can be seated as we please." He began to eat meat, removed some placards, invited his daughter Vera to come and run his household. The tragicomic period in his life was over, leaving him feeble as both man and artist.

Evidently with the passage of years, Repin began to feel the weightiness of

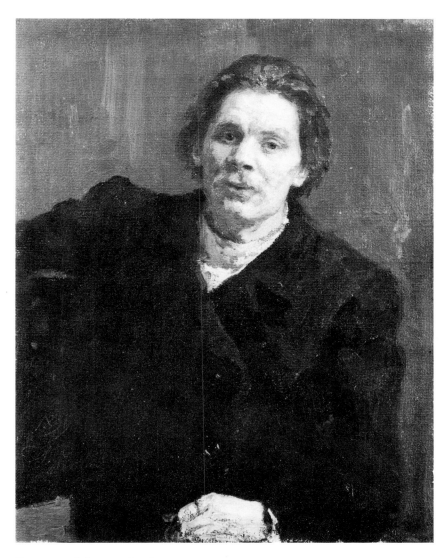

Portrait of A. M. Gorky.

Nordman's whimsical, consuming, and agitated personality. Moreover, he discerned that no matter how many hours he spent in his studio at the easel, his product gave him more pain than pleasure. Even though he never expressed it, it is possible that he too finally realized the detrimental effect Nordman had on his art. Chukovsky wrote: "In the course of many years I was a constant visitor of his studio and I can testify that he exhausted himself with work to a fainting state; that each of his paintings he repainted totally ten, twelve times; that during the creation of one or another composition such despair would overtake him, such bitter lack of confidence in his abilities, that he would in one day destroy a

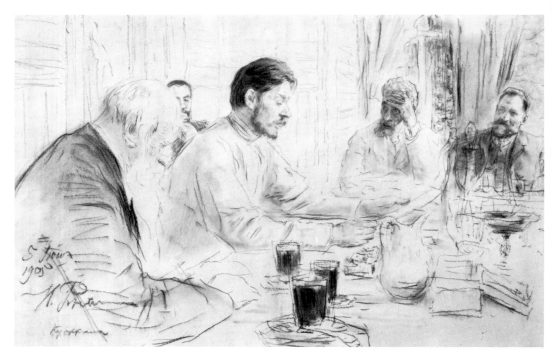

A. M. Gorky Reads His Play "Children of the Sun." Seated left to right V. V. Stasov, A. I. Kuprin, N. G. Garin-Mikhailovsky, F. D. Batyushkov.

whole canvas on which he had worked several years, and on the next day would again begin to paint it."[36] His right hand began to atrophy, complicating the work, and even though he learned with time to paint with his left hand a malaise was added to the work which had given meaning to his life.

The revolutionary tempest which was engulfing his country was especially ominous in St. Petersburg, but Repin, having resigned his professorship at the Academy in 1907, had less need to travel to the capital and thus he responded to events through a ceaseless correspondence with old and new friends. Life on his dacha was staid, and Repin ceased to be an active observer and became a concerned bystander. The life with Nordman at Penaty had robbed him of the emotional and intellectual excitement of the Russian scene which had often dictated his choice of themes. His late works—*The Manifestation of October 17, 1905* (1907–1911); *The Black Sea Freemen* (1908); *Gogol Burning His Manuscript* (1909); *The Fifteen-Year-Old Pushkin Reading His Poem "Recollection in Tsarskoe Selo"* (1911), and *Pushkin on the Shores of the Neva* (1911)—are weak and show his decline as an artist. Only a few portraits of visitors to Penaty can be considered successful and equal to his earlier artistic strength.

Until the Revolution of 1917 Repin's Wednesdays attracted the most famous creative personalities in Russian life. Among the callers were the scientists

Photograph. Left to right A. M. Gorky, V. V. Stasov, I. E. Repin, N. B. Nordman.

Pavlov and Mendeleev; the musicians Cui and Glazunov; the writers Leonid Andreev, Alexander Kuprin, Korney Chukovsky, Maxim Gorky, Vladimir Mayakovsky; and the singer Fyodor Shalyapin. Portraits of all these men were executed by Repin. The extent to which his artistic abilities had lowered are suggested by his failure to create excellent portraits of Shalyapin and Mayakovsky.

As in the case of Repin, Stasov and Mamontov had also played a decisive role in the career of Shalyapin. When in 1896 the twenty-three-year-old Shalyapin sang in Nizhny-Novgorod, Mamontov, recognizing the startling qualities of his voice and the unusual dramatic talent of the young man, invited him to sing in his private opera in Moscow, where he introduced him to the intellectual circles. Whenever Repin came to Moscow he stopped at the Mamontov's, and there he heard Shalyapin sing. Upon the restoration of Repin's *Ivan* (slashed by a crazed spectator in 1913), a group of the artist's friends marked the reappearance of the painting in the Tretyakov Gallery with a dinner in his honor. It was here that Repin invited Shalyapin to sit for him during the singer's intended visit to Finland that winter. In January 1914 Shalyapin spent about a week in Penaty

and sat for Repin several hours each morning, but his portrait was still incomplete when he left for St. Petersburg where rehearsals for *Don Quixote* were about to commence. Repin continued work on the portrait without his model and sent the completed work to the Forty-Third Exhibition of the Society. The portrait showed Shalyapin reclining on a wide divan with his right hand extended and his left hand placed around a small dog resting on his lap. He wears an open collar above a tight-fitting sweater and knickers. The likeness was good, but the portrait lacked any force and vitality and received much negative criticism. A few years later, evidently displeased with his work, Repin painted a female nude over it.

The Mayakovsky portrait did not fare much better. In the spring of 1915, the poet was visiting Chukovsky in Kuokkala and reciting his poetry on the terrace of Chukovsky's home when the host and his guest noticed Repin approaching. Knowing Repin's hostility to the Futurists and taking into account his temperament, Chukovsky feared that a conflict was inevitable between the artist and the poet. After Repin greeted those present in a slow, deliberate manner, he turned to Mayakovsky to apologize for the interruption and asked that he continue his recitation. At the end of it he asked Mayakovsky to come to sit for him. At the appointed time Mayakovsky came to Repin's studio and was met by the agonized look of the artist. Mayakovsky's "lion's head" was gone; he had stopped at the barber on the way to the sitting to make himself more presentable. In dismay, Repin painted a small portrait with very little enthusiasm.[37]

An observer of Repin's life and technique of painting at this period was Anton Komashka; in 1914 the eighteen-year-old Komashka had sent Repin a letter from Kharkov in which he spoke of his desire to become an artist, saying he had no financial resources to realize his aspiration. He also sent a drawing and asked Repin to evaluate it. Repin offered Komashka a stipend and directed him to enter the Kharkov Art School. They met personally in the summer of that year when Repin came to Chuguev for a few days in regard to his proposed establishment there of a Free School for anyone who wished to study the arts and the trades. The war prevented the realization of Repin's plan, and he invited Komashka to come to study in Penaty instead. There Komashka spent three years from 1915 through 1918, leaving in 1917 to serve in the army. What follows is Komashka's testament as an eyewitness to Repin's painting approach and habits—a singular document.

> The model is placed. A piece of canvas stands on the tripod. Repin holds a long charcoal drawing pen. With very light strokes he draws the whole contour and at once applies thinned paint using a fine long brush making the drawing of the whole portrait. Already in the two hours of the first sitting, his portrait is filled with color, tonal shadings and modeled shapes.
>
> At other times he used his largest bristle brushes, placed large quantities of paint on his palette and without an outline, like a sculptor, modeled the

figure, its head, body, hands, and feet. At still other times, like in a drawing, Repin applied color with free brush strokes at random. He also painted with water-colors, pastel, sanguine, Italian dull and red pencils, and sometimes even made drawings with a brush which he fashioned out of a piece of paper.

When using pastel colors Repin employed short, quick brush strokes on a golden, dense cardboard without rubbing in the colors. The drawings with sanguine and red pencil he would "wash" with water, using a water-color brush. With the pen he made contours, modeled with free strokes and blackened with spots. With sepia he would place succulent spots of light and shade.

His studio occupied the entire second floor of Penaty which he always kept in perfect order. He worked from a palette which, when his ailing right hand was rigid, was supported by a belt around his torso.

Paints were abundant, ordered from two sources: Dosekin (Moscow) and Windsor and Newton (England); the varnish came from France.

He dissolved the paints in purified oil. He used mostly large bristle brushes and palette-knife. He painted on canvas, cardboard, linoleum, and oil-cloth.[38]

To a large extent World War I and the Revolution passed Repin by, failing to evoke a sustained emotional response, even though in his letters he expressed his joy that Russia was finished with tsardom and was now a republic. After the Revolution, Kuokkala was cut off from Soviet Russia by the Soviet-Finnish border but on November 24, 1917, Repin was once again, and for the last time, in Petrograd, as St. Petersburg was renamed by the Bolsheviks. The occasion was a jubilee celebration in his honor. The Community of Painters (founded in St. Petersburg in 1908 and dissolved in 1932) arranged an exhibition and a celebration and sent Repin the following letter:

> The Community of Painters addresses itself to you with a great request—to honor—to come on November 24 to the Palace of Art at 4 o'clock. Forty-five years have passed since the appearance of your painting *The Resurrection of Jairus's Daughter* followed by your great and fine artistic activity, which compels us to react to this great event. . . . Postponing the All-Russian public celebration to the next year, we in the intimate circle of the artistic world decided to celebrate this cultural holiday. The whole artistic Petrograd responded to our modest beginnings: the Community of Artists; the Society of Traveling Exhibitions, the A. I. Kuindzhi Society; the Council of the Academy of Art; students of the Academy of Art; the Society of Water-Colorists; the Association of Painters; literary men; musicians, and many other artistic organizations.[39]

He sent to the exhibition his painting *Ukrainian Cossacks* (Gaidamaki) and several portraits, and surrounded by a crowd of admiring artists viewed the

exhibition and shared his impressions. Even though arranging a dinner in those hungry days was a stupendous undertaking, a dinner by candlelight was managed, lasting into the early morning hours. When Repin was about to leave, "There was noise, everyone left his table and crowded around him. When he had put on his coat, we gave him a wild ovation; we lifted him and carried him like a hero."[40] Repin then returned to Kuokkala, the once busy but now desolate seashore resort.

In 1917 Repin painted a new variation of the *Burlaki* to which he gave a rather pretentious title, *The Cattle-Slaves of Imperialism* (Bydlo imperialisma); he sent it to the Forty-Sixth Society Exhibition of the same year. For the most part he gave the next years to paintings on religious and biblical themes, such as *The Morning of the Resurrection* (1921) and *Calvary* (1921–1922). The *Miracle Icon*, which he had completed in 1899, went through many changes in the passing years and a last variant, dated 1917–1924, was exhibited in Prague and sold there as *The Church Procession in an Oak Forest.*[41] Sales abroad were Repin's only means of earning his livelihood since the Russian market was closed by its own internal imbalance.

It seemed as if Repin had lived to come full circle: his early life in Chuguev had certain similarities with his late years in Kuokkala. He had to rely on his own labor to be able to make the next step, and in both places he was alone, though surrounded by relatives. In the deprived year 1917 he sent his son Yury 300 rubles, not an inconsiderable sum, and two years later in a letter to an artist friend he speaks of his want: "Truly the days are black in all respects, and even elemental, the most dark times coincide with the shortest day and the coldest. It is no longer possible to have my studio heated to enable the old drunkard to rest, to forget, to relax. Joyless, hopeless thoughts disjointedly come to mind. . . . One lives altogether in captivity, in exile, enslaved, limited by frozen fingers and compressed brains." And to his daughter Vera he writes: "Last Wednesday not a soul was here. True, the weather was bad. Have I written you? We have already eaten the goat; her meat was so tasty, soft, white. Kuokkala is totally broken-down. The window panes are knocked out, the fences are down, the little bridges tumbled down, many houses are sold for junk. Now we all live poorly, there is no income, everything is expensive."[42]

Visitors from the Soviet Union were rare, and those who surrounded him in Finland were antagonistic to the new Russian government. He was thus especially grateful for the arrival at Penaty of I. P. Pavlov, the famous physiologist, in 1924, who by special permission was able to return to Finland to his dacha in the summers. Repin happily painted his portrait.

But though visitors were rare, Repin was not forgotten in the Soviet Union. "On July 24, 1924, Repin was eighty years old—a portentous and grand period in our rapid, all forgetting, hurried years. This day stirred up the whole of artistic Russia—at first in Moscow, then in Leningrad. In the Tretyakov Gallery and the Russian Museum large and rich Repin exhibits took place where the

Photograph. I. E. Repin.

most varied works were gathered, beginning from his early years."[43] Congratulations poured in to Kuokkala and Repin responded with grateful acknowledgment: "My dear friends! Torn from my beloved people, from friends and peers in art, I am full of desire to see all of you and to thank you personally for the sympathy and good wishes of which I was a recipient yesterday above all measure. Even strangers from distant places sent me friendly greetings and sincere wishes for many more good years. Thank you, thank you my friends."[44]

It should be remembered that at this time Russia was striving to lift herself out of the chaos of Civil War by the introduction of the New Economic Policy. It was a nation groping its way through a labyrinth of unprecedented laws and new

moral, political, and esthetic standards. A new order was replacing the collapsed social and political prewar structure, shaking a vast country to its foundations and cutting Russia loose from its moorings to the past. At one point Chukovsky had sent Repin excerpts from Pobedonostsev's letter to Tsar Alexander III, reprinted in the two-volume edition of Pobedonostsev's materials in 1925, wherein Pobedonostsev severely criticized Repin's *Ivan and His Son Ivan* and insisted that public showings of the painting be prohibited. In his reply to Chukovsky, the artist, who had been an active participant in the historical canvas of his time, explained in an elliptical paragraph the last act of the Russian drama: "*It did not even pay* to copy the words of Pobedonostsev. For the first time I clearly see what a nonentity, a gendarme, a mere ass he is, not above our A.A.[45] The Russian catastrophe for which they themselves are responsible becomes more and more obvious. Of course, the illiterate muzhlan[46] *Rasputin* was their *genius*, and he put together for all of them a much deserved end. It came to pass no matter how they were forewarned."[47]

Experiencing continuous difficulties in earning some money and feeling disconcerted, he wrote to Chukovsky: "For quite a while now I am here entirely alone. I recall the words of Dostoevsky about the hopeless condition of a man who has 'no place to go.' "[48] Much-needed financial help finally came from the Soviets in 1926 through a delegation expressly sent to Kuokkala by the Minister of Education of the Soviet Union. Depositing a generous sum in the Finnish bank in his and his son's names, the delegation also endeavored to convince Repin to return to his native land. But for Repin it was too late. He wished to be buried under the "Chuguev Hill" in Penaty. "Please don't think that I am in a bad mood because of approaching death," he wrote Chukovsky in May 1927.

> On the contrary, *I am gay*. First of all I did not forsake *art. I worked to the best of my abilities* over all my paintings. Even now I am working on a painting more than half-a-year (why keep it a secret any longer), *over the painting Hopak* (Ukrainian Folk Dance) dedicated to the *memory* of Modest Petrovich Musorgsky. . . . What a pity, I don't seem to be able to finish it. And I still have more and more themes, all of them gay and lively. There are no changes in the garden. Soon I am going to dig my grave. Too bad that I myself don't have sufficient strength to do it, and I don't even know whether I'll be permitted.[49] But it is a good place. Under the Chuguev Hill. You haven't forgotten it?[50]

It was there that Repin was buried at his death on September 29, 1930.

Repin had stood in the center of Russia's cultural life of his day. The times in which he worked, the last quarter of the nineteenth century and the first quarter of the twentieth century, saw various developments in the world of Russian painting: reforms in the Academy of Art; the creation, flowering, and fall of the

Society of Traveling Exhibitions (Peredvizhniky); the growth of new esthetics; the conflict between the Realists and the Symbolists; the birth of modern art. After the revolution, and in spite of the confusion of the 1920s, Repin's art stood inviolate. In the 1930s, notwithstanding the formulation of the method of Socialist Realism officially prescribed for all the arts, Repin's achievements, his unique dedication to critical realism and national themes, were enthusiastically embraced. Two major exhibitions in 1936 and 1957; multiple reproductions of his canvases; the search for his paintings; publication of his correspondence; multiple publications of *Far and Near*; the place reserved to him in the magazine *Iskusstvo* (Art); the giving of his name to ships and locales; the renaming the Institute of Art, Sculpture, and Architecture of the Academy of Art as the Repin Institute of Art, Sculpture, and Architecture of the Academy of Arts; the renaming of Kuokkala as Repino in 1948—all of this is testimony to the reverence in which Russia has held and still holds Ilya Repin, her national artist.

Notes

Introduction

1. Richard Hare, for example, notes with some chagrin and disapprobation, in *The Art and Artists of Russia*, "Some of Repin's excursions into historical painting were considerably cruder than his portraits, but they won for him wider popular acclaim." Another art historian, Tamara Talbot Rice, in *The Concise History of Russian Art*, gives Repin a passing nod and concludes: "It is the tragedy of both Surikov and Repin, who were artists of quite unusual ability, that their outlook and styles were formed at a time when it was considered more important for artists to point a moral than to give form to a vision."

Chapter 1

1. V. V. Stasov, "Kartina Repina *Burlaki na Volge*" (letter to the editor of *Sankt-Peterburgskie vedomosti*), in V. V. Stasov, *Izbrannoe* (Moscow-Leningrad: izd. Iskusstvo, 1950), 1:67–69.

Chapter 2

1. I. E. Repin, *Dalekoe blizkoe* (Far and Near), ed. Kornei Chukovskii (Moscow-Leningrad: Gosudarstvennoe izdatel'stvo, 1949). The work made its first appearance in 1937, with revised editions in 1944 and 1949. The 1949 edition, containing additions and corrections, edited with an introductory statement by Korney Chukovsky (1882–1969), has been used extensively in this work to fill in pertinent information on Repin's life. Careful examination of Repin materials dealing with his childhood and youth seems to indicate that all Russian Repin scholars, even Sergey Ernst and Igor Grabar, relied upon this autobiographical information which Repin first disclosed in his article "How I Became an Artist" (*Neva*, no. 29) in 1914, and which subsequently formed part of the final volume.

2. I. A. Brodskii and V. N. Moskvinov, eds., *Novoe o Repine* (Leningrad: izd. Khudozhnik RSFSR, 1969), p. 30.

3. Sergei Ernst, *I. E. Repin* (Leningrad: izd. Komiteta populiarizatsii khudozhestvennykh izdanii, 1927), p. 13. Igor Grabar considered this work to be the prime reference work on Repin.

4. Had Persanov persisted in his fidelity to nature, his own fate might have been less tragic. Having accepted the offer of a patron, he entered the St. Petersburg Academy of Art, where at first he won some distinction. However, stifled by the atmosphere there he soon began to deteriorate mentally. In the end, hungry and in rags, he fled from the Academy and made the return journey of 1500 versts (nearly 1000 miles) to Chuguev on foot. Arriving at his mother's village (a few versts further) he collapsed and completely lost his sanity. He died soon thereafter.

Chapter 3

1. The school had five classes in drawing and ten in specialties. It specialized in applied art and had a registration of about 1000 students.

2. Repin, *Dalekoe blizkoe*, pp. 146–151.

3. N. Moleva and E. Beliutin, *Russkaia khudozhestvennaia shkola vtoroi poloviny XIX–nachala XX veka* (Moscow: izd. Iskusstvo, 1967), pp. 11–16.

4. The fourteen dissenters were: I. N. Kramskoy, K. B. Venig, N. D. Dmitriev-Orenburgsky, A. D. Litovchenko, A. I. Korzukhin, N. S. Shustov, A. I. Morozov, K. E. Makovsky, E. S. Zhuravlev, K. V. Lemokh, A. K. Grigoriev, M. I. Peskov, N. P. Petrov, and V. P. Kreitan.

5. Ernst, *Repin*, p. 18.

6. Igor Grabar, *Repin* (Moscow: Gosudarstvennoe izdatel'stvo izobrazitel'nykh iskusstv, 1937), 1:82.

7. *Repin, Khudozhestvennoe nasledstvo*, eds. I. E. Grabar and I. S. Zilbershtein (Moscow-Leningrad: Akademiia Nauk, 1948), 2:328–331.

8. F. M. Dostoevskii, *Dnevnik pisatelia za 1873 goda* (Berlin: izd. I. P. Ladyzhnikova, 1922), pp. 321–323.

9. Vladimir Vasilievich Stasov, like most of his compatriots, was educated in a specialized institution which had no relationship to one's life or interests. In the School of Jurisprudence where he studied from 1836 to 1843 he was less affected by the study of law than by the two concurrent circumstances—the oppressive policies of Nicholas I and the Belinsky interpretation of the masterpieces of Pushkin, Lermontov, Gogol. Gogol's *Dead Souls* (1842) was read and reread by young Stasov and his fellow students until hundreds of expressions from it were committed to memory. The writings of Diderot, Heine, and Lessing were studied and criticized in the spirit of Belinsky. Stasov, a fine musician, and his schoolmate A. N. Serov, the future composer and critic, were already praising the music of Glinka as superior to the sentimental Italian music preferred by St. Petersburg society.

Upon graduation in 1843, Stasov first served in the Senate and later in the Ministry of Jurisprudence. In 1851 he accepted the position of secretary to a wealthy industrialist, A. N. Denisov, and spent three years in Florence in his service. From 1856 to his death in 1906 Stasov held the post of Head of the Art Division of the St. Petersburg Public Library.

Returning to St. Petersburg in 1854, Stasov became closely associated with the musicians grouped around Glinka. The "Mighty Five" (Kuchka), as Stasov nicknamed them, were young men of varied professions: M. A. Balakirev (1836–1910), Ts. A. Cui (1835–1918), M. P. Musorgsky (1839–1881), A. P. Borodin (1833–1887), and N. A. Rimsky-

Korsakov (1844–1908). Under the steadfast influence of Stasov and Balakirev, Russian national music was created.

Again two other concurrent circumstances—the Crimean War and Chernyshevsky's dissertation *The Aesthetic Relationship of Art to Reality*—convinced Stasov that Art for Man's Sake was a noble pursuit. Like a religious orthodox believer, he never wavered from this catechism.

10. The Society of Traveling Exhibitions held forty-eight exhibitions, the first in 1871 and the last in 1924.

11. M. D. Calvocoressi and Gerald Abraham, *Masters of Russian Music* (New York: Tudor, 1944), pp. 196–197.

12. See G. A. Tiumeneva, "Muzyka v zhizni Repina," *Repin, Khudozhestvennoe nasledstvo*, 1:544–579.

13. I. A. Brodskii, *I. Repin. Izbrannye pis'ma v dvukh tomax, 1867–1930* (Moscow: izd. Iskusstvo, 1969), 1:95.

14. Underground circles led by S. G. Nechaev.

15. Brodskii, *Repin-Pis'ma*, 1:39–42.

Chapter 4

1. Ernst, *Repin*, p. 131. This letter to Iseev was in lieu of an official report.

2. Ibid., pp.131–132.

3. V. V. Stasov, *Polnoe sobranie sochinenii* (St. Petersburg, 1906), 2:163.

4. *Perepiska s P. M. Tretiakovym, 1873–1898* (Moscow-Leningrad: Gosudarstvennoe izdatel'stvo, Iskusstvo, 1946), p. 25.

5. M. K. Kleman, *Letopis' zhizni i tvorchestva I. S. Turgeneva* (Moscow-Leningrad: Akademiia, 1934), pp. 198–200. Turgenev arrived in St. Petersburg on February 25 and stayed in the city until March 20. During this short stay he posed for Makovsky and Ge. On the day after his arrival he visited Antokolsky's studio where he met the sculptor and viewed the statue which Antokolsky had just completed, *Ivan the Terrible*. Turgenev was overwhelmed by its excellence of execution, historical depth and Antokolsky's psychological insight.

6. I. S. Zilbershtein, *Repin i Turgenev* (Moscow-Leningrad: Akademiia Nauk, 1945), p. 13.

7. Repin, *Dalekoe blizkoe*, p. 316.

8. *Repin, Khudozhestvennoe nasledstvo*, 1:380.

9. *Perepiska s Tretiakovym*, pp. 27–28.

10. The second variation when completed was shipped to Moscow to Tretyakov, who did not consider it successful. In 1877 Tretyakov exchanged the Turgenev portrait for the Repin portrait of the noted historian I. A. Zabelin. Repin, on the other hand, sold the Turgenev portrait to the financial magnate and art patron S. I. Mamontov. Repin painted two other portraits of Turgenev, one in 1879 during Turgenev's brief stay in Moscow, the other in 1883.

11. For a full account of the Repin-Turgenev-Stasov relationship, see *Repin i Turgenev*.

12. I. S. Turgenev, *Polnoe sobranie sochinenii* (Moscow-Leningrad: izd. Nauka, 1965), 10:317.

13. Ibid., 11:56.

14. A. I. Kuindzhi was a close friend of Repin's. In a letter of 1873 to Kramskoy, Repin wrote: "About Kuindzhi: He is an intelligent, interesting man, but Eastern. The ideas which he shared with you are his own. I treasure him very much. Speaking about any subject he will not be content with two or three definitions, he always goes to the core. Too bad his education is limited because he is quite a philosopher and quite a politician. That is true. Only I don't believe that he is a spokesman of our younger generation because he is an Eastern Greek. I don't agree with him concerning the role of the Academy. Of course, in our Eastern way of life the Academy will wear for a long time to come the gilded uniform and will give exultant celebrations, but this not forever. In the end the ideas of the decayed West will penetrate to us, the ideas of freedom, equality, and fraternity." (Brodskii, *Repin-Pis'ma*, 1:98.)

15. Grabar, *Repin*, 1:142.

16. Ibid., 1:152.

17. Brodskii, *Repin-Pis'ma*, 1:122–123.

18. In 1936 an all-state exhibition of Repin's works was held at the Tretyakov Gallery in Moscow. About ten paintings of his Paris period were shown, but none of the drawings or watercolors were included. A possible explanation for this, according to Soviet sources, is that Repin may have sold his works in Paris immediately after completion. Another reason may be that many of his paintings and drawings had found their way to Europe and America in recent times. Repin had gathered together many of his works and carefully preserved them in his studio at Penaty, in Finland. However, after his death they were sold indiscriminately. Some of his other works are to be found in museums of remote Russia or in private collections, and therefore remain unknown. Careful investigations have been carried out since 1936 and some hitherto unknown works of his Paris period have been uncovered. These include many studies, drawings, and sketches. A study dated 1873, showing the head of a man dressed in a Spanish costume, was located in England. Many sketches for his *Paris Café* should be in existence. He made about twenty, twelve of which were exhibited in St. Petersburg in 1891. Most of these studies are in Western European countries; some of them have never been seen in Russia. One study dated 1873 was recently discovered in a private collection in Leningrad. Some studies done in Normandy in 1874 were also found.

Over 200 Repin works, mostly drawings, were recently located but the whereabouts of many more is still unknown, according to I. A. Brodskii (*Novoe o Repine*, pp. 351–370).

Chapter 5

1. M. Musorgskii, *Pis'ma i dokumenty* (Moscow, 1932), p. 251.

2. Letter of V. V. Stasov to D. V. Stasov, 31 July 1876, Stasov Archives, Institute of Russian Literature. Quoted in Grabar, *Repin*, 1:163.

3. I. S. Aksakov, *Sochineniia* (Moscow, 1886), p. 271.

4. Other Repin works in which the influence of French Impressionism can be found include *Beggar Girl* (Nishchaya), 1874; *Little Vera à la Manet*, 1875; *Dragonfly*, 1884; *Tolstoy Resting under a Tree in the Forest*, 1891.

5. *I. E. Repin i V. V. Stasov, Perepiska* (Moscow-Leningrad: Gos. izd., 1949), 2:12.

6. On April 4, 1866, D. V. Karakozov had fired a pistol at Alexander II near the Tsar's Summer Garden in St. Petersburg. It was later established that Karakozov had chosen this nihilistic method of expressing his dissatisfaction with the monarch's reforms. Karakozov was sentenced to death by hanging, and Repin and Murashko, then young students at the Academy, were present at the execution. One week later, while strolling and sketching on the outskirts of the city, they found themselves at the Smolensk Field where the execution had taken place. They came upon newly dug graves, agreed that Karakozov was probably buried there, and were apprehended by a militiaman who took them in for interrogation. It then took all of their ingenuity to convince the police to return them to the Academy for clearance. The event is recorded in Repin, *Dalekoe blizkoe*, pp. 204–210.

7. O. A. Liaskovskaia, *Ilya Efimovich Repin* (Moscow: izd. Gosudarstvennoi Tretiakovskoi Gallerei, 1953), pp. 52–53.

8. *Repin i Stasov, Perepiska*, 1:20–21.

9. Letter, 13 February 1878. Brodskii, *Repin-Pis'ma*, 1:210. Repin's relationship with the Society was uneven. From 1883 to 1887 he was a member of the executive board. In 1887 he resigned his membership, objecting to the growing bureaucracy within the Society. From 1890 to 1896 he was only an exhibitor. In 1897 he once again joined the organization.

10. Musorgskii, *Pis'ma i dokumenty*, p. 372.

11. In 1879 Repin played the part of the Cynic in A. N. Maikov's tragedy *Two Worlds*; in Abramtsevo, the summer of 1881, he acted in a comedy written by S. I. Mamontov; in 1882 he played the part of Beryata, the boyarin-friend of Tsar Berendei in Ostrovsky's *Snowmaiden*; and again in Abramtsevo in the summer of 1882 he acted in a vaudeville by Mamontov. V. S. Mamontov, "Repin i semia Mamontovykh," in *Repin, Khudozhestvennoe nasledstvo*, 2:37–56.

12. Only limited information on Russian medieval art was available at the time since concerted research in this area began only in the mid-1850s. See brief bibliography in R. Peresvetov, *Po sledam nakhodok i utrat* (Moscow: vtoroe izd., Sovetskaia Rossiia, 1963), pp. 283–287. Restoration of architectural structures, renovations of icons, and systematic studies began only after the 1917 Revolution and extensive work continues. See *Drevne russkaia zhivopis', novye otkrytiia* (Leningrad: izd. Avrora, 1969).

13. The iconostasis is a wide screen separating the altar from the sanctuary, sometimes consisting of five tiers of icons. In the center are the *Deesis*, Christ, the Madonna, and John the Baptist; the side panels depict the saints; the rest of the screen has representations of other holy figures.

14. *Burlaki* and *The Farewell of a Recruit* remained in the Tsar's Palace unseen by the general public until the Revolution of 1917.

15. In 1878 at Abramtsevo, Mamontov's estate where Repin and his family were spending the summer, Turgenev suddenly arrived with Elena Blaramberg, a young writer who was attracting some attention from the public at the time. She was the sister of one of the publishers of the Moscow newspaper *Russkie vedomosti*. Repin made a study of her for his painting. Another model was V. Serova, mother of Valentin Serov, the distinguished artist. The third known model was the house seamstress. The whereabouts of these studies are unknown.

16. *Repin i Stasov, Perepiska*, 2:50–51. In 1880, *Scribner's Monthly* published two

articles by Eugene Schuyler: "Peter the Great" and "Peter the Great as Ruler and Reformer." The first article was illustrated by Repin's drawings "Sophia's Appeal to Her Partisans" and "Towing a Russian Barge." The second article was illustrated by "The Princess Sophia as the Nun Susanna in the Novodevichy Monastery." In 1891, Repin made a series of sixteen sketches of St. Petersburg, some of which were used by *Scribner's Monthly* to illustrate Isabel F. Hapgood's article "The Nevsky Prospect."

17. *I. E. Repin, Perepiska s Tolstym. Materialy* (Moscow-Leningrad: Gos. izd. Is-kusstvo, 1949), 2:5–7.

18. *Repin i Stasov, Perepiska*, 2:54–55.

19. Repin wrote Stasov on January 2, 1881: "Yes, Moscow can be called the belly of Russia, that same 'satiated belly' which is 'deaf to learning.' " (*Repin i Stasov, perepiska*, 2:58; the following quote is from the same source.)

20. *Repin i Stasov, Perepiska*, 2:59–60.

21. In 1885 through the efforts of Musorgsky's friends a monument was erected on Musorgsky's grave.

22. This letter, dated 26 March 1881, bears a postscript which says that he had just returned from the funeral of Nikolay Rubinstein even though he was not his admirer. This terse note suggests that Repin still carried the memory of the *Slav Composers*. In *Repin i Stasov, Perepiska*, 2:61–62.

23. Brodskii, *Repin-Pis'ma*, 1:250.

24. It is regrettable that Repin did not record his conversations with Tolstoy. In his letter to Stasov, 7 December 1881, he merely states: "How interesting this man is. He makes progress all the time, and one can now discern in him a change for the better. Some day I shall give you a more detailed account of our conversations." In *Repin i Stasov, Perepiska*, 2:72–73.

25. Alexander Benois, *Istoriia russkoi zhivopisi v XIX veke* (St. Petersburg: izd. Znanie, 1902), p. 178.

26. Almost nothing had been written about this sojourn, not even in Russian, prior to the 1948 publication of a two-volume edition, *Repin, Khudozhestvennoe nasledstvo*, edited by I. E. Grabar and I. S. Zilbershtein. New documentary materials in the archives of the Institute of Literature of the Academy of Sciences of the USSR enrich the very limited Repin biographical data. Revealing information concerning the voyage of 1883 is contained in twenty letters written by Stasov to his relatives and to his friend the art critic and art historian N. P. Sobko; in Stasov's travel diary; and in Repin's reminiscences of this trip written forty years later for a proposed publication in honor of the hundred-year anniversary of Stasov's birth. The latter manuscript was in the possession of Stasov's niece until 1942, and only after her death in that year did it become the property of the USSR Academy of Sciences. See also I. S. Zilbershtein, "Puteshestvie I. E. Repina i V. V. Stasova po zapadnoi Evrope v 1883 godu," in *Repin, Khudozhestvennoe nasledstvo*, 2:429–525.

27. Letter to T. L. Tolstoy, 25 June 1893, in *Repin, Khudozhestvennoe nasledstvo*, 1:440.

28. Ibid., p. 443. When Stasov died and friends were gathered at the apartment of his brother, Dmitry, to honor his memory, Fyodor Shalyapin walked over to the "Dresden" portrait and kissed it.

29. *Repin, Khudozhestvennoe nasledstvo*, 1:451.

30. Repin's letters to Kramskoy are located in the Russian Museum, Leningrad. They remain unpublished. The letters quoted here appear for the first time in *Repin, Khudozhestvennoe nasledstvo*, 1:454.

31. Ibid., p. 472.

32. *Repin perepiska s Tretiakovym*, p. 74.

33. *Repin, Khudozhestvennoe nasledstvo*, 1:475.

34. Ibid., p. 482.

35. Ibid., p. 483.

36. Ibid., p. 484.

37. Ibid., p. 496.

38. This painting is at present in a private collection in France. Only in 1946 did a photograph of the work reach the USSR.

39. I. S. Turgenev, *Polnoe sobranie sochinenii i pisem* (Moscow-Leningrad: izd. Nauka, 1967), 13:207.

Chapter 6

1. I. E. Repin, *Pis'ma k khudozhnikam i khudozhestvennym deiateliam* (Moscow: izd. Iskusstvo, 1952), p. 53.

2. G. H. Hamilton, *The Art and Architecture of Russia* (Baltimore: Penguin Books, 1954), p. 252.

3. V. V. Stasov, *Russkoe iskusstvo* (Moscow: izd. Iskusstvo, 1950), p. 194.

4. Maurice Hindus in *Humanity Uprooted* gives the following remark regarding the term "intelligentsia": "Intelligentsia! What a hallowed word it was in Russia in the pre-Bolshevik days! What nobility it symbolized, what reverence it inspired! Coined in Russia, the word had made the rounds of the world, but nowhere had it attained the distinction and distinctness that it had in the land of its birth. Everywhere in Russia it roused respect and adoration. . . . The intellectual was the soul of Russia."

5. *Repin perepiska s Tretiakovym*, pp. 100–101.

6. In August 1887 Repin was in Moscow. The Tretyakov Gallery was closed to the public and Tretyakov was out of town. Repin brought his oils to the gallery where *The Unexpected* was exhibited and spent several hours changing the face. He thought he had improved it, but he had only weakened the expression. When Tretyakov returned the following day he was enraged. He sent the painting to Repin in 1888 and asked him to attempt to recapture the original. Again Repin made some changes, but the original expression was never recaptured, as a photograph of the first version testifies. The exile still represents a sympathetic member of the intelligentsia, but the spiritual qualities of the face were lost and the intent of the painting had greatly suffered.

7. *Repin, Khudozhestvennoe nasledstvo*, 1:521.

8. Grabar, *Repin*, 1:274.

9. In 1888 Garshin plunged to his death, jumping down a stairwell, during a fit of melancholia, thus prematurely ending a gifted life known to posterity only by twenty brilliantly written short stories. See Fan Parker, *Vsevolod Garshin: A Study of a Guilty Conscience* (New York: King's Crown Press, 1946).

10. Grabar, *Repin*, 1:260–261.

11. L. N. Tolstoi, *Polnoe sobranie sochinenii* (Moscow: izd. Khudozhestvennaia literatura, 1956), 63:222–223.

12. Twenty years later an attempt to destroy the painting was made. On January 16, 1913, a young artist, Abram Belashev, an Old Believer, was browsing through the Tretyakov Gallery. When he came upon *Ivan the Terrible* he suddenly became infuriated, drew a knife, and slashed the painting three times. He was stopped before he could cause irreparable damage. One incision was from Ivan's temple to the shoulder; another from the cheek, touching the nose and the fingers of the right hand; and the third cut across the fingers of Ivan's right hand and the cheek and chin of his son. The whole nation was outraged and demanded punishment for the negligence which had resulted in this national loss. The director of the gallery was discharged, and Igor Grabar was appointed in his place. With great skill the canvas was mended, but the color still needed restoration. Repin, living at the time in Finland, arrived unexpectedly at the gallery one day when Grabar was absent. He did exactly what he had done with *The Unexpected*. He repainted the Tsar's head using much purple color, and when he was finished with his work he left satisfied. When Grabar returned to the gallery later the same day he was shocked, as had been Tretyakov earlier, but kept his calm. He immediately took a dry cloth and deftly wiped off the offending purple paint. Then with cotton and kerosene he went over the surface removing every trace of oil, since in his judgment if the oils were left on they would turn dark in a few years in the places where the scars had been mended. His theory that only water colors covered with wax would save the painting proved to be correct. Repin, now in his declining years, was not informed, and when he looked at the painting several months later he himself could not find the restored parts, and in ignorance of Grabar's actions remained quite satisfied. In this manner *Ivan the Terrible and His Son Ivan* was preserved for posterity.

13. *Repin i Stasov, Perepiska*, 2:100.

14. A. P. Chekhov, *Polnoe sobranie sochinenii i pisem* (Moscow: izd. Khudozhestvennaia literatura, 1948), 13:290.

15. Ibid., 13:119, 15:36.

Chapter 7

1. Part of this description of Repin and factual information concerning his private life were recorded by A. V. Zhirkevich (1853–1927), a military jurist by profession who aspired to a literary career, publishing some of his writings in provincial journals. Appreciating Repin's eminence and exhilarated by his friendship, which lasted many years, Zhirkevich began to keep a diary from the first meeting. Entries recorded detailed accounts of their discussions, his personal impressions of the artist, and his observations of Repin's domestic life, which are of special interest since almost no other information now available would explain his sudden, drastic act of separation from his wife and children.

2. *Repin perepiska s Tretiakovym*, p. 79.

3. Grabar, *Repin*, 2:56.

4. *Repin i Stasov, Perepiska*, 2:105.

5. Ibid., p. 115.

6. The Tsar-Bell was cast in 1735 and weighed 200 tons. During the 1737 fire in

the Kremlin the bell fell from its scaffolding, and a fragment weighing more than eleven tons broke off. Only 100 years later was the bell raised out of the pit which it had made in falling and installed on a granite base upon which it stands to this day.

7. *Repin i Stasov, Perepiska,* 2:116.

8. I. E. Repin, *Perepiska s L. N. Tolstym* (Moscow-Leningrad: Gos. izd. Iskusstvo, 1949) 2:36.

9. Ibid., p. 39.

10. Ibid., p. 41.

11. Ibid., p. 43.

12. Repin to Zvantseva, 28 January 1889 (Letter 9). The letters are held in the Repin Archival Fund of the Academy of Art, Leningrad. The correspondence between Repin and Zvantseva lasted from 1888 to 1906. It began with six letters in November and December 1888, and sixty-three letters written by Repin from 1889 to 1891. For 1893 there are two letters; 1894, one letter; 1895, one letter; and two notes for 1903 and one for 1906. In 1897, when her personal relationship with Repin was ended, Zvantseva travelled to Paris with her friend K. A. Somov, and there she studied art. Consequently she opened an art school, first in Moscow and then in St. Petersburg. She died in 1922. The location of Zvantseva's letters to Repin is unknown. Complying with her request, Repin returned all her letters to her. One supposes that she destroyed them while preserving his letters in order to assure herself a place in the life story of the famous artist.

13. The Zaporozhie Sech, beyond the Dnieper Rapids in the Ukraine, was an autonomous Cossack settlement in the sixteenth century.

14. *Repin, Khudozhestvennoe nasledstvo,* 2:69.

15. S. A. Tolstoi, *Dnevniki, 1891–1897* (Moscow: izd. M. A. Sabashnikovykh, 1929), p. 56.

16. Letter 68, mid-November 1891. Repin's letters to Zvantseva remain unpublished.

17. Letter 70.

18. An entry in Countess Tolstoy's diary vividly describes a historic event connected with this painting: "Yesterday was peaceful; we spent a pleasant evening with Repin. He told us that in St. Petersburg, at the Peredvizhniki exhibition where the portrait of Lev Nikolaevich was exhibited, there were two demonstrations. At the first, a small group of people had placed flowers before the portrait. At the second, on March 25, 1901, a huge crowd gathered in the big hall. A student had climbed a chair and placed bouquets of flowers around the frame of the picture. Then began a laudatory speech: shouts of 'hurrah' resounded and flowers rained from the gallery. As a result the portrait was removed and will not be shown in Moscow, and certainly not in the provinces. . . . This is indeed regrettable." The occasion was the Twenty-Ninth Exhibition of the Society and the demonstrations took place as a gesture of protest against Tolstoy's excommunication from the Russian Orthodox Church by decree of the Synod. (S. A. Tolstoi, *Dnevniki,* p. 149.)

19. *I. E. Repin. Perepiska s L. N. Tolstym,* 1949, pp. 9, 10–11. The connection between the two men is reflected in Repin's record of an incident during the winter of 1892 when the countryside was being ravaged by famine. He had gone to see Tolstoy in the province of Ryazan, where Tolstoy was organizing food centers for the stricken

peasants. The scarcity of food contrasted markedly with the abundance of snow. Return-
ing from a tour of neighboring villages, their sleigh, rising and falling as if on the crest
of waves, suddenly capsized on a hilly road. A sharp turn had forced it over, burying the
two men and the horses in a deep ravine. It may well be that this incident was the
germination for the central snowstorm sequence in Tolstoy's *Master and Man* (1895).

In total, Repin painted ten oil portraits of Tolstoy: *Tolstoy at His Writing Desk,
Tolstoy in an Armchair with Book in Hand, Tolstoy at the Plough, Tolstoy in His
Yasnaya Polyana Study under the Eaves, Tolstoy Resting under a Tree in the Forest,
Tolstoy at Prayer, Tolstoy in the Forest at Prayer, Tolstoy with His Wife at a Table,
Tolstoy in the White Blouse*, and *Tolstoy in the Rose Armchair*. In addition, in 1891
Repin executed three sculptured busts of Tolstoy (two in plaster and one in bronze) and
two paintings, *The Entrance to Yasnaya Polyana* and *The Green Stick* (the spot at
Yasnaya Polyana where Tolstoy's brother, in their youth, had said he buried a green
stick upon which was written the secret to happiness—and the spot at which Tolstoy was
subsequently buried). Repin also made numerous watercolors and drawings of Tolstoy
and the members of his family.

20. I. I. Shishkin was a coexhibitor.

21. V. V. Chuiko, *Khudozhestvennye vystavki g. g. Repina i Shishkina*, "*Nabliuda-
tel*," February 1892, p. 52.

Chapter 8

1. *Repin i Stasov, Perepiska*, 2:168–171, 173.

2. Chekhov, *Polnoe sobranie sochinenii*, 16:16.

3. Brodskii, *Repin-Pis'ma*, 2:16–17.

4. *Novosti i birzhevaia gazeta*, 9 March 1893.

5. *Repin i Stasov, Perepiska*, 2:184.

6. Repin, *Dalekoe blizkoe*, pp. 412–413.

7. Ibid., p. 335.

8. N. Moleva and E. Beliutin, *Russkaia khudozhestvennaia shkola*, pp. 227–237.

9. *Repin, Khudozhestvennoe nasledstvo*, 2:233–234.

10. Letter 5 to Zvantseva mid-December 1888. Letter 32, 19 May 1889. Letter 36, 8
November 1891.

11. It is inherent in the tradition and practice of Soviet letters to expose as little as
possible the personal details of a person's life. Thus there are no works or documents
available which speak of Repin's apparently stormy and eventful personal life—his wife,
his children, his amorous affairs. Only a very fragmentary picture emerges from pain-
staking research.

12. On the day of his father's death, when the body was laid out on a table, Yury
went into the woods, killed a rabbit, brought it home, and nailed it at the feet of the
dead man. To another nail he hung a basket of apples. And then he said: "This is the
best I can offer in tribute to my father."

13. Chekhov, *Polnoe sobranie sochinenii*, 17:24.

14. Brodskii, *Repin-Pis'ma*, 2:134–135.

15. Chekhov, *Polnoe sobranie sochinenii*, 18:309.

16. Ibid., 19:70–71.

17. Brodskii, *Repin-Pis'ma*, 2:162–163.

18. With the financial support of Countess Tenisheva and in cooperation with Alexander Benois, K. Somov, and Léon Bakst, Diaghilev began publishing in 1898 the magazine *World of Art* (Mir iskusstva).

19. Grabar, *Repin*, 2:140.

20. *Repin i Stasov, Perepiska*, 2:158.

21. Ibid., 3:36.

22. On Sunday, January 9, 1905, Tsarist troops fired on a procession of workers who marched peacefully to bring a petition to the Tsar, killing and wounding several hundred.

23. Brodskii, *Repin-Pis'ma*, 2:195–196.

24. Repin left his teaching position at the Academy in a rather strange manner, as recorded by one of his students. One day in the tea room of the Academy a conversation took place between Repin and some students. One of the students remarked that they were having a hard time financially and that while the students hardly had money for dinner, delectable odors emanated from professors' apartments. Moreover, while the students hardly had sufficient room in which to paint, professors' apartments often consisted of ten rooms. Repin immediately responded by saying that from then on he would no longer occupy his apartment at the Academy and would give it over to the students to work in. He got up, left the tea room, and that evening went to Yasnaya Polyana, having left the Academy forever. A delegation of his students followed him there and he received them with an unequivocal refusal to return to the Academy. In G. N. Gorelov, "Velikii khudozhnik i pedagog," in *Repin, I. E. Sbornik dokladov i materialov* (Moscow: Akademiia khudozhestv SSSR, 1952), pp. 29–30.

25. Brodskii, *Repin-Pis'ma*, 1:385.

26. A persistent pain for many years resulted in the atrophy of Repin's right hand. He painted *The State Council* with his left hand, assisted by two students, B. M. Kustodiev and I. S. Kulikov.

27. *Novoe o Repine*, p. 83.

28. Ibid., p. 114.

29. The exhibition was held at the Kingore Galleries. The introduction and the catalogue were by Dr. Christian Brinton. The introduction read as follows: "The rigorous realistic and nationalistic tradition represented alike by Repin in paintings and by contemporaries in music and letters is the specific legacy of their day and generation . . . this art does not address itself primarily to the imagination. It is in no sense a product of fancy; it is rather a convincing transcription of outward and visible fact. . . . In its every accent the artistic legacy of Ilya Repin typifies the man's own particular age and epoch." It is not known what sale Repin paintings had and how many of the unsold paintings were returned to him at Kuokkala. It may well be that Repin was again "ravaged," judging by a small item in the *New York Evening Post* (25 March 1930): "Today a half dozen Repin paintings are in the studio of a young New York commercial artist, purchased here last month for almost nothing at an auction, circumstances obscure."

30. *Novoe o Repine*, pp. 26–27.

31. From the archives of K. I. Chukovsky. These and other documents were presented to the authors by Chukovsky in Peredelkino.

32. Kornei Chukovskii, *Repin, Vospominaniia*. (Moscow-Leningrad: izd. Iskusstvo, 1945), p. 144.

33. Brodskii, *Repin-Pis'ma*, 2:197, 251.

34. L. N. Tolstoi, *Polnoe sobranie sochinenii*, 77:249, 56:68.

35. *Rech*, no. 163, 18 June 1914, p. 1.

36. Chukovskii, *Repin*, p. 85.

37. Kornei Chukovskii, *Sovremenniki* (Moscow: izd. Molodaia gvardiia, 1962), pp. 253–294.

38. A. M. Komashka, in *Repin, Khudozhestvennoe nasledstvo*, 2:283–287.

39. *Novoe o Repine*, pp. 276–277.

40. Ibid., pp. 275–276.

41. Repin's friend and representative from 1921 to 1930 was the artist V. F. Levi (1879–1953). He arranged Repin exhibitions and sales abroad. See Brodskii, *Repin-Pis'ma*, 2:346.

42. Ibid., p. 326.

43. Ernst, *Repin*, p. 59.

44. Brodskii, *Repin-Pis'ma*, 2:349–350.

45. Alexander Alexandrovich Romanov, Tsar Alexander III.

46. A coarse, uncouth muzhik (peasant).

47. Brodskii, *Repin-Pis'ma*, 2:356.

48. I. A. Brodskii and Sh. N. Melamud, *Repin v "Penatakh"* (Moscow-Leningrad: izd. Iskusstvo, 1940), p. 8.

49. Penaty did not belong to Repin but to the Academy.

50. Brodskii, *Repin-Pis'ma*, 2:389.

Biographical Notes

Aksakov, I. S. (1823–1886). Publicist and prominent Slavophile.

Aman-Jean, Edmond (1860–1936). French portrait painter.

Antokolsky, M. M. (1843–1902). Sculptor. Born in Vilno of poor Jewish parentage. Entered the Academy of Art in 1862. His first work, *Ivan the Terrible* (1870–1871), offered in competition for the Grand Medal, enjoyed great success, and the Academy designated him Academician in 1871. Because of ill health spent many years abroad. He first executed small genre sculptures in wood and ivory such as *The Tailor* (1864) and *The Miser* (1865), but soon his attention turned to historical figures. Among his major works are: *Ivan the Terrible* (1871). Bronze. Russian Museum, Leningrad (the Tretyakov Gallery holds a copy hewn in marble, 1875); *Peter I* (1872). Bronze. Tretyakov Gallery, Moscow; *Christ before the People* (1874). Bronze (the Tretyakov Gallery holds a copy hewn in marble, 1876); *Ermak* (1881–1891). Bronze. Russian Museum. He is considered one of Russia's outstanding sculptors.

Belyaev, M. P. (1836–1903). Responsible for the organization of popular symphonic concerts and publisher of Russian music abroad.

Böcklin, Arnold (1827–1901). Swiss landscape painter.

Bogolyubov, A. P. (1824–1896). Russian landscape painter. Member of the Council of the Academy of Art, member of the Society of Traveling Exhibitions. Lived in Paris most of his life as a representative of the Academy and in charge of the pensioners.

Bridgeman, Frederick (1847–1927). American painter. Painted in Brittany, Algiers, and Egypt.

Chertkov, V. G. (1854–1936). Most trusted friend, follower, and collaborator of Leo Tolstoy. An aristocrat, he forsook the self-indulgent life of St. Petersburg high society and found meaning for his life in the service of Tolstoy. From 1883, when he first met him, to the end of Tolstoy's life in 1910, Chertkov exerted influence upon the writer. Tolstoy's wife and other critics, however, characterized this influence as "evil." In 1897 Chertkov was exiled to England for assisting the Dukhobors, a sect which believed in nonresistance to violence, nonservice in the army, sharing common property, chastity, vegetarianism—principles of Christian anarchy upheld by Tolstoy. In England Chertkov published Tolstoy's works that had been banned in Russia. Upon his return to

Russia his association with Tolstoy intensified, and finally it was in Chertkov's home, in the vicinity of Moscow, in 1910 that Tolstoy executed his last will and testament, naming Chertkov executor of his literary estate and editor. In 1928, and during the remainder of his life, Chertkov served as general editor of the Jubilee Edition of Tolstoy's complete works, which finally comprised 90 volumes (1928–1958). In the introduction to volume 1 he states that the will of Leo Tolstoy is being honored by making his writings available free to all humanity, free for reproduction in any country, in any language, without need to secure permission from any government or person.

Chistyakov, P. P. (1832–1919). Painter. Pensioner of the Academy of Art, he studied in Paris and Rome. As professor at the Academy he was considered an outstanding pedagogue. Surikov, Vasnetsov, Serov, and others studied under him. His painting *The Boyar* (1876) is in the Tretyakov Gallery.

Conder, Carl (1868–1909). English artist.

Cui, Ts. A. (1835–1918). Composer, one of the "Mighty Five." Of French descent, he taught at the Engineering Academy of St. Petersburg and wrote several textbooks on fortification. Besides operas—*Le Prisonier du Caucase, Le Fils du Mandarin, William Ratcliffe*—he also composed symphonies and piano works. Repin painted his portrait in 1890 and made two drawings of him in 1892 and 1900.

Diaghilev, S. P. (1872–1929). Jurist, musician, art critic, impresario. Born in Novgorod. Graduated from St. Petersburg Conservatory of Music in 1892. In 1898 in cooperation with Alexander Benois, K. Somov, and Léon Bakst he began publishing the magazine *World of Art*. In 1899 he joined the staff of the Imperial Russian Theater in Moscow and in cooperation with its director, Mikhail Fokine, and Léon Bakst he brought fame to the Russian ballet by radiant coordination of dancing, costumes, lighting, stage sets, and music. He adapted the music of Rimsky-Korsakov and Debussy for ballet and enhanced the Russian ballet through the music of Stravinsky written for the ballet. Until 1903 Diaghilev was responsible for annual art exhibits; in 1906 he brought the Russian ballet to New York; in 1907 he organized concerts of Russian music in Paris. In 1909 he created his own company, *Ballet Russe*, with Nijinsky as its principal male dancer. After 1921 the company performed mainly in Paris and London.

Fet, A. A. (1820–1892). Russian poet. His father, A. N. Shenshin, and his mother, Charlotta Fet, were landowners. His first collection of poetry, *Lyrical Pantheon*, was published in 1840. His two dominant themes: nature and love. Many of his poems were set to music by Russian composers—Rimsky-Korsakov, Taneev, Rachmaninov—and became popular romances.

Garshin, V. M. (1855–1888). Writer. His twenty short stories expressed his indignation against war and social evils and helped to establish the short story genre in Russian literature.

Ge, N. N. (1831–1894). Russian artist. Studied at the Academy of Art and lived in Italy as its pensioner. Upon his return to St. Petersburg he participated actively in the Society of Traveling Exhibitions and his major canvas, *Peter I Interrogates Tsarevich Alexei Petrovich in Peterhof*, completed in 1871, was exhibited at the Society's first exhibition

that year. He also painted portraits of Turgenev (1871) and Antokolsky (1871). Early in the 1880s Ge met Tolstoy and almost immediately became his devoted disciple. From then on he painted on religious themes. He painted an excellent portrait of Tolstoy, *Tolstoy at Work*, in 1884.

Golovin, A. Ya. (1863–1930). Stage designer and artist. Associated with *World of Art*. Executed brilliant set designs for opera.

Hindus, Maurice (1891–1969). Writer. Born in Russia, emigrated to the United States in 1905. Known for his works on Russia: *Humanity Uprooted* (1929), *Mother Russia* (1943), *The Cossacks* (1945).

Ignatiev, A. P. (1842–1906). Count. Served as governor of Kiev and from 1896 was member of the State Council. Close association with Tsar Nicholas II. Was responsible for extreme police repressions. Assassinated in 1906.

Iseev, P. F. (1831– ?). Member of the Council of the Academy of Art. From 1869 to 1889 was the administrative director and also in charge of the Art Department. Later convicted of embezzlement, he was exiled to Siberia.

Ivanov, A.A. (1806–1858). Artist. Born in St. Petersburg. After completion of his studies at the Academy, Ivanov left for Rome in 1830 and lived there most of his life. His painting *Christ Appearing to Mary Magdalene* (1834–1835) was exhibited in St. Petersburg in 1836 and earned him the title of Academician. The next year he began work on a huge canvas (540 × 750 cm), *The Appearance of Christ before the Multitude* (1837–1857), for which he sacrificed his personal life and suffered material deprivation. The canvas remained incomplete, but in the process of work in the course of twenty years he executed over 300 studies in oil and numerous sketches of men, women, children, and nature in the open air with an uncommon mastery of line and fluidity of color. He finally returned to Russia in 1858 and died in the city of his birth six weeks after his return. The Russian Museum in Leningrad holds his *Christ Appearing to Mary Magdalene*; the Tretyakov Gallery holds the painting and most of the oil studies to *The Appearance of Christ before the Multitude* and periodically arranges Ivanov exhibits.

Karakozov, D. V. (1840–1866). Revolutionary. Believed that personal terrorist tactics would advance a revolution. Came to Petersburg in 1866 and attempted to assassinate Alexander II. He failed, was caught, and was condemned to death by hanging.

Katkov, M. N. (1818–1887). Publicist. Headed the newspaper *Moskovskie vedomosti*. In close relationship with Alexander II and Alexander III, he advocated reactionary policies.

Kharlamov, A. A. (1842–1922?). Painter. Studied at the Academy of Art. Sent to Paris in 1869 as pensioner of the Academy, he made it his permanent home. Was named Academician in 1874. Primarily known for his 1875 portrait of I. S. Turgenev now located in the Russian Museum, Leningrad. Illustrated Turgenev's *Nest of Gentlefolk* and *On the Eve*.

Kivshenko, A. D. (1851–1895). Studied at the Academy of Art (1867–1877) and was later named professor.

Kovalevsky, P. O. (1843–1903). Painter. Graduated from the Academy of Art in 1871. Grand Medal winner, he was sent to study in Rome and later in Paris, and was named Academician in 1876.

Kramskoy, I. N. (1837–1887). Painter. Entered the Academy of Art in 1857. When in 1863 fourteen students broke with the Academy in protest against its rigid regulations, Kramskoy formed an Artel, a union of artists. When it failed he organized the Society of Traveling Exhibitions (the *Peredvizhniki*). He is widely known for his excellent portrait of Leo Tolstoy (1873).

Kuindzhi, A. I. (1842–1910). Russian landscape painter. Born to the family of a shoemaker of Greek origin. Admitted to the Academy of Art in 1868. He became a member of the *Peredvizhniki* in 1875. His early painting *On the Isle of Valaam* (1873) depicting northern nature was followed by masterful canvases of central and southern Russia: *Birch Grove* (1879); *After a Thunderstorm* (1879); *The Dnieper in the Morning* (1881); *Night on the Dnieper* (1882); *Oaks* (1900); *Sunset in the Steppe* (1900). After 1882 he did not exhibit with the *Peredvizhniki*. He assumed new duties as professor in the Academy of Art in 1892.

Lenbach, Franz von (1836–1904). German portrait painter.

Makovsky, K. E. (1839–1915). Painter. One of the fourteen students who broke away from the Academy of Art in 1863. He was a member of the Artel, a union of artists, and the Society of Traveling Exhibitions. Painted genre scenes, *Burial in the Village* (1872), *Children Escaping the Storm* (1872). In 1882 he severed his association with the Society of Traveling Exhibitions and painted portraits of the officialdom.

Mamontov, S. I. (1841–1919). Industrialist, art patron. He made his estate, Abramtsevo, an art center from 1870 through 1890 where many famous artists gathered for work and artistic productions. In 1885 Mamontov founded the private Moscow Russian Opera.

Murashko, N. I. (1844–1909). Ukrainian painter. Studied at the Academy of Art. In 1875 he founded the Kiev Art School where he taught for twenty-six years.

Myasoedov, G. G. (1835–1911). Painter. Entered the Academy of Art in 1859. As pensioner of the Academy studied in France, Italy, and Spain. Upon his return from abroad he became an active member of the Society of Traveling Exhibitions. Painted on peasant themes, for example, *The Zemstvo at Dinner* (1872).

Nordman, N. B. (1863–1914). Wrote under the pseudonym Severova. From 1900 common-law wife of I. E. Repin. Owner of a dacha, Penaty, in Kuokkala, Finland, she settled with him there. In 1900 Repin illustrated a Nordman story; two years later a novel. In 1901 she edited and published *I. E. Repin's Recollections, Articles, and Letters from Abroad*. An energetic and colorful personality, Nordman had many idiosyncrasies. She gloried in her role of wife of the famous Repin, identifying herself with Sophia Andreevna, wife of Leo Tolstoy, as one who served her man and art. Repin painted her innumerable times but those who knew her maintained that Repin tended to flatter her rather plain physiognomy.

Ostroukhov, I. S. (1858–1929). Russian artist.

Pierce, Charles Sprague (1851–1914). American artist. Studied in Paris with Bonnat. Lived permanently in France. One of his paintings, *The Arab Jeweler*, is in the Metropolitan Museum of Art, New York.

Pirogov, N. I. (1810–1881). Famous Russian surgeon and scientist.

Pisemsky, A. F. (1820–1881). Writer and dramatist. His works deal with serfdom, civil servants, and the philistinism of the nobleman's life.

Pleve, V. K. (1846–1904). Ultrareactionary state official. Served in the judiciary; was appointed head of the Police Department in the Ministry of the Interior; served as Minister of the Interior; served as Minister and Secretary of State of Finland where he carried out a ruthless policy of Russification. Was assassinated in 1904.

Pobedonostsev, K. P. (1827–1907). Procurator of the Holy Synod. Exerted great influence upon Alexander III and Nicholas II and is noted for his ultrareactionary policies. His doctrine is expressed in his *Reflections of a Russian Statesman* (trans. R. C. Long, London, 1898).

Polenov, V. D. (1844–1927). Painter. Graduated from the Academy of Art in 1871. Was an active member of the Society of Traveling Exhibitions. An active member of the Mamontov Circle, he gave much time and energy to stage decorations of theatrical productions at Abramtsevo. In 1881 he traveled to Syria, Palestine, Egypt, and Greece. From 1882 to 1895 he taught at the Moscow School of Art, Sculpture, and Architecture. His paintings: *Grandmother's Garden* (1878); *A Moscow Courtyard* (1878); *The Overgrown Pond* (1879); *Fall in Abramtsevo* (1890). In 1926 he was named People's Artist of the USSR.

Pradilla, Francisco (1848–1921). Spanish painter. Director of the Prado, Madrid.

Prakhov, Andrey (1846–1916). Russian art historian, archaeologist, and art critic. He studied at the University of St. Petersburg and later taught art history and art theory there from 1873 and at the Academy of Art from 1875. Art editor of the journal *Pchela*. Mstislav Prakhov was his brother.

Pryanishnikov, F. I. (1793–1867). Served as Postmaster General. He was one of the first collectors of Russian paintings, before Tretyakov. He bought paintings from needy artists and later added works of the Russian masters. After his death his collection found its way to the Tretyakov Gallery.

Puvis de Chavannes, Pierre (1824–1898). French painter. Known for his murals in the museums of Amiens, Marseilles, and Lyons.

Savitsky, K. A. (1844–1905). Painter. Studied at the Academy of Art from 1862 to 1873. Active member of the Society of Traveling Exhibitions. His canvases include *Railway Repair Work* (1874); *Meeting the Icon* (1878); *Off to the Wars* (1880); *Morning in the Pine Forest* (1889).

Sechenov, I. M. (1829–1905). Famous physiologist. Repin painted his portrait in 1889.

Semiradsky, G. I. (1843–1902). Painter of Polish origin. Studied at the Academy of Art from 1864 to 1870. Grand Gold Medal winner, he lived several years as pensioner in

Rome. Was named Academician in 1873. He painted on themes of ancient Greece and Rome. One of his noted canvases in the Tretyakov Gallery is *Dance among Swords* (1881).

Serov, A. N. (1820–1871). Composer, musicologist, music critic.

Serov, V. A. (1865–1911). Artist. Son of the composer A. N. Serov. From the age of nine studied under Repin. Spent much of his boyhood in Abramtsevo in the company of artists. As youth traveled with Repin to the Zoporozhie. Studied at the Academy of Art from 1880 to 1885 under the tutorship of P. P. Chistyakov. Is known for his excellence in portraiture, for painting figures in the atmosphere of light and air in pure, cool, bright colors. *Girl with Peaches* (1887); *Girl in the Sunlight* (1888); *K. A. Korovin* (1891); *I. I. Levitan* (1893); portrait of the industrialist *M. A. Morozov* (1902); *M. N. Ermolaeva* (1905), a famous tragedienne. He also painted the Russian landscape. His best, perhaps, is *October* (1895). In 1894 he joined the Society of Traveling Exhibitions, but six years later he pledged his allegiance to the group of artists associated with *World of Art*. In 1907 he painted his famous canvas *Peter I*, and in 1908 he executed numerous masterful drawings of various personages (of the theater, for example, K. S. Stanislavsky, I. M. Moskvin, V. I. Kachalov). He created stage designs; illustrated books; taught at the Moscow School of Art, Sculpture, and Architecture from 1897 to 1909. Acknowledged as one of the most talented in the realist school of Russian painting. Most of his canvases are located in the Tretyakov Gallery.

Shishkin, I. I. (1832–1898). Landscape painter. Studied at the Moscow School of Art, Sculpture, and Architecture (1852–1856) and the Academy of Art in St. Petersburg. A Grand Gold Medal Winner (1860), he studied in Germany and Switzerland as pensioner of the Academy. Was named Academician in 1865. His major landscapes: *Felling Trees* (1867); *A Field of Corn* (1878); *Pines Colored by the Sun* (1886); *Morning in a Pine Wood* (1889); *In Countess Mordvino Woods* (1891). Considered Russia's most talented landscape painter.

Soloviev, V. S. (1853–1900). Russian philosopher. Believed in the synthesis of science, philosophy, and religion.

Stasov, V. V. (1824–1906). Art and music critic, art historian, archaeologist. Born in St. Petersburg. Father an architect. Studied law, music, art, and literature. In 1847 he wrote his first articles on literature and music. He lived abroad from 1851 to 1854. From the mid-50s he was associated with the St. Petersburg Public Library and in 1856 became head of its Art Department. Sponsor and friend of most of Russia's musicians and artists of his time. Author of numerous works on art and music. Highly nationalistic.

Strakhov, N. N. (1828–1896). Literary critic, journalist. Biographer of Dostoevsky and close friend of Tolstoy.

Surikov, V. I. (1848–1916). Painter. Born in Krasnoyarsk, Siberia, of Cossack lineage, he began his studies at the Academy of Art in 1869. In 1877 Surikov moved to Moscow where he lived and painted his famous canvases: *The Morning of the Execution of the Streltsy* (1881; bought by Tretyakov); *Menshikov in Beriozov* (1883); *Boyarina Morozova* (1887); *The Taking of a Snow Town* (1891); *Ermak Conquers Siberia* (1895); *Suvorov*

Crossing the Alps (1899); *Stepan Razin* (1907). He also painted portraits and landscapes, but is ranked among the greatest of Russian painters for his historical canvases.

Suvorin, A. S. (1834–1912). Journalist and publisher. Owner of the newspaper *Novoe vremya*, which he acquired in 1876 and issued until 1917. He founded a theater in St. Petersburg. He also conducted a book publishing business. A conservative critic, his journalistic writings supported autocracy.

Szyndler, Pantaleon (1846–1905). Polish painter. Studied in Munich, Rome, and Paris. Later settled in Warsaw.

Tenisheva, Countess M. K. (1867–1928). Founded an art school in St. Petersburg and a school of applied art in Smolensk. An intimate friend of Repin; he painted seven portraits of her during 1896–1898 and assisted her in running her art schools. In 1898 gave financial support to the magazine *World of Art*.

Tiepolo, Giovanni Battista (1696–1770). Italian painter best known for his frescoes and etchings.

Ton, K. A. (1794–1881). Russian architect.

Tretyakov, P. M. (1832–1893). Founder of the Tretyakov Art Gallery in Moscow. Collector of Russian paintings of the realistic school for over forty years. In 1892 he gave the city of Moscow his and his brother's art collections. He dedicated his life to the advancement of Russian national art.

Vasnetsov, V. M. (1848–1926). Painter. Born in a village in Viatka province to a priest's family. He came to St. Petersburg to study at the art school sponsored by the Society for the Advancement of Art, and entered the Academy of Art in 1868. His early genre paintings, *Moving Day* (1876), *A Book-Stall* (1876), *Military Telegram* (1878), were exhibited at the exhibitions of the *Peredvizhniki*, whose organization he joined in 1878, as were his later works. When he moved to Moscow in 1878 his interest in ancient art and architecture, epics, and legends was augmented; these themes were embodied in his theatrical designs and in his paintings upon which his reputation rests: *Flying Carpet* (1879); *Three Tsarevnas of the Underground Kingdom* (1879); *After the Battle of Igor Svyatoslavich with the Polovtsy* (1880); *Alyonushka* (1881); *Ivan Tsarevich on the Grey Wolf* (1889); *Tsar Ivan Vasilievich Grozny* (1897); *The Warriors* (Bogatyri) (1881–1898).

Vereshchagin, V. V. (1842–1904). Painter. Studied at the Academy of Art and in Paris. Traveled extensively through Russia, India, Turkestan, and many other countries. Participated in battles and was wounded several times. He was not a member of the Society of Traveling Exhibitions and exhibited in salons in Moscow, St. Petersburg, and Western cities, arranged privately. His paintings deal mainly with military subjects and express his condemnation of war: *Apotheosis of War* (1871); *Rich Kirghiz Hunter with Falcon* (1871); *The Sale of Child-Slave* (1872); *Fatally Wounded* (1873); *Flag of Truce* (1873); *Tomb of Taj Mahal in Agra; Horseman in Jaipur* (1874–1876); *Shipka-Sheinovo* (1878–1879); *Before the Attack* (1881); *After the Battle* (1881); *Sudden Attack* (1881). From 1889 to 1900 Vereshchagin painted a series of paintings on "Napoleon in Russia." He went down with a cruiser off Port Arthur during the Russo-Japanese War.

World of Art. Represented an association of artists grouped around the magazine of the same name which was published from 1898 to 1904. It organized exhibitions from 1899 to 1903 under the leadership of S. P. Diaghilev and A. N. Benois. After a lapse of several years the association was resurrected and under the leadership of Benois it again organized exhibitions from 1911 to 1924. Its major credo was "art for art's sake."

Zhirkevich, A. V. (1853 [1857?]–1927). Military jurist. Aspired to a literary career publishing some of his writings in provincial journals. Appreciating Repin's eminence, he began to keep a diary from their first meeting. His records include detailed accounts of their discussions, his personal impressions of the artist, and his observations on Repin's home life.

Zvantseva, E. N. (1864–1922). Daughter of a landowner and the granddaughter of N. A. Polenov, critic, journalist, and publisher of *Moskovsky telegraf* (1825–1834). Zvantseva was educated at home and traveled abroad several times with her mother. She came to St. Petersburg to study painting. She met Repin at the home of her aunt, E. N. Gaevskaya, wife of a noted attorney. In the course of three years, 1889–1891, she received sixty-three letters from Repin. All these letters are preserved in the Repin Leningrad archives. The location of Zvantseva's letters to Repin is unknown. Complying with her request, Repin returned all her letters to her leading to a supposition that she might have destroyed them. Ironically it was she, the casual, unresponsive partner in their lasting romance, who understood the need to preserve his letters to assure herself a place in the life story of the famous artist. In 1897 she traveled to Paris with her friend K. A. Somov, and upon her return she organized a drawing school first in Moscow and later in Petersburg where in 1910, still desiring to hang on to Repin, she sought his criticism of her students' art work. Repin looked at the "art" and left in indignation, never again returning to Zvantseva.

Selected List of Repin Canvases

Preparing for an Examination, 1865. 38 × 46. Russian Museum.*

The Cry of Jeremiah on the Ruins of Jerusalem, 1867. 93 × 76. Russian Museum.

The Angel of Death Smites the First-Born Egyptians, 1869. 83.2 × 116.2. Russian Museum.

Job and His Friends, 1869. 137 × 199. Awarded the Small Gold Medal, which offered Repin the right to compete for the Gold Medal. Russian Museum.

The Resurrection of Jairus' Daughter, 1871. 229 × 382. Gold Medal Winner and award to study abroad. Russian Museum.

Slav Composers, 1872. 128 × 393. Moscow.

Bargemen on the Volga, 1870–1873. 131 × 281. Exhibited at the Academy of Art, March 1873; Vienna, 1873; Paris, 1878; Stockholm, 1897. Russian Museum.

The Beggar Girl, Veules, 1874. 110 × 83. Museum of Art, Irkutsk.

Little Vera à la Manet, Paris, 1874. 73 × 60. Tretyakov Gallery.

Paris Café, Paris, 1874. Exhibited in the Paris Salon, 1875; Repin Exhibition, 1891. Private collection, Stockholm.

Sadko, Paris, 1874–1876. 323 × 233. Bought by the Heir Apparent Alexander. Russian Museum.

On the Grassy Bank (Family Bench), 1876. 37 × 56. Russian Museum.

Under Military Conveyance, 1877. 26 × 53. Tretyakov Gallery.

The Muzhik with the Evil Eye, 1877. 63 × 50. Exhibited at the Paris International Exhibition, 1878. Tretyakov Gallery.

The Timid Muzhik, 1877. 65 × 54. Exhibited in the Sixth Society Exhibition. Gorky Museum, Moscow.

In a District Court, 1877. 47 × 80. Russian Museum.

The Archdeacon, 1877. 125 × 96. Exhibited at the Paris International Exhibition. 1878. Tretyakov Gallery.

Examination in a Village School, 1878. Private collection.

A Hero of the Past War, 1878. 48 × 32. Tretyakov Gallery.

Farewell to the Recruit, 1878–1879. 143 × 224. Russian Museum.

On a Small Bridge (the artist's wife at Abramtsevo), 1879, 38 × 61. Collection of I. S. Zilbershtein, Moscow.

The Ruler Tsarevna Sophia Alekseevna, a Year after Her Internment in Novodevichi Monastery during the Execution of the Streltsy and the Torture of Her Retinue in 1698, 1879. 199 × 144. Tretyakov Gallery.

Vechernitsy, 1881. 116 × 186. Tretyakov Gallery.

Rest (the artist's wife asleep in an armchair), 1882. 130 × 91. Exhibited in the Tenth Society Exhibition, 1882. Tretyakov Gallery.

Religious Procession in the Province of Kursk, 1878–1883. 175 × 280. Tretyakov Gallery.

Annual Memorial Meeting at the Wall of the Communards in the Cemetery of Père Lachaise, Paris, 1883. 39 × 60. Tretyakov Gallery.

Dragonfly (the artist's daughter Vera in Martyshkino), 1884. 111 × 84.4. Tretyakov Gallery.

The Unexpected, 1884. 160.5 × 167.5. Exhibited in the Twelfth Society Exhibition, 1884. Tretyakov Gallery.

Refusal from Confession before Execution, 1879–1885. 48 × 59. Tretyakov Gallery.

Ivan the Terrible and His Son Ivan, 16 November 1581, 1885. 199.5 × 254. Tretyakov Gallery.

The Address of Alexander III to Rural Foremen, 1886. The Moscow Kremlin. Repin executed about twenty studies for this painting; twelve were displayed at his 1891 exhibition.

L. N. Tolstoy at the Plough, 1887. 27.8 × 40.3. Exhibited in the Sixteenth Society Exhibition, 1888. Tretyakov Gallery.

The Miracle Icon (Church Procession in an Oak Forest), 1878–1889. Exhibited in the Repin 1891 exhibition. Private collection, Czechoslovakia.

The Fall Bouquet (artist's daughter Vera in Zdravnevo), 1892. 111 × 65. Exhibited at the Society's Twenty-First Exhibition, 1893. Tretyakov Gallery.

Zaporozhie Cossacks Writing a Reply to the Turkish Sultan, 1880–1891. 217 × 361. Exhibited in the Repin 1891 exhibition. In 1896 exhibited in Munich and Budapest and awarded a gold medal in each city. Repin painted over forty studies for this painting. Russian Museum.

Arrest of the Propagandist, 1880–1892. 34.8 × 54.6. Tretyakov Gallery.

The Duel, 1896. Private collection, Italy.

A Girl in the Sun (the artist's second daughter, Nadya), 1900. 94.3 × 67. Tretyakov Gallery.

The State Council in Session on May 7, 1901, 1901–1903. Repin's twenty-two portraits for this painting were exhibited in the Twenty-Second Society's exhibition, 1904. Russian Museum.

Selected List of Repin Portrait Paintings

I. S. Turgenev, Paris, 1874. 116.5 × 89.* Tretyakov Gallery.

A. I. Kuindzhi, Russian artist, 1877. 146 × 105. Russian Museum.

I. I. Shishkin, Russian artist, 1877. 111 × 90. Russian Museum.

I. D. Polenov, Russian artist, 1877. 79 × 64. Tretyakov Gallery.

Self-Portrait, 1878. 18 × 13. Tretyakov Gallery.

I. S. Aksakov, writer, 1878. 97 × 76. Tretyakov Gallery.

P. P. Chistyakov, Russian artist, 1878. 87 × 67. Tretyakov Gallery.

I. V. Repin, the artist's father, 1879. 89 × 70. Russian Museum.

A. F. Pisemskii, writer, 1880. 87 × 68. Tretyakov Gallery.

N. N. Ge, Russian artist, 1880. 82 × 65.

M. I. Musorgsky, composer, 1881. 69 × 57. Painted at the Nilolaevsky Hospital in St. Petersburg a few days before Musorgsky's death. Tretyakov Gallery.

N. I. Pirogov, surgeon, 1881. 64 × 52. Tretyakov Gallery.

A. G. Rubinstein, pianist and composer, 1881. 112 × 85.

I. N. Kramskoy, Russian artist, 1882. 94 × 72. Tretyakov Gallery.

A. P. Bogolyubov, Russian artist, 1882. 64 × 53. Radishchev Museum, Saratov.

V. V. Stasov, critic. Dresden, 1883. 74 × 60. Russian Museum.

V. M. Garshin, writer, 1883. 47 × 39.

P. M. Tretyakov, founder of Tretyakov Gallery, 1883. 98 × 75. Tretyakov Gallery.

V. G. Chertkov, Tolstoy's friend and collaborator, 1883. 53 × 42.

M. P. Belyaev, music publisher and patron of "The Mighty Five," 1886. 125 × 89.

G. G. Myasoedov, Russian artist, 1886. 88 × 68. Tretyakov Gallery.

L. N. Tolstoy in an Armchair with Book in Hand, 1887. 125 × 88. This famous portrait was painted in three sittings in August 1887 at Yasnaya Polyana. Tretyakov Gallery.

*Dimensions given in centimeters.

A. K. *Glazunov*, composer, 1887. 125 × 90. Russian Museum.

V. I. *Surikov*, Russian artist, 1887. 62 × 54. Tretyakov Gallery.

A. P. *Borodin*, composer, 1888. 225 × 140. A posthumous portrait. Russian Museum.

M. S. *Shchepkin*, actor, 1888. State Academy of Maly Theater, Moscow.

I. M. *Sechenov*, physiologist, 1889. 86 × 67.

M. M. *Antokolsky*, sculptor, 1889. Repin painted this portrait in Paris where he was attending the International Art Exhibition in 1889.

E. N. *Zvantseva* (Zvantsova), 1889. Atheneum Museum, Helsinki.

E. N. *Zvantseva*, 1889. 61 × 52. Exhibited in the Repin 1891 exhibition.

Baroness V. I. Ikskul, 1889. 196 × 71. Tretyakov Gallery.

V. V. *Stasov* in red blouse in the country, 1889. 39 × 32. Tretyakov Gallery.

A. K. *Glazunov*, 1890. Private collection, Moscow.

V. S. *Serov*, Russian artist, 1890.

Ts. A. Cui, composer, 1890. Tretyakov Gallery.

L. N. *Tolstoy in the Forest at Prayer*, 1891–1901. 207 × 73. The portrait was exhibited at the Twenty-Ninth Society Exhibition in 1901. Russian Museum.

L. N. *Tolstoy in the Forest at Prayer*, 1891. 23 × 14. Tretyakov Gallery.

L. N. *Tolstoy Resting under a Tree in the Forest*, 1891. 60 × 50. Tretyakov Gallery.

L. N. *Tolstoy in His Yasnaya Polyana Study*, 1891. 64 × 90. Institute of Russian Literature, Leningrad.

V. G. *Chertkov*, friend and collaborator of L. N. Tolstoy, 1891. 53 × 42.

Eleonore Duse, actress, 1891. 108 × 139. Tretyakov Gallery.

L. N. *Tolstoy in His Study*, 1893. Watercolor. 35 × 25. Tolstoy Museum, Moscow.

N. A. *Rimsky-Korsakov*, composer, 1895. 125 × 89. Exhibited in the Twenty-Third Society Exhibition, 1895. Russian Museum.

Princess M. K. Tenisheva, 1896. 195 × 120. Repin's close friend and collaborator. He painted four portraits of her in 1896, and subsequently three more. Private collection, Leningrad.

Maxim Gorky, writer, 1899. 75 × 57. Exhibited at the Twenty-Eighth Society Exhibition and marked "unfinished" in the catalogue. Institute of Russian Literature, Leningrad.

N. B. *Nordman-Severova*, 1900. Atheneum Museum, Helsinki.

N. B. *Nordman-Severova in a Red Beret*, 1900. 119 × 56. Exhibited in the Twenty-Ninth Society Exhibition.

A. P. *Ignatiev*, statesman, 1902. 83 × 62.5. Russian Museum.

K. P. *Pobedonostsev*, statesman, 1903. 68.5 × 53. Russian Museum.

N. B. *Nordman-Severova at Her Desk in Penaty*, 1903. 142 × 172.

L. N. Andreev, writer, 1904. 76 × 66. Tretyakov Gallery.

Tsar Nicholas II, 1905. Russian Museum.

M. F. Andreeva, actress; close friend of Maxim Gorky, 1905. 120 × 82.

N. B. Nordman-Severova, Fasano, Italy, 1905. Museum of Academy of Art, Leningrad.

Tolstoy with his Wife at a Table, 1907. 87 × 104. In 1911, a year after Tolstoy's death, Repin repainted Tolstoy's head turning it away from his wife. Institute of Russian Literature, Leningrad.

L. N. Tolstoy in White Blouse. 1908. 63 × 56. Exhibited in the Thirty-Eighth Society Exhibition in 1910. Institute of Russian Literature, Leningrad.

A. G. Rubinstein, composer, 1909. 216 × 135.

L. N. Tolstoy in the Rose Armchair, 1909. 106 × 90. Exhibited in the Thirty-Eighth Society Exhibition in 1910.

K. I. Chukovsky, writer, 1910. Exhibited in the International Art Exhibition in Rome, 1911. Private collection. Germany.

V. G. Korolenko, writer, 1912. 75 × 64. Exhibited in the Forty-Second Society Exhibition, 1914. Tolstoy Museum, Moscow.

I. P. Pavlov, physiologist, 1924. 55 × 48.

Some Works by Repin Held in American Collections

The authors have located a number of Repin works held in collections in the United States which have not been previously reproduced in other publications.

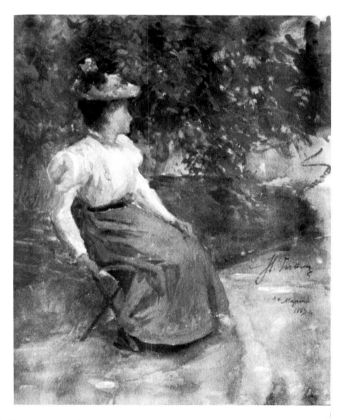

Untitled. 1869. Watercolor. Collection of Mrs. Alexandra Nikolaevna Pregel, New York City. Reproduction courtesy of Mrs. Pregel.

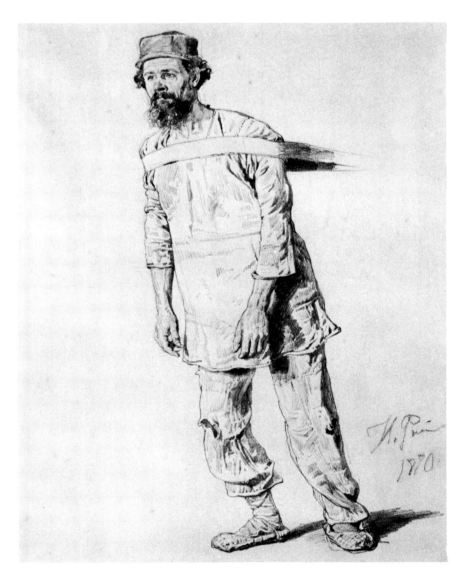

Study for Bargemen on the Volga. 1870. Pencil. Collection of Mr. and Mrs. A. Herenroth, New York City. Reproduction courtesy of Mr. and Mrs. Herenroth.

Study of Heads for *The Cossacks* (1880–1891). Undated. Pencil. Collection of Mrs. Alexandra Nikolaevna Pregel, New York City. Reproduction courtesy of Mrs. Pregel.

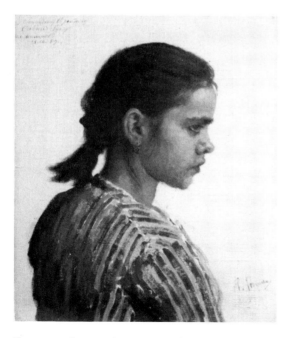

Portrait of a Girl. 1889. Oil on canvas. Collection of Mrs. V. N. Bashkiroff, New Preston, Connecticut. Reproduction courtesy of Mrs. Bashkiroff.

Portrait of a Peasant Girl. Undated. Oil on canvas. The Virginia Museum of Fine Arts, Richmond. Gift of the Josephine Bay Paul and C. Michael Paul Foundation, Inc., and the Charles Ulrick and Josephine Bay Foundation, Inc. 1968.

Portrait of the Artist's Doctor. Undated. Oil on panel. The Virginia Museum of Fine Arts, Richmond. Gift of the Josephine Bay Paul and C. Michael Paul Foundation, Inc., and the Charles Ulrick and Josephine Bay Foundation, Inc. 1968.

The Year 1905. 1925. Watercolor. Collection of Mrs. Alexandra Nikolaevna Pregel, New York City. Reproduction courtesy of Mrs. Pregel.

Selected Repin Bibliography

Brinton, Christian. "Russia's Greatest Painter, I. Repin." *Scribner's Magazine*, vol. 40 (1906).

————. *The Ilya Repin Exhibition*, introduction and catalogue of the paintings. Kingore Galleries, New York, 1921.

Brodskii, I. A. *Repin pedagog*. Moscow: Izd. Akademii khudozhestv SSSR, 1960.

Brodskii, I. A., and Sh. N. Melamud. *Repin v "Penatakh."* Leningrad-Moscow: Izd. Iskusstvo, 1940.

Chukovskii, Kornei. *Repin, vospominaniia*. Leningrad-Moscow: Izd. Iskusstvo, 1945.

————. *Sovremenniki*. Moscow: Izd. Molodaia gvardiia, 1962.

Durylin, S. N. *Repin i Garshin*. Moscow: Izd. Akademii khudozhestv SSSR, 1926.

Ernst, Sergei. *Ilya Efimovich Repin*. Leningrad: Komitet populiarizatsii khudozhestvennykh izdanii pri gosudarstvennoi akademii istorii material'noi kul'tury, 1927.

Grabar, Igor. *Repin*. 2 vols. Moscow: Izd. Izobrasitel'nykh iskusstv, 1937.

Laiskovskaia, O. A. *Ilya Efimovich Repin*. Moscow: Izd. Gosudarstvennoi Tretiakovskoi Gallerei, 1953.

Mashkovtsev, N. G. *I. E. Repin*. Moscow-Leningrad: Izd. Iskusstvo, 1943.

Minchenkov, Ia. D. *Vospominaniia o Peredvizhnikakh*. Moscow: Izd. Iskusstvo, 1940.

Minskii, N. "Kartiny i eskizy I. E. Repina." *Severnyi vestnik*, vol. 2, 1897.

Morgunova-Rudnitskaia, N. D. *Ilya Repin*. Moscow: Izd. Iskusstvo, 1965.

Moskvinov, V. *Repin v Moskve*. Moscow: Gos. izd. Kul'torno-prosvetitel'noi literatury, 1954.

Novoe o Repine [stat'i i pis'ma khudozhnikam, vospominaniia uchenikov i druzei, publikatsii]. Ed. I. A. Brodskii i V. N. Moskvinov. Leningrad: Izd. Khudozhnik RSFSR, 1969.

Ocherki po istorii russkogo iskusstva. Moscow: Akademiia khudozhestv SSSR, 1954.

Paramonov, A. *Illiustratsii I. E. Repina*. Moscow: Izd. Iskusstvo, 1952.

Pribul'skaia, G. *Repin v Peterburge*. Leningrad: Lenizdat, 1970.

Prorokov, S. *Repin*. Moscow: Seriia zhizn' zamechatel'nykh liudei, 1958.

Repin, I. E. *Dalekoe blizkoe*. Ed. Kornei Chukovskii. Moscow-Leningrad: Gos. izd.,
1949.

————. "Iz vremen vozniknoveniia moei kartiny *Burlaki na Volge*." *Golos minuvshego*
(1941):1, 3, 6.

————. "Mysli ob iskusstve." *Novyi put'*, no. 1 (1903).

————. "O grafe L've Nikolaeviche Tolstom (lichnyia vpechatleniia i vospominaniia."
Sovremennyia zapiski, vol. 3 (1921).

————. *Pis'ma k E. P. Tarkhanovoi-Antokol'skoi i I. P. Tarkhanovu*. Leningrad: Izd.
Iskusstvo, 1937.

I. E. Repin i I. N. Kramskoi, Perepiska. Moscow: Izd. Iskusstvo, 1949.

I. E. Repin, Perepiska s L. N. Tolstym. Materialy. 2 vols. Moscow-Leningrad: Gos.
izd., Iskusstvo, 1949.

I. E. Repin i V. V. Stasov, Perepiska. 3 vols. Moscow-Leningrad: Gos. Izd., 1948,
1949, 1950.

Repin. Khudozhestvennoe nasledstvo. 2 vols. Eds. I. E. Grabar and I. S. Zilbershtein.
Moscow-Leningrad: Akademiia Nauk, 1948.

I. E. Repin Pis'ma k pisateliam i literaturnym deiateliam. Moscow: Izd. Iskusstvo,
1950.

I. E. Repin Pis'ma k khudozhnikam i khudozhestvennym deiateliam. Moscow: Gos.
Izd., 1952.

I. E. Repin Pis'ma, perepiska s P. M. Tretiakovym. Moscow-Leningrad: Izd. Iskusstvo,
1949.

I. E. Repin Sbornik dokladov i materialov. Moscow: Akademiia khudozhestv SSSR,
1952.

I. E. Repin Izbrannye pis'ma v dvukh tomakh, 1867–1930. Ed. I. A. Brodskii. Mos-
cow: Izd. Iskusstvo, 1969.

Stasov, V. V. *Izbrannoe*. Moscow-Leningrad: Izd. Iskusstvo, 1950.

————. "Pavel Mikhailovich Tretiakov i ego kartinnaia gallereia." *Russkaia starina*
(1893).

————. *Sobranie sochinenii*. 3 vols. St. Petersburg, 1894.

Zilbershtein, I. S. *Arest propagandista*. Moscow: Izd. Iskusstvo, 1951.

————. *Repin i Gorky*. Moscow-Leningrad: Izd. Iskusstvo, 1944.

————. *Repin i Turgenev*. Moscow-Leningrad: Akademiia Nauk, 1945.

Index

Note: Boldface page numbers indicate illustrations.